MY COUCH IS YOUR COUCH

ALSO BY THE AUTHOR

Toy Stories: Photos of Children from Around the World
and Their Favorite Things

In Her Kitchen: Stories and Recipes from Grandmas Around the World

MY COUCH IS YOUR COUCH

EXPLORING HOW PEOPLE LIVE AROUND THE WORLD

GABRIELE GALIMBERTI

POTTER STYLE
New York

All rights reserved.
Published in the United States by Potter Style,
an imprint of the Crown Publishing Group, a division of
Penguin Random House LLC, New York
www.clarksonpotter.com
www.crownpublishing.com

POTTER STYLE and colophon are registered trademarks of
Penguin Random House LLC.

Selected photographs previously appeared in *D la Repubblica*
between 2010 and 2012.

Library of Congress Cataloging-in-Publication Data
is available.

ISBN 978-0-8041-8557-8
ebook ISBN 978-0-8041-8558-5

Printed in China

Book design by Sonia Persad
Photographs by Gabriele Galimberti
Jacket design by Gabe Levine

10 9 8 7 6 5 4 3 2 1

First Edition

To my parents, who were with me
through all of my travels, though
they never left home

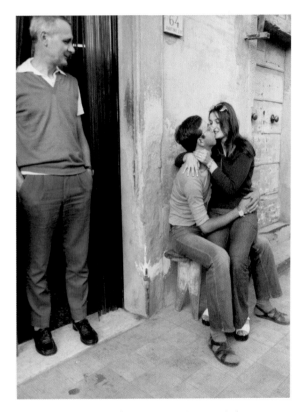

My grandfather and my parents in Rigutino, Italy, 1970.

INTRODUCTION

My couchsurfing journey began in November 2010. I decided I wanted to travel because I wanted to meet different people and see the world from a different perspective. I had been thinking for a long time about using couchsurfing as a way to do so. Also, because I take pictures by trade, I thought of making it into a photographic project. I'd pitched the idea to a number of magazines but had never gotten a solid response from any of them. Then, out of the blue, I got a call from a friend of mine who worked as photo editor for *D*, the well-known weekly style magazine of Italian newspaper *La Repubblica*. Her director was interested in my journey, and I had just thirty days to prepare. Once a week, for the next twenty-four months, the magazine would publish the stories and portraits of couchsurfers that I sent in from wherever I happened to be.

I was excited—and, at the same time, terrified. This was long before the days of Airbnb, VRBO, and other home-rental programs. The first time I'd ever tried couchsurfing had been in China, a few years earlier. On one gloomy November morning, as damp and cold as only China can be, after I had been there for work for more than fifteen days, I realized that in all that time, I had not spoken to a soul. The Chinese didn't understand me, and I didn't understand them. That's when I remembered that someone had told me about couchsurfing: surfing (well, sleeping on, if we want to be literal) strangers' couches. In theory, it's a way to travel without spending much money, as one of the basic rules is that the hosts cannot ask for any sort of monetary compensation. In practice, though, it's much more. Entering someone's home means attempting to understand their lifestyle and habits, immersing yourself in their history, their day-to-day, their intimate space. Sometimes it's easy, and other times it's more complicated. In

Xi'an, China, I was driven not only by financial motives, but also by the desire to find somebody who spoke English, with whom I could have a friendly chat. I ended up sleeping on a yoga mat on the floor of a student's room. I shared the space that night with a dozen other people, and the sanitary conditions were awful—at best. A few days later, in Shenzhen, I was hosted by a wealthy local businesswoman who was looking for a chance to practice her English. I had my own private room in a princely villa and was welcomed to stay as long as I wished. That dichotomy was my first taste of the human diversity and richness of experience that can be had while couchsurfing.

In the years that followed, I hosted hundreds of couchsurfers in my home in Italy. It was by letting the world into my space that, little by little, the idea of taking my own couchsurfing journey began to evolve in my mind. By the time I began pitching the idea to magazines, the couchsurfing community had grown. In 2014, Couchsurfing.com had approximately seven million members from one hundred thousand cities worldwide. It is a social network made up of people from all sorts of backgrounds. What they all have in common, though, is their desire to meet face-to-face. One way is by offering fellow members a place to sleep, but some couchsurfers have other methods.

There are members of the community who (for a variety of reasons, ranging from lack of space to cultural taboos to work commitments) cannot host others. So, instead, they offer some of their time. In the course of my travels, I met many such couchsurfers and spent entire days talking with them and letting them be my guides. They shared with me their cities, their traditions, and their passions. Once, I played cricket under the midday sun in India. Another time, I rode through the snow-covered forests of Alaska on a sled pulled by a dozen dogs. I burned rubber on the streets of Dubai and even had breakfast with one of my musical idols. (He can no longer host anyone in his home— that's the price of celebrity—but he hasn't lost his human curiosity.)

Couchsurfing my way around the world, I discovered a different approach to travel and also, perhaps, to life. I learned to open myself up to others, to put myself in their hands, and to trust them. Obviously, it wasn't always an easy thing to do. The first step was to put aside the prejudices, stereotypes, and unfounded fears we all carry inside.

COUCHSURFING FROM continent to continent is no easy feat emotionally, but it can be a logistical struggle, too. How do you pack when you're leaving to travel around the world? The planning phase is crucial, complex, and less glamorous than one might imagine. You need a veritable mountain of patience and keen attention to detail. Precision and a focus on technical minutiae have always been part of my character, and these traits were a great help to me. To prepare for my trip, I spent an entire week at my computer, reading the profiles of couchsurfers from all over the world; wading through information on prices, climates, permits, and visas; comparing flights and airlines; and studying ferry, train, and bus schedules.

In designing my itinerary, I applied two selection criteria—one technical, the other human. In other words, I considered a city's weather, but also my curiosity regarding particular couchsurfers (as opposed to specific cities). This is how I decided to move from the cold toward the hot. I would start in Alaska and move into progressively warmer climes—and I have to tell you, it was a brilliant choice. It meant that I would have to check one less bag on my last flight than I would on my first. After the first stops along my journey I shipped home my wool sweaters, thick socks, and heavy jacket. This cut my baggage down to just three pairs of pants, a dozen T-shirts, underwear, swim trunks, a scarf, two light sweaters, and a sweatshirt.

What I couldn't leave at home, of course, was my photographic equipment, or my computer, my lucky charm Polaroid picture of a

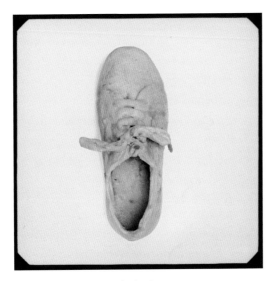

My lucky charm

deep-fried shoe (one of the first photos I took), and a survival kit with a few medications—those things you never think about, but that could end up saving your life (if, for example, you come down with diarrhea in Africa). Waiting to board the first plane, I looked a bit like a weird kangaroo, with a gigantic pack on my back and a smaller one over my chest.

As time went by, I became progressively better at using the Internet to track down the best airlines to match my itinerary. I was able to travel all around Africa—nine countries—for only twenty-five hundred euros ($2,850), using exclusively local airlines (whose planes had definitely seen better days). It was so cheap that a friend of mine who was the editor in chief of one of the most important French newspapers at the time wanted me to teach his reporters how to do it!

Over the course of nearly two years, I traveled through fifty-eight countries, took nearly one hundred ten flights, eight trains, two ferries, a couple of motorized rafts, two dogsleds, one horse, dozens of motorcycle taxis, and hundreds of regular taxis, buses, and various makeshift vehicles, spending approximately twenty-five thousand euros (about $28,000) on transportation, all told. My total budget was around forty thousand euros (about $45,000), which meant that I had fifteen thousand left over to cover everything else. There wasn't much else I needed, though.

Even when I found myself in situations that pushed the boundaries of the absurd—including sharing a bed with a strange man while his pet snake eyed me from less than two feet away—I always found myself among couchsurfers for whom, for one reason or another, I felt an affinity. After all, before the trip, I had spent a long time studying the different members' profiles on the website, allowing instinct and curiosity to be my guides. On the site, you can look at photographs of the members, read their stories, and get a feel for what they like to do, how they spend their time, and what sort of place they live in. You can also read feedback from people they've already hosted, which gives a pretty clear idea of what you'll be getting yourself into. When it was time to decide, I did not choose based on whether a given couchsurfer lived in a place that was conveniently located or difficult to get to, beautiful or ugly. Instead, I chose those couchsurfers who inspired me the most on a human level, and whose world would enable me to get the most out of my experience.

The only wall I occasionally hit was bureaucracy. Couchsurfing is prohibited by law in Cuba and North Korea, and I wasn't able to obtain a tourist visa to get into Russia. I managed to get one in Algeria, but it took a lot of time and patience. For the most part, I tried not to complicate an already difficult challenge by wasting too much time on

stamps and permits. My favorite countries are the ones where you can get your visa at the airport.

Writing about it now is much easier than having done it! In two years of travel, I allowed myself to stop off in Italy, home, just five times. Sometimes I thought I wouldn't be able to make the full two years. At those times, the only remedy was the comfort of friends. Many people helped me, motivated me to keep going, and listened to me at every stop along the way, but three most of all: Elisa (my girlfriend when I started this trip), Arianna (the photo editor at *D*), and Paolo (my best friend). Without their help, I couldn't have seen my journey through to the end.

No amount of support or planning, however, could protect me from glitches, mishaps, or the occasional moment of exhaustion or discouragement. There were many difficulties. Sometimes they were the littlest things, but they could still tie a knot in my stomach for a moment or make me curse the day I decided to set out. In retrospect, however, I see that they were important moments of my life, at the very least because they taught me a lesson, showed me a different way of living than the one I'd always known, and threw wide open a window into self-awareness. In China, for instance, I took the worst shower of my life. It was essentially inside a latrine, a place so unsanitary and stinky that I looked at the running water and could barely stop myself from gagging. I knew I'd come out more filthy than I'd gone in, and I was afraid of catching some disease. In the end, I didn't catch anything. Actually, that shower must have boosted my immune system, because I traveled the length and breadth of Africa and Asia, eating practically everything that was put in front of me and sleeping on any surface spacious enough to fit me, without once getting sick. I can't count how many times I had to wash myself using only a bucket or a washbasin or the number of cold showers I had to take.

In Alaska I relieved myself deep in the snow outside the house where I was staying, in temperatures of forty degrees below zero. My only comfort was the knowledge that bears hibernate in the winter, so I knew I wouldn't have one biting me in the behind! (When would I ever have had to worry about bears if I'd never left the well-ordered garden of my home in Tuscany?) During a twelve-hour drive along snow-covered Canadian roads, en route to Whitehorse, I saw caribou crossing the road. From the skyscrapers of New York I'd found myself transported to this wild, overwhelming, and untamable landscape, as quiet and bleak as the surface of the moon. I encountered the same degree of wildness, albeit on the other end of the spectrum, on the Fiji islands. I also found it in Costa Rica, where I had the chance to feed a newborn sloth. That tiny, lazy little animal sprawled in my hand warmed my heart. In Egypt, I went snowboarding (although it would be better to say "sandboarding") on the desert dunes. In Alaska, I rode a dogsled through the forest. In Norway, I sailed the fjords on my couchsurfer's sailboat. In China, I found myself in a karaoke bar, singing at the top of my lungs to celebrate the birthday of my couch-surfer's girlfriend. In Kenya, I slept in a tent surrounded by zebras and giraffes. In the Republic of Fiji, I saw some of the most beautiful land-scapes in the world, and even bribed a customs official—only twenty dollars; nothing too serious—who didn't want to let my photographic equipment through.

In addition to having adventures, being a couchsurfer usually means immersing yourself in your hosts' lives, adapting yourself to their rhythms, and sharing their habits, diet, and space. It's not easy to sleep on a stranger's couch (even when you get along with that stranger) and still find time for yourself—you want to explore, but also need your alone time. It's not easy, except for the rare cases when you move, by some gift of fate, from the couch to the bed—not alone, but to share it with a marvel only just met.

It was my fervent wish that this would happen with Camille, whom I met in Marseille, but things didn't go my way. We liked each other, we wrote to each other and even pursued each other for a few days, but it never worked out. What a strange coincidence that love was destined to arrive at my very last port of call, in Bogotá, Colombia, where I met Catalina. It didn't take me long to realize that she was a special person. Even after I'd left, with an ocean between us, we found a way to be together, and remained together for nearly two years. She came to Italy to stay with me, and we traveled far and wide, even couchsurfing together. There is no doubt that Catalina gave the most special conclusion to a journey that had already been pretty special. She also broke a fairly long streak of chastity.

While there may have been a shortage of intimacy on my journey, there was often an excess of absurdity. In Nopaltepec, Mexico, I shared Christmas dinner with a Mexican family, singing silly Italian songs and drinking tequila as if it were water. In Manila, in the Philippines, my host took me to her boxing gym. Maybe I was tired or maybe I just wasn't that good, but instead of throwing punches, I ended up holding the score cards, playing the part of the ring card girl—you know, the kind with the bikini and the big smile? There was no bikini, but I definitely made the spectators smile.

The condition of being a guest has become ingrained in my psyche. I am now so accustomed to being invited into others' homes that when I travel these days I always feel at ease, even in the homes of strangers. Couchsurfing also taught me to assess places and situations at a glance. All it takes is one look around to know where I can sleep, what an accommodation will be like, and how I will feel staying there. The couch doesn't tell you everything. I always check out the kitchen, too—and often take it over. During my two-year journey, I cooked at least one Italian meal for every couchsurfer I stayed

with. Not only does cooking help me relax, but I believe it is also a means by which to create a genuine cultural and personal exchange. Indeed, it was through cooking that I won Catalina. Also, by taking over the kitchen, I would have one room all to myself for at least one day in every house. Oddly, I was always able to find utensils and objects before the person whose kitchen it was told me where to find them—as though I had been there before. Nobody ever complained. I always obeyed certain unwritten but fundamental rules of conduct. I washed the things I used, kept the couch or room I'd been given neat and tidy, and was respectful of others' spaces and habits.

ULTIMATELY, COUCHSURFING gave me experiences and feelings, both small and big, that I never would have had otherwise—that would have remained nothing more than dreams. I saw everything—and the opposite of everything. I experienced the lives of the wealthiest and of the humblest. I found myself in landscapes of dreamlike beauty and in reeking, chaotic, dangerous metropolises. I can't say I liked one more than the other. Herein lies the difference between being a tourist and being a couchsurfer—the latter is not only a way of traveling; it's also a way of life.

Naturally, two years of this changed me. For better or for worse? I don't think it's for me to say, but the richness and diversity of the experiences I had is a good measure. I took so much away with me. Some of the experiences are so deeply rooted in me that they have changed the way I handle myself. Bit by bit, place by place, every couch and every experience slowly brought about a change. It was as though every portion of my journey spent with someone new gave me the gift of a little more humanity, curiosity, empathy, the ability to adapt and to listen. For this reason, I believe that couchsurfing could almost be a type of therapy. It could be prescribed as a way to restore one's ability to connect with others, to evolve, to overcome certain kinds

of fears and, most important, to enjoy traveling the world. When you couchsurf, you can be sure the experiences and encounters you have will fall far outside the limits of your everyday life and routine. You will never find or learn any of this in a hotel.

It's not a coincidence that many of the couchsurfers who opened their homes to me have become my friends. Several years have passed since I returned from my journey, but I am still in touch with most of them. We exchange e-mails and chat on Skype. Some of them have come to visit me in Italy, where I've hosted them, of course. I have gone back to visit others, this time without researching profiles and Internet sites, but simply asking if my "usual" place on the sofa was free. These people have enriched my life, my knowledge, and my personality, and that's why I wanted to collect their stories and photograph their faces and their places. The seventy-eight photos in this book are only a few of the many I took. Unfortunately, there was not enough room for all the people I met. My selection was based on specific criteria: each couchsurfer I selected for this book had a great story to tell or an amusing anecdote to share, or taught me something. With each entry, I include the couchsurfers' names, age at the time of our meeting, and location. I hope these portraits act as an invitation, that they allow you to be swept up by the world and to experience an alternative approach to travel.

BANGKOK
—
THAILAND

JANE, 31, and TOMHOM, 33

Take two Thais, a man and a woman. Dress them up in seventies style, with square tortoiseshell glasses, bell-bottom trousers, flowered shirts, and hot pants. Now add long hair and dance moves reminiscent of Austin Powers, and you've got the best of the surreal music group Simple of Detail (S.O.D.), the brainchild of Jane and Tomhom, the only rock-solid couple who aren't actually a couple. They live and work together—and not just anywhere, but in the offices of *Penthouse* Asia. He's a photographer (specializing in women, mostly nude), and she's the stylist in charge of his sets. Since 2010, when they created S.O.D., the group has grown into a real phenomenon on the national music scene.

I found them more or less by chance. I had stumbled across Tomhom's picture on the couchsurfing website, and couldn't resist finding out who he was. He and Jane belong to that category of couchsurfers who can't actually host visitors (usually because their homes aren't big enough or because they live with people who don't like the idea of strangers coming and going) but who instead offer travelers their time. And what a time we had!

The first time I saw them was at one of their shows, a concert/cabaret performed for an audience of hundreds of adoring fans, not to mention national TV cameras. During two fantastic concerts, I felt as if I'd either traveled back in time or ended up on a movie set. One was in a very large venue in front of a shopping mall, the other in a small club reserved for die-hard fans. Tomhom and Jane's role in S.O.D. is mostly to sing, but it's also exhilarating to watch them perform their choreography. Two guitarists and a drummer make up the rest of the group. Neither Tomhom nor Jane speaks much English, so when I met them for dinner after a concert, the others attempted to translate for me, the level of hilarity rising with every round of beer.

Tomhom and Jane are a perfect example of the numerous possibilities and scenes that couchsurfing offers. Without it, I'd never have met them or been able to take this photo. Looking at it always makes me happy.

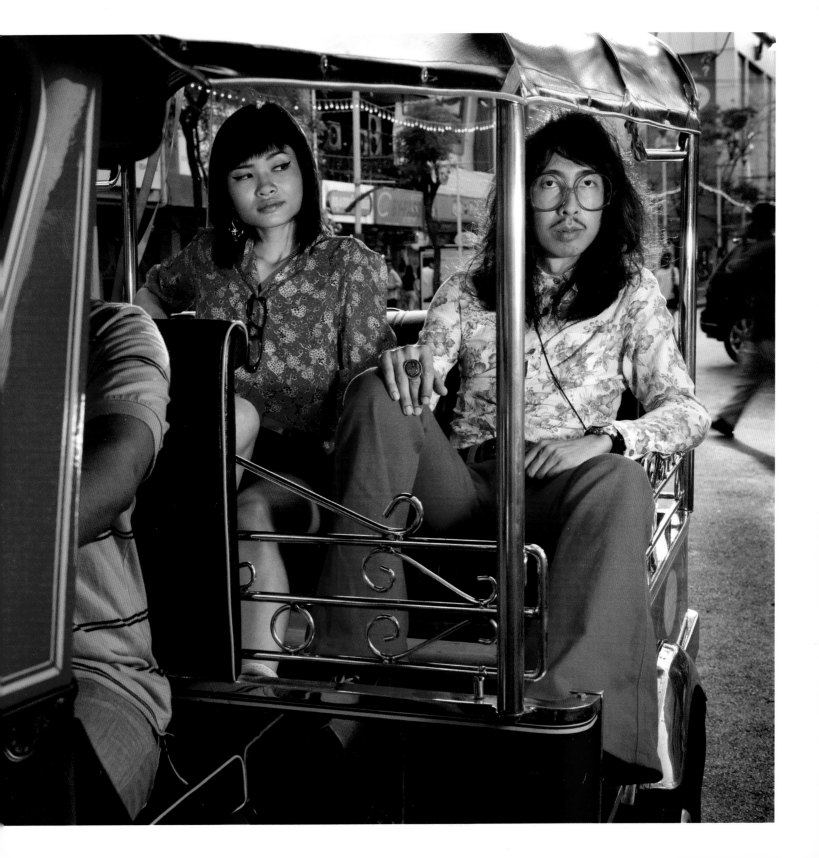

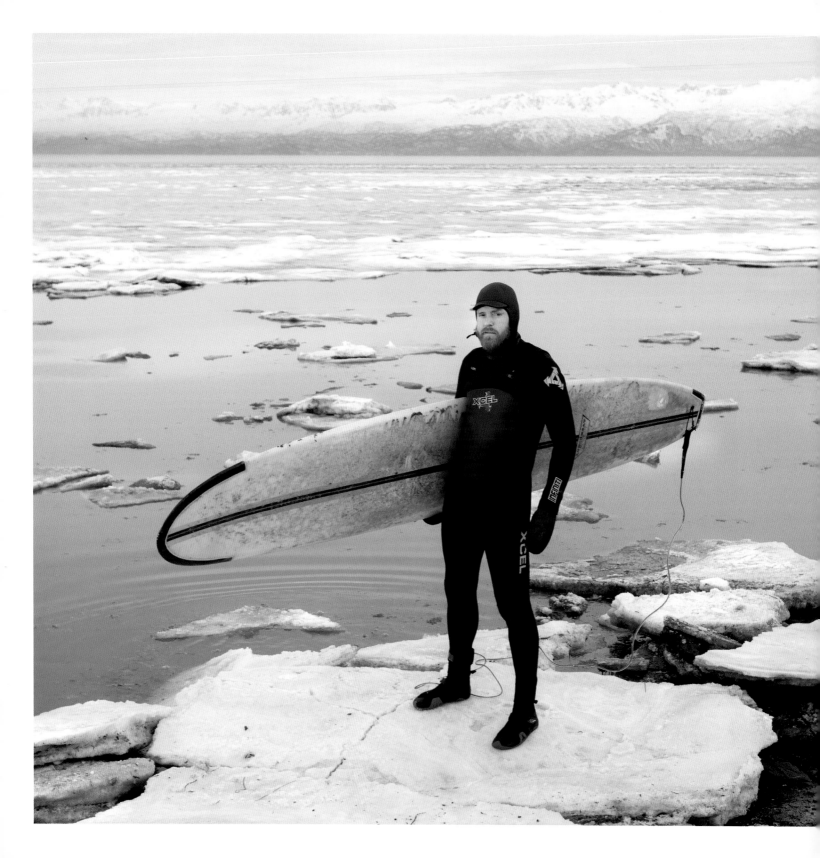

MICHAEL SHARP, 35

Two things you must know: First, there are waves in Alaska; second, there are men, extraordinary men, who surf them. They do it in freezing cold weather, amid the ice, testing their own limits day after day.

Michael is one of those men. He's also a couchsurfer. Born and raised in Denver, Colorado, he uses the word *difficult* to describe his life. "My soul is called by wild and remote places, far from the things of man. As a young man, I fell in love with white-water rivers, sailboats, my wife, and the sea—in that order." In 2006 he and his wife were living on a boat in Portland with their dog when they raised anchor and set sail, heading north.

They stopped when they reached Homer, Alaska. It's a place of ice and exploration, of both nature and one's soul, a place where the first question you ask in the morning is "What's the weather like today?" At these latitudes, it can make all the difference, even if Michael does break out his surfboard when the thermometer reads well below zero. He dives into the floating ice, his long strokes taking him away from land until there's nothing around him but icebergs and snowcapped peaks that seem to belong to another universe. He comes back with a frozen beard, full of peace and quiet.

The confidence it requires to open your home to a stranger is the same kind of confidence it takes to try something new every day, until you master it. When I visited him, having read his blog about his surfing, Michael tried to convince me to join him in the water. It was winter and the temperature was fifteen degrees Fahrenheit. I didn't have the courage. I've since come to regret that decision, especially when I remember something he told me over a beer. I asked him his idea of happiness. "Variety and a bit of adventure," he answered, "and the opportunity to try something new."

MAUN
BOTSWANA

KENIAS HICHAABA, 23

Every day at 3:00 p.m., Kenias sits down in his threadbare armchair, inches from the television, with his keyboard in his lap. Then, gathering all his concentration, he begins to sing and play, accompanying whichever preacher is on the air. There's no risk of missing a broadcast, since Emmanuel TV, Nigeria's religious station, is always showing a sermon.

The satellite dish he needs to receive it is the only luxury—if we can call it a luxury—in this humble yet dignified two-room house on the outskirts of Maun, Botswana, where Kenias has lived with his younger brother and their mother since his father died. These tight quarters are built on enthusiasm and an unshakable faith in the Pentecostal doctrine. "I believe strongly in manifestations of the gifts of the Spirit, like healing, speaking in tongues, and the gift of ongoing revelation," he told me from deep in the armchair. Above his head, two plush tigers of unknown origin looked down on the scene, while a prayer on the wall invoked protection for the house and those within it. "I pray and I study a lot. I am certain that one day the gifts will manifest in me," he said.

In the interim, he attends the local Bible school and fulfills his duties as head of household, sharing a mattress with his younger brother while his mother sleeps in a bed nearby. All other activities, including personal hygiene, are attended to outside their home's rickety walls. There's no real bathroom in the house, just a sort of closet in the courtyard where they and their neighbors wash using a bucket. Everything is shared, even dinner, which is prepared by the women working amid the children's chatter, using whatever meager ingredients they have.

Kenias has been waiting for his God to grant him a miracle, and perhaps the first of these has already come to pass: his belief in the spirit of community led him to become a couchsurfer—and to host me for three nights. Not that I was the miracle; rather, the miracle was the chance we each had to get to know a world so very different from our own, an experience that is truly moving.

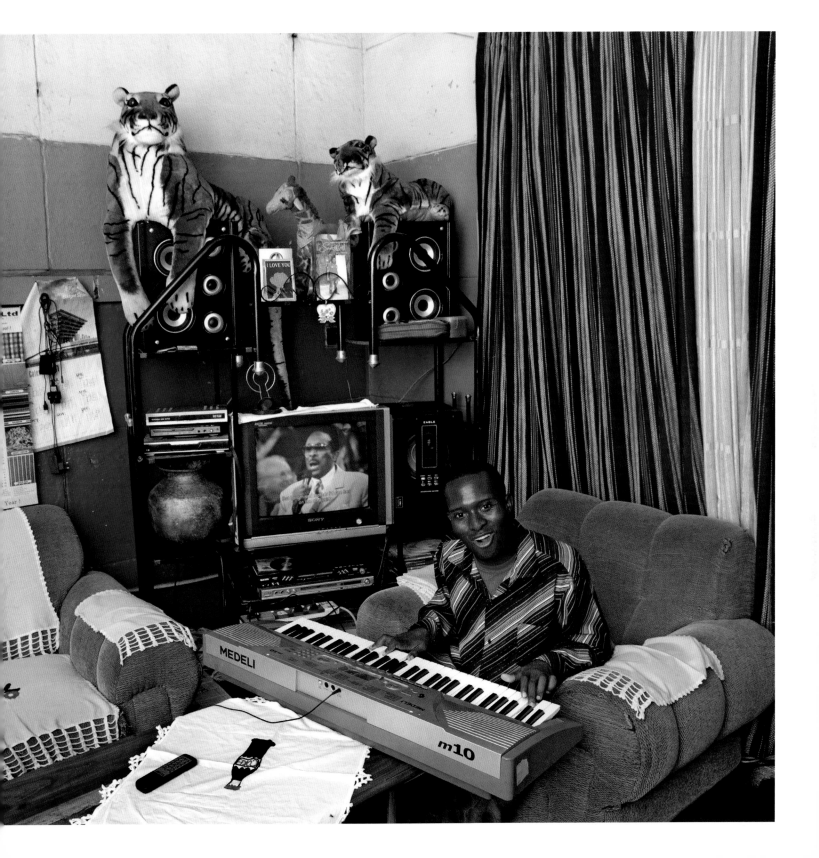

SYDNEY
AUSTRALIA

LISA JOY, 33

The colorful, very high-heeled shoes heaped haphazardly around Lisa's bedroom are signs of her personal renaissance. So are the other items—corsets, earrings, swatches of fabric, and sewing kit—piled on the bed and every other surface in the apartment. Lisa had a difficult past, but her present is radiant. She grew up in Sydney's poorer suburbs. "We had nothing, but we were happy," she told me simply. At twenty-three, she married the man she loved; he died just three years later. "He was a special man. We loved each other very much. I still miss him terribly, and I don't think it will ever be easy to get over what happened."

Nonetheless, with wisdom and light-heartedness, she is attempting to do so. She started by moving to Newtown, Sydney's liveliest neighborhood, a place full of young people and new chances. This is where she got the idea to try burlesque. She signed up for a class just for fun but soon realized she had a true passion for it. Now she performs in a number of clubs around the city, sometimes alone, other times with a few girlfriends. "I love to put on a costume and take myself less seriously than I have to when I'm sitting behind my desk at the office," she explained to me.

When I was there, I spent four nights on an inflatable mattress stuffed into the kitchen-cum-living room of her home, where the chaos of the various trappings of her transformation into Miss Burlesque gave a sense of her rediscovered joie de vivre. Yet it is a creative, constructive chaos that has helped her build a new life.

"What makes me proudest is when people tell me I've inspired them," Lisa told me during the course of our long talks over dinners in restaurants. After having overcome so much pain, there is only one thing she is afraid of: "Fear itself."

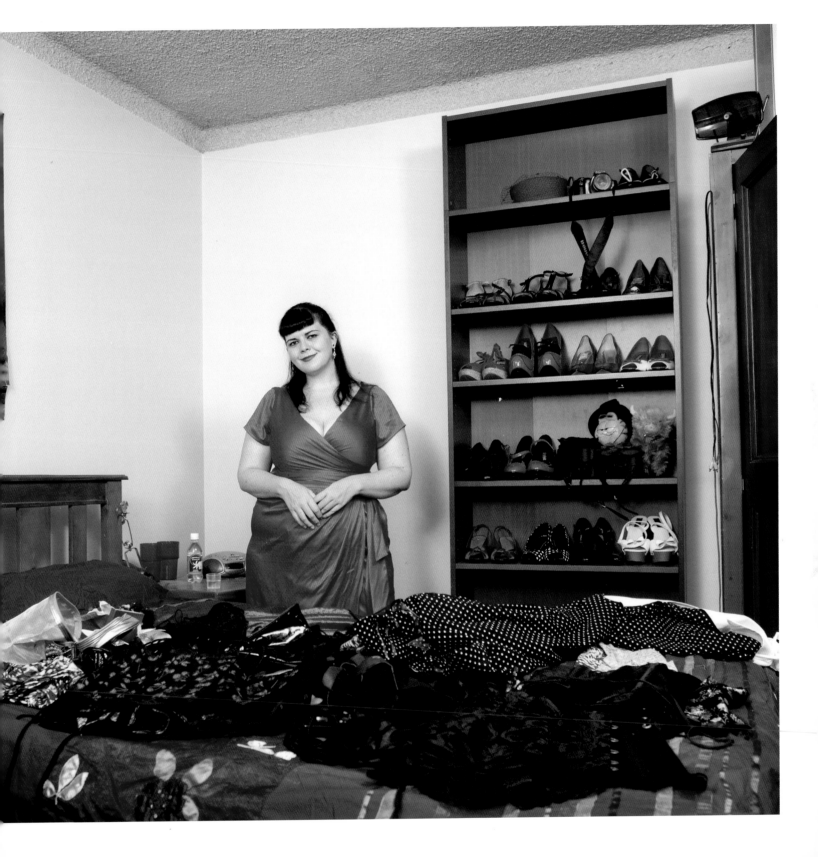

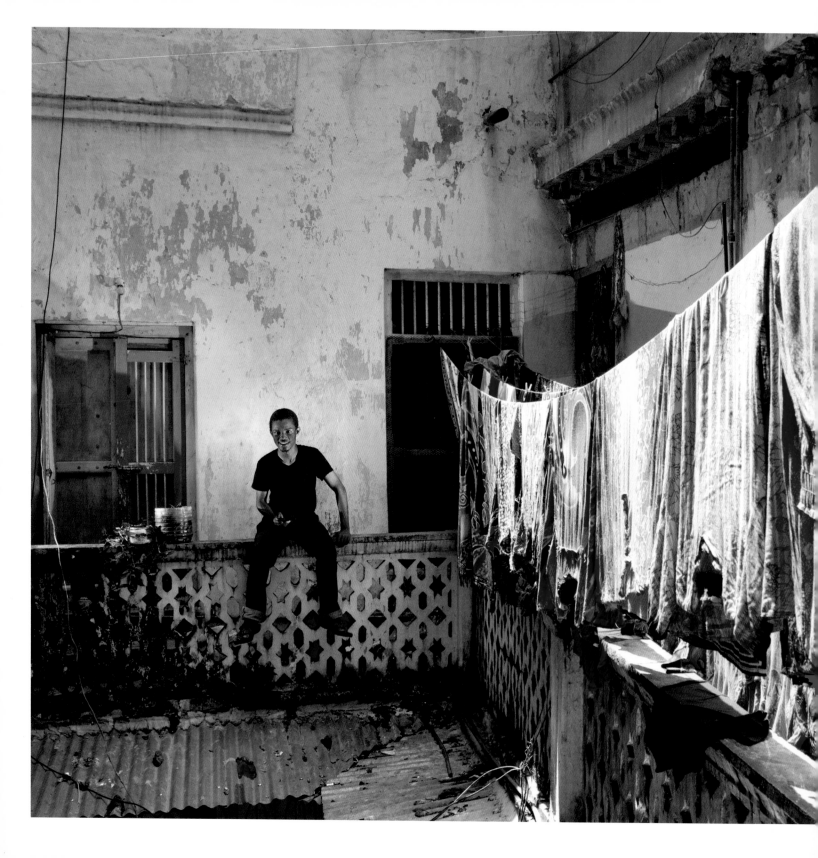

STONE TOWN, ZANZIBAR
— TANZANIA

PSAM, 24

Psam's real name is a secret, and he won't tell it to me. He says it reminds him of his past, which is a very painful one. That was all before he came to live in this colonial building in Stone Town six years before we met. He was eighteen at the time, and four years before that, he had lost "the only important person" in his life, as he calls her: his mother. She died, following Psam's father, who died when Psam and his six siblings (five brothers and one sister) were young. Psam's adopted name is the acronym of his mother's full name: Pili Suleiman Abdallah Mulombo. It is his way of keeping her with him.

The apartment where Psam lives has two bedrooms and a bathroom. There are no photographs on his walls, except for one of his mother. It may be the only thing not piled haphazardly on his bed or lost among the jumble of clothes, PlayStation wires, and other objects strewn about. His aunt gave him this place to live when she left to work as a housekeeper in Dubai.

Psam makes his living as a guide for the many tourists who come to Zanzibar. It was thanks to one of them that he discovered couchsurfing and began hosting foreigners in his living room, on a mattress incongruously covered with a Tom and Jerry bedspread. One night, I inadvertently overheard the unmistakable sounds of two people making love. They were right in the building's open courtyard, not far from where I lay. Suddenly and to my surprise, the woman cried out in Italian! Before I could stop myself, I burst out laughing. Psam never heard a thing. He was sleeping peacefully amid the clutter in the next room.

CAHUITA

COSTA RICA

MELISSA SORO, 27

Where there should be a roof, or at least a skylight, is a sky full of stars. There is no glass in the upper story of Melissa's large house in Cahuita, a small city on the Caribbean coast. The heat is such that there's no need for any sort of barrier that would keep the (scant) air that circulates up there from reaching my mattress. The couchsurfers who pass through—and there are always a lot of them, often at the same time—sleep on their mattresses or in the hammock suspended from the ceiling just as if they were out in the middle of the Central American jungle.

Melissa was born and raised in Costa Rica, where she went to school and earned a degree in sustainable tourism. Her husband, Rick, is a biologist from Florida. Every once in a while he travels to Miami, and when he does, one of his tasks is to replenish the supply of English-language books in the bookshop Melissa opened in the tiny downtown of her village by the sea, and which has seen a fair amount of success.

The couple also owns a travel agency that organizes tours and excursions to explore the local culture and natural land-scapes. "I'm a sociable person with an open mind, without prejudices," Melissa told me. "I'll host anyone, regardless of their sexual orientation or religion. I don't care if they're rich or poor, either."

In the big, colorful kitchen on the ground floor of the couple's red house, it's easy to feel truly at home. One day during my stay, I offered to cook a fish dinner with the help of another couchsurfer, while Melissa took care of the household chores. We labored over the stove while she was busy doing the laundry. I felt a part of a community, each of us with our own role to play.

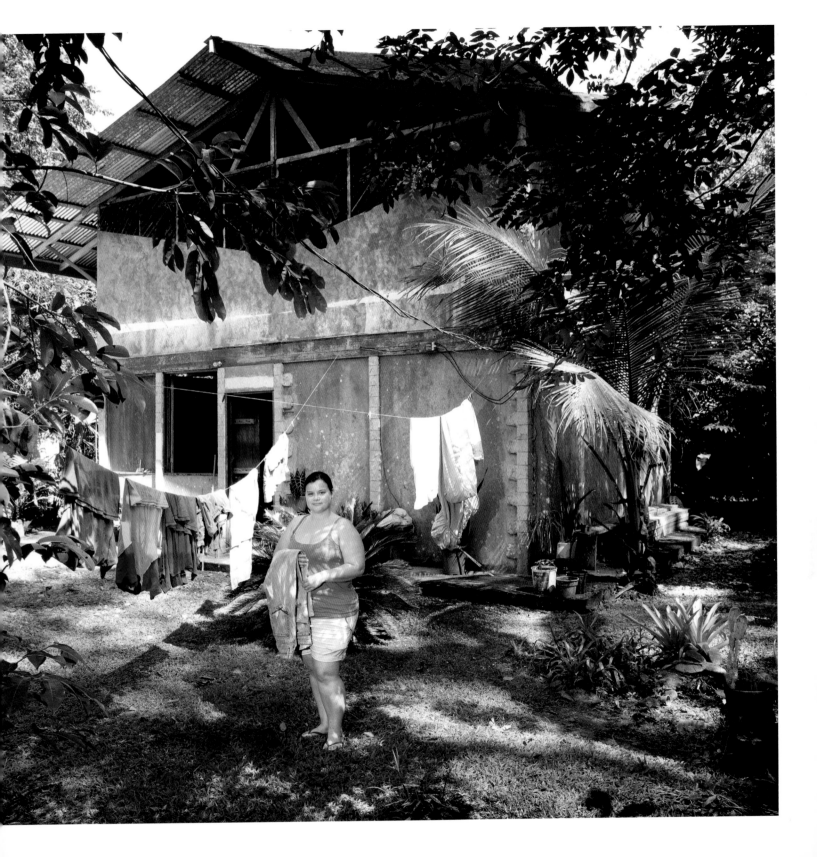

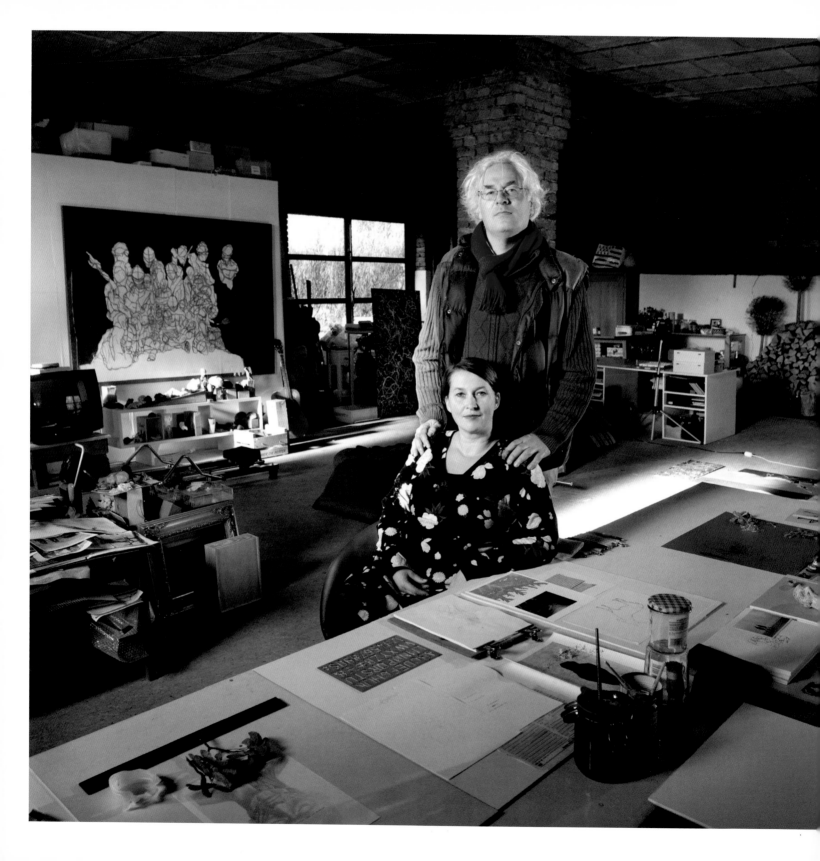

ASPERSCHLAG
—
GERMANY

EDMUND RADMACHER, 45, and ANDREA DUNG, 43

Edmund and Andrea's story is divided into two acts.

Act 1: They meet in a nightclub in Cologne in 1985. They start dating, and then Edmund disappears. He spends twelve years traveling around the world, from Canada to Italy, from Singapore to Botswana.
Act 2: Edmund and Andrea live in a castle-like house in the countryside outside Cologne, an immense estate surrounded by a moat and a river. It can be reached only by crossing a bridge.

Obviously, a lot happened in between. In 1997, having returned to Cologne, Edmund went to see Andrea. Incredibly, the spark was still there, so strong that they got back together right away. They headed to Botswana armed with a business plan that would eventually end up failing. Unwilling to accept defeat, they traveled through Africa for a year before returning to Germany to put down roots and have a child, their daughter, Emmi.

Edmund is an agronomist, and Andrea is a landscape architect. Until recently, they worked together in a design studio in Frankfurt. Andrea is still there, but now Edmund devotes his energy to their immense property, which he's restoring, with only two laborers helping him. The work moves slowly.

When I visited, only one of the castle's three wings was habitable. That wing is a feverish jumble of creative chaos: drawings propped up on desks, paintings stacked on the walls, and carpenter's tools in every corner. Firewood is stacked against the walls, Andrea's drawings and designs lie scattered about, and a small television and some mattresses are at the disposal of couchsurfers.

Edmund and Andrea are friendly, funny, and unconventional. One day, Edmund took me to meet their neighbor, describing it as an experience not to be missed. He was right. The Fakir, as they call him, lives in another castle and is famous for the frequent S/M parties he throws, with guests arriving from as far away as the Netherlands. Looking down at the leather chairs and benches arranged around one room beneath a glass floor, I was almost sorry I wouldn't be there for the next one.

HOMER
ALASKA

TOM BURSCH, 47

The view from his window reveals, better than any words could, why Tom's house is so special. The landscape one sees from that window seems to be the product of the most magnificent imagination, but it is real. You can touch it, walk on it, smell it. You can also feel it—and it's freezing. When I arrived in Homer, the temperature was hovering around minus four degrees Fahrenheit, and the sun shone for no more than five hours a day—from ten in the morning until about three in the afternoon.

Tom's little house is two stories tall, with spacious, comfortable rooms, and is constructed entirely of wood. It looks out on a body of water, the Kachemak Bay, which freezes over at numerous points during the very long winters. Beyond the bay, you can see snowcapped Alaskan peaks, the endless snowscape broken only by the occasional moose or, in summer, when the snow melts, a brown bear venturing into the yard.

It was almost pure chance that brought Tom to this icy part of paradise, when he hitchhiked his way up from his home state of Minnesota at the age of fifteen. "I've always been geographically and culturally curious," he explained. Once here, he began working as a salmon fisherman, and has continued to do so for the last twenty-seven years. His

work has brought him much happiness and even a wife, Catie, who is also a fisher. They both work six months of the year, during the summer, weather permitting. The rest of the time, they travel around the world. Meanwhile, Tom has also been studying to become a nurse. "I'd like to fish for six months in summer and work as a nurse the rest of the time, wherever there's a need," he told me.

Tom and Catie have two grown daughters. One lives in Texas and the other in Bosnia. When they come home to visit, they all like to go salmon fishing together for a few days. Yet the Bursch family does more than fish for salmon; they also cook it extremely well. At Tom and Catie's, I ate the best baked salmon I've ever had in my life; it was unforgettable.

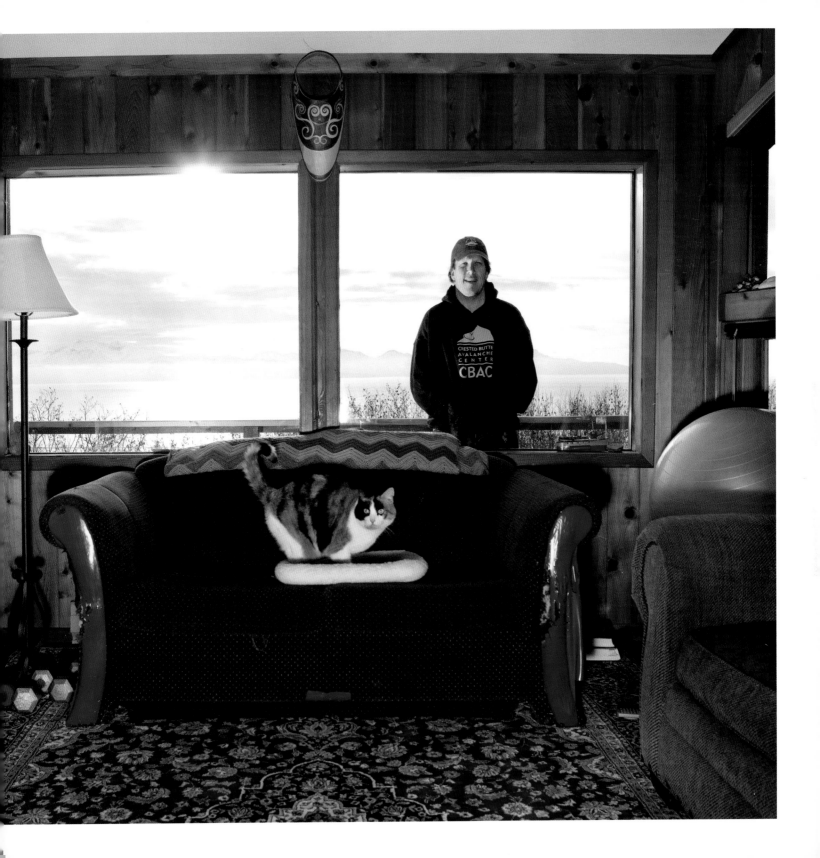

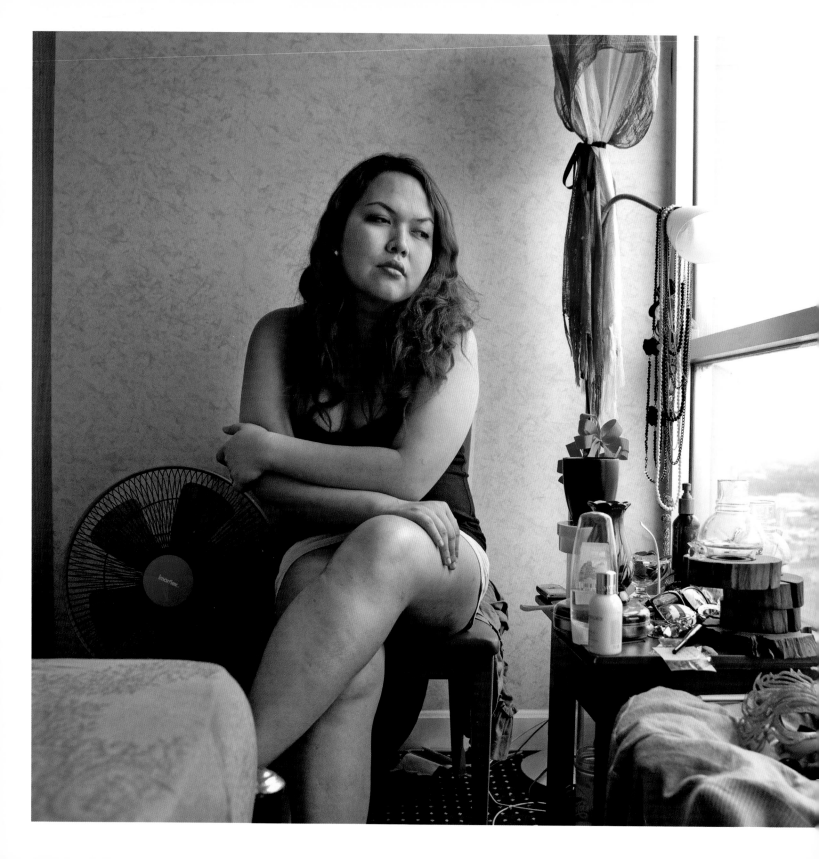

SAMUT PRAKAN
—
THAILAND

SKYLAR TINAYA, 28

Skylar's sweet face with its rounded curves once belonged to Alfie, the man Skylar was before becoming a woman. She shared this fact with me as soon as we had broken the ice after my arrival in Samut Prakan, a little town near the Thai coast about twelve miles south of Bangkok.

Hers is a story of pain and redemption. Skylar is originally from the Philippines. Her father died young, and when her mother moved to Dubai to look for work, Skylar was left behind to be raised by her grandmother and an uncle. Back then, she was still Alfie, a boy her grandmother never bothered to care for. Worse still, Alfie was sexually abused by a relative from the time he was eleven. Perhaps it was to overcome that trauma that Alfie gradually became Skylar. He initially came to Thailand to have his first operation. Although she rejected the transformation at first, Alfie's mother eventually accepted her child's true nature and even paid for Skylar's breast augmentation surgery.

Skylar now has an American boyfriend, with whom she's in a serious relationship. Her life is untroubled, thanks in part to the financial help he provides. She lives in a small apartment, high in a skyscraper. Looking out the windows, as Skylar often does during her long phone conversations with her boyfriend, she sees a vista of tall buildings and crowds milling around the entrance of a shopping mall far below. Her bedroom is full of feminine touches: dresses draped over the furniture, bottles of perfume, necklaces, makeup, and even a golden mask. The rest of the apartment consists of a kitchen and a cozy living room with a parquet floor, home to the black leather couch where I slept and a television and DVD player for lazy evenings in.

From the outside, Skylar's life seems quite ordinary, and it will be even more normal once she's had her final breast operation. "You can add things to your body, but you can't take away what God has lent you" was her answer when I asked her if her transformation was 100 percent complete. In other words, what God gave Alfie at birth is still part of the woman Skylar.

BERGEN
NORWAY

ERLEND ØYE, 36

It's not often that you get invited into the home of one of your idols, but it can happen when you couchsurf and open yourself up to new worlds—especially if your idol used to be a couchsurfer, too. Erlend Øye, of the indie folk duo Kings of Convenience, used to be the lead singer of the Whitest Boy Alive, one of my favorite bands. Our paths crossed one evening in a bar in Bergen while I was staying with Andreas, another couchsurfer (see page 143). I observed him for a while before asking someone if that was really Erlend Øye and then, timidly, introduced myself.

Finding myself chatting with one of my favorite singers was a surprise, but the biggest shock was discovering that he knew my work, too. Erlend spends a lot of time in Sicily; while there, he saw my photographs in *D*, an Italian magazine I had been working for at the time. He knew I was traveling around the world couchsurfing, so he invited me to stay with him and take his picture to surprise my Italian friends. "My friends read your column, too," he said. "They'll have a laugh when they see me there."

Erlend lives in a colorful wooden house in the center of Bergen. His quiet, pastel-tinted neighborhood looks a little bit like a Lego village. It goes almost without saying that the most plentiful thing in his house are the guitars. There are dozens, some in every room. Erlend is a down-to-earth kind of guy, and even though his agenda was full when I came to visit, he still found time for me. Over breakfast, served in his living room with its pale-wood furnishings, we talked about how he had loved to couch-surf until his growing fame began to make it difficult for him to stay with strangers. He hasn't lost his curiosity, though, or his desire to meet new people and experience the opportunities that come with opening oneself up to others.

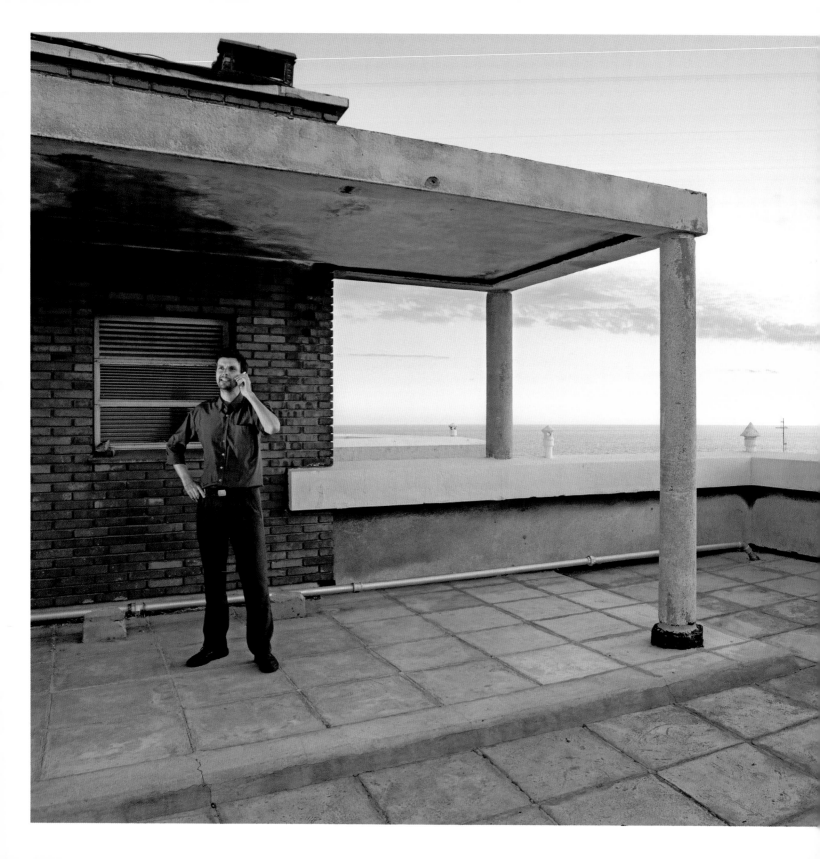

MONTEVIDEO
—
URUGUAY

JAVIER FRANCÍSCO MARTÍNEZ BENVENUTTO, 40

The notion I used to have of people who were into the Internet and programming languages as bespectacled nerds was quickly demolished when I met Javier. He taught me that you can be into computers and still be a creative type—live for software without forgetting the arts, music, a love of cooking, and all the rest. Couchsurfing at his home was an excellent antidote to stereotypes.

As a computer engineer for the Uruguayan government, Javier is the creator of the complex system that manages the national pension scheme. While in school, however, he didn't limit himself to studying computer science. He took an unimaginably wide range of courses, including cooking, literature, the art of the graphic novel, painting, and German—all this while playing with his band nearly every day. Music is his great passion; his dream of being a rock guitarist lives on between algorithms.

Considering his talents, it's not surprising that Javier's home in Montevideo was a very wise investment. He told me that he bought it for forty thousand dollars, and now it's worth at least three times that. The apartment near the sea has a terrace overlooking the ocean and direct access to the roof (where this picture was taken), a space often transformed into a venue for parties. Javier surrounds himself with people and positive influences. He trusts couchsurfers enough to give them his house keys immediately, and in his guest room, they sleep next to his most precious possessions: his computer, his guitar, and his drum kit.

"The only world I know is the same age as me and in constant evolution. I try to broaden it by traveling, reading, and welcoming people from far away into my home," he told me. From where I stand, his attempt is succeeding.

AUSTIN
TEXAS

JULIE WILSON, 30, and ALBERTO SERAFINI, 34

When Alberto met Julie, he was still a philosophy student. In the Tuscan town where he was born and raised, he was considered one of the most promising drummers on the Italian music scene. Julie, meanwhile, had been catapulted to Italy from Texas, for a university course. A few months after they met, Julie found herself with a ring on her finger and scraping out a living teaching English.

They were finally able to strike a balance between their two worlds in 2009, when they moved to Austin, Texas, taking with them just a few bags and their faithful cat, Rita. Julie went back to school to get her master's in psychology, and Alberto abandoned music to work behind the bar of a café in North Austin. He spends his days making cappuccinos with an Italian's artistry—a life much less stressful than the one he led while trying to make it as a rock star. Still, their former life has followed them, making their living room the scene of improvised jazz sessions. Next to the sofa—which is where couchsurfers stay—sit a drum set and two guitars, just waiting for someone to play them.

This balance of ordinary and exciting is one of the mainstays of Julie and Alberto's life together. It extends not only to their friends, but also to the one hundred families who live in their apartment complex, with its shared gym, small swimming pool, laundry room, and Internet access point. It's no accident that Julie has seen fit to adopt as a motto some very apropos words of a musical icon from another era, Vanilla Ice: "Stop, collaborate, and listen."

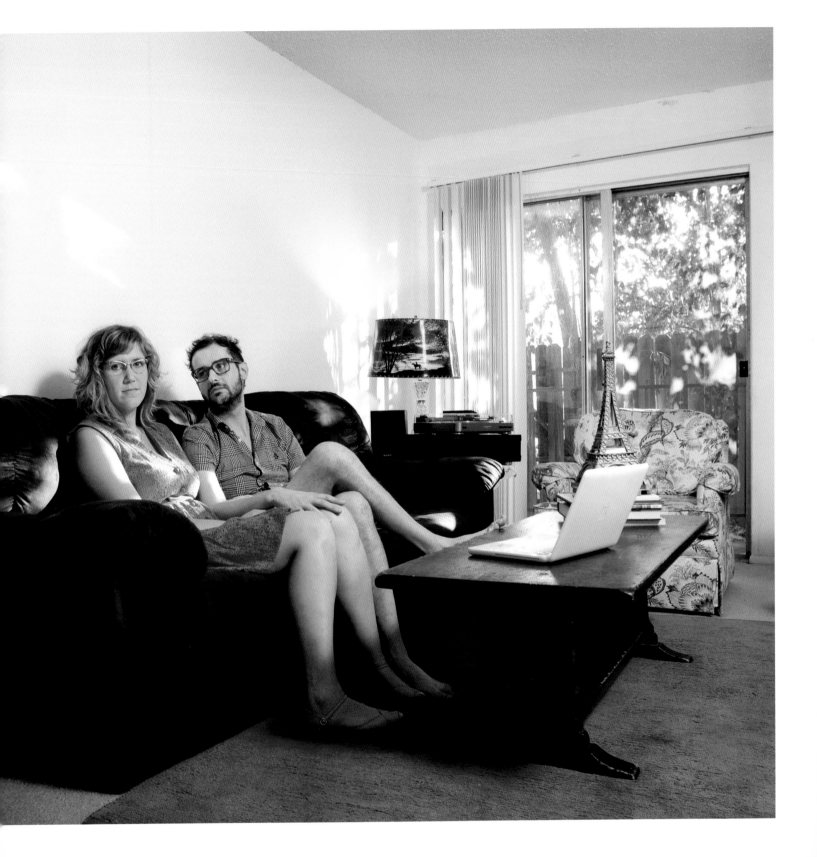

NAIROBI
KENYA

KUI GITONGA, 30

Kui and I could have made a game of who'd seen the most countries. Despite the fact that I'd been traveling around the world for months, she probably would have won. Kui is thirty years old, single, and happy. A flight attendant for a large African airline, she spends much of her time flying from one part of the world to another—so much so, in fact, that for the six days I spent in her home (a large, modern apartment near the airport, of course), I was alone. She was working the Bangkok route and so, without making a big deal of it, she left me the keys.

This sort of nonchalance is not common among Kenyan women of her age, but an ongoing journey of self-awareness has made Kui different from others. In 2004 she left her husband-to-be just two weeks before the wedding, and she's never looked back. "Society here wants to push you to take the traditional steps: school, marriage, then children by age thirty," she told me. "I'm lucky, because thanks to my job, I've been exposed to the world outside of Kenya. I was attracted to it, and now I'm happy."

It's no accident that almost all her friends are foreigners living in Nairobi for work. I met some of them on the evening of the day I arrived in the city. Kui took me to a restaurant for dinner, and then to meet her friends for drinks. The fact that she barely knew me didn't concern her in the least. I saw her friends often over the following days, and even spent a couple evenings with them, dancing in nightclubs until the wee hours. Kui offered me her guest room and the use of, among other things, her DVDs. She's quite proud of her collection, which has a place of honor in her big living room next to the flat-screen TV.

In return for her hospitality, I've been lucky to be able to host Kui in my home. A couple of years ago, one of her flights had a stopover in Rome, and I invited her to visit me in Tuscany. The two days we spent in the country there, though, were nowhere near as cosmopolitan as my stay in Nairobi.

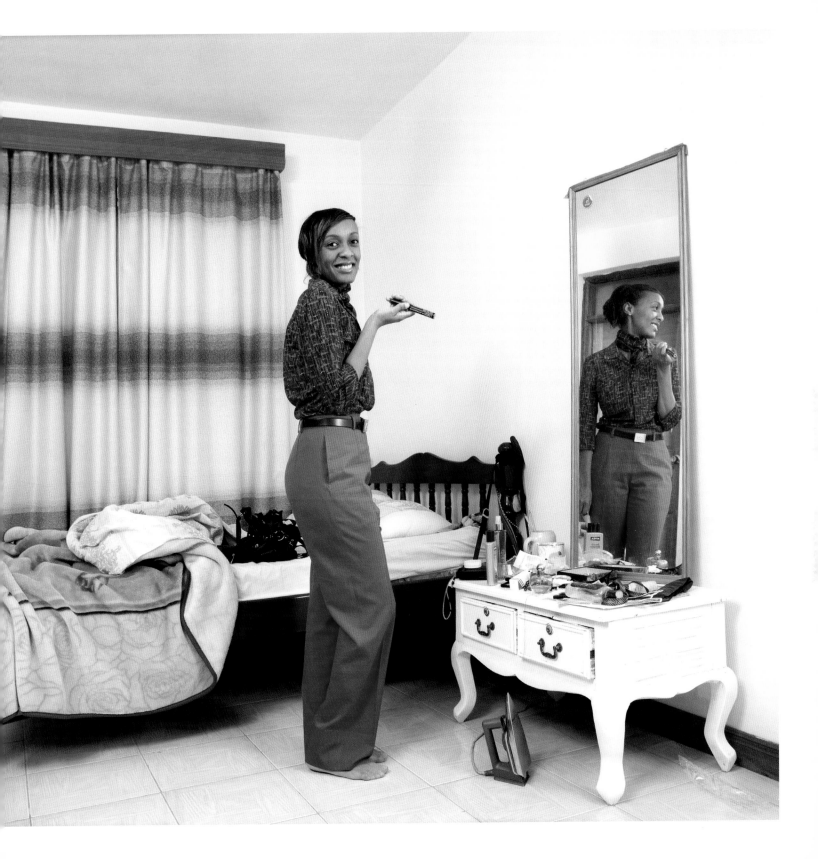

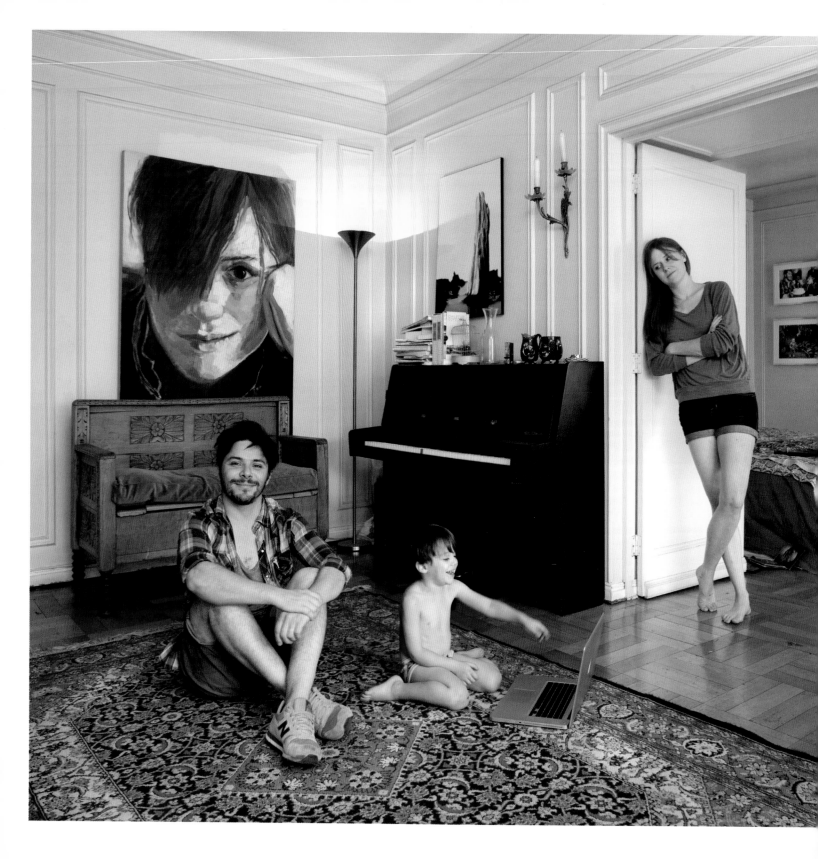

SANTIAGO
CHILE

REBECCA EMMONS, 28, and VICTOR ODDO, 35

Enormous, bright rooms showcase large windows; fine paintings hang on the walls; and expensive rugs grace the floors. This is Rebecca and Victor's apartment—or, at least, the apartment they lived in when I met them. They are successful architects who love their work. "Our son, Sam, has spent most of his three years with the babysitter," Rebecca admitted freely, wasting no time on sentiment.

Victor is a partner in one of Santiago's most well-known architecture firms and receives invitations to extravagant events, such as the Venice Biennale. Rebecca, originally from Texas, ended up at his firm almost by chance. In 2006, after finishing her degree, she set off for a journey through South America to Rio de Janeiro with the man she was seeing at the time. Even before arriving at their destination, the two argued so much that they decided to separate. Rebecca headed for Santiago de Chile on her own, in search of an architect she had studied and admired in college. He wasn't the architect she'd been hoping to find, but Victor was there to greet her. She soon realized he was the man she'd been looking for after all. It wasn't long before they got engaged. She left Texas for good, and their son, Sam, was born.

Despite the fact that neither has much free time to spare—when I asked them what they thought their future held, their instantaneous reply was "Work!"—they were accommodating during my stay. We ate meals together in their home and in the fashionable restaurants in their trendy neighborhood. They took me on a trip outside the city, to a place halfway between the Andes and Santiago, a peak with a spectacular view.

We stayed in touch after my stay, so I know that Victor and Rebecca are now separated. Although they are in new relationships, they maintain a good rapport. Perhaps we could have foreseen it. After all, Rebecca confessed to me that it was her recurring dream "to fall in love with random people."

JAKARTA
—
INDONESIA

OKTOFANI ELISABETH, 24

The view out of the only window in the mini-apartment gave me the impression of being inside a cement beehive. Not twenty yards away loomed another gray building, identical to the one I was leaning out of. Beside it rose another, and another, and so on. Not the most beautiful view, but certainly emblematic of Jakarta's transformation. It has become a city of identical skyscrapers housing tiny living spaces.

The couchsurfer who welcomed me on a torrentially rainy day fits in perfectly with this picture. With a tiny three-room apartment on the twenty-eighth floor of one of these buildings, Fani (as Elisabeth likes to be called) lives an intense life as a trainee journalist, constantly immersed in the chaos of the city. Although I was sleeping on the sofa in her sitting room, I almost never saw her in the mornings. She set off for the newsroom before 7:00 a.m. every day and stayed there until after dinnertime, pouring all her energy into her work. At the newspaper, they rely heavily on her enthusiasm to cover the dozens of newsworthy events that happen every day. These consist mainly of terrorist attacks (fortunately, not all serious) around the city.

The things Fani has seen are probably one reason she has developed an allergy to conversations about faith. She was raised in a strict Catholic family, but now that she faces the effects of fanaticism every day, she has become skeptical toward belief of any kind. "Religion makes human beings lose their humanity. It's harmful," she told me vehemently during the evenings we spent together going to trendy bars and clubs. In fact, the only thing Fani believes in at the moment, other than work, is fashion. "What do I need to be happy? A pair of shoes," she told me. If you step into the shoe-strewn chaos of her miniature bedroom, you'll see that she must be a very happy woman indeed.

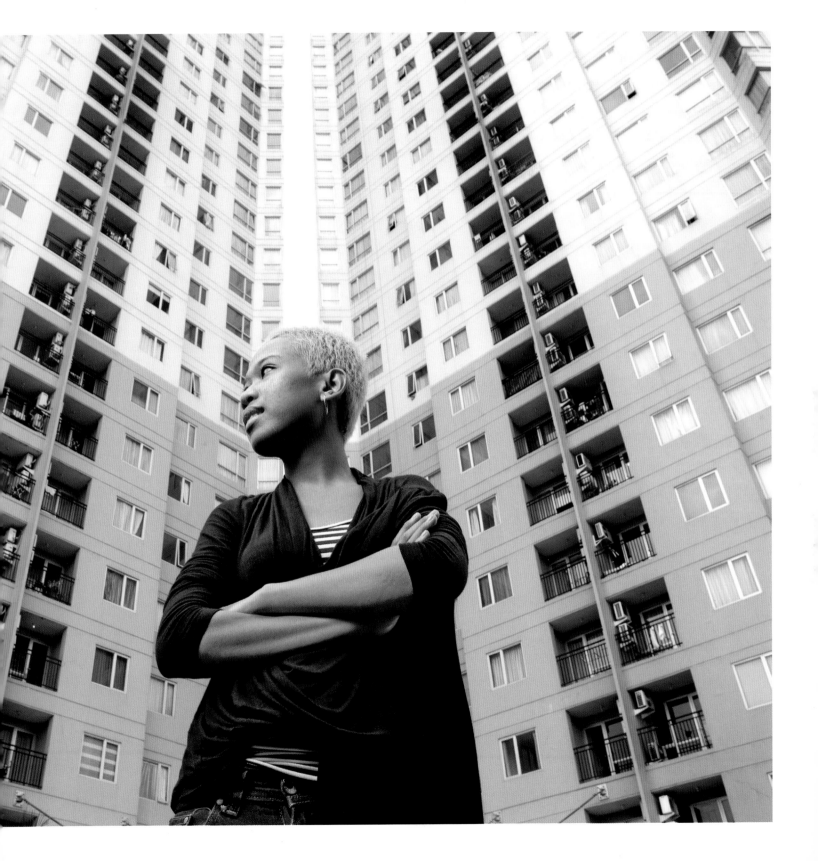

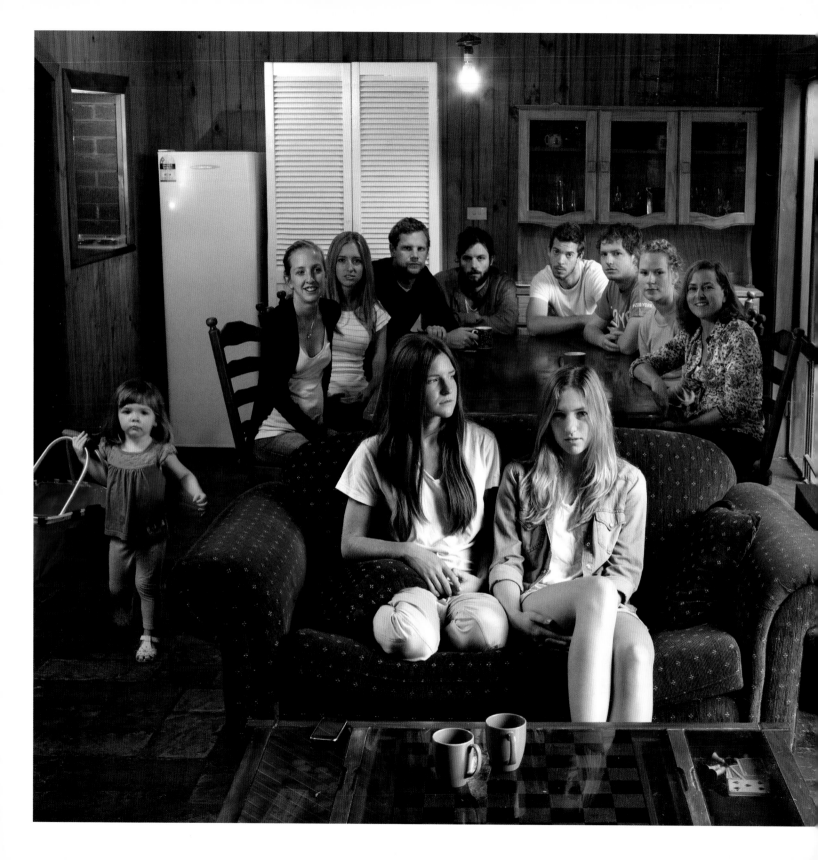

BLUE MOUNTAINS
AUSTRALIA

CAROLINE PRESBURY, 24, and ELLEN PRESBURY, 20

When I saw how many people were gathered around their table, the first thing I thought (of course, being Italian) was that this family could form its own soccer team. Sisters Caroline and Ellen, the Australian couchsurfers I spent a few days with in Katoomba, in Australia's Blue Mountains, have five sisters and two brothers. That makes nine siblings in all, plus their mother, a nephew, and various boyfriends and husbands. The size of their house matches the size of their family, and the family comes here when everyone, give or take a sibling or two, wants to spend a weekend together, the occasional couchsurfer, like me, in tow. There's room for everyone, thankfully. The wooden house has three floors, the top one with enough bedrooms for all the couples to have one of their own. I slept down below, on a couch in the "basement," a room with a view that belies its name: its windows look out onto the garden and the magnificent mountains that are such a popular destination for tourists visiting Australia.

I was invited here by Caroline and Ellen, whom I'd met years earlier. They had been traveling around Europe and spent a few pleasant days couchsurfing in my home in Tuscany. We stayed in touch afterward, and once I was in Australia, I called them. That's how I ended up in the middle of this gigantic family reunion, with all members gathered around the table, busy filling one another in on recent events in their lives while they waited for breakfast. Some of the most momentous updates came from my personal hosts, who had just moved to Sydney: Caroline to study art and photography, and Ellen to study economics.

Ellen once told me, "What scares me most is the thought of reaching the end of my life and realizing I haven't done the things I wanted to do." This time, then, was the beginning of a new life.

VERACRUZ
——
MEXICO

DEISY MEDEL, 28

Deisy became a couchsurfer for love. She was attending a photography workshop in Mexico City where she met a Belgian man. She fell madly in love and, to find him again, had no choice but to travel to Europe, asking for hospitality on people's couches along the way. That was two years before I met her. She never found the man, and has since settled back in her home city, where she plays host to others.

Deisy lives in Veracruz, Mexico's largest port city. Her neighborhood has a less-than-savory reputation, but Deisy feels perfectly safe there. Her apartment is in a two-story building with bare cement stairs and a minimalism that borders on the spartan. She works as a photographer for a local newspaper, and the most important things in her home, as she will tell you, are her cameras. Despite the lack of frills, I was pleased to find the guest room furnished with a comfortable bed.

It was in Deisy's company that I had one of the most memorable experiences of my eighteen months of couchsurfing. When I asked Deisy if there was a local hero I could photograph for another project I was working on, Deisy took me to meet a transsexual who was very well known in the area—a Britney Spears fanatic who has done everything possible to resemble her idol (and quite a good job of it, I must admit). By the end of the night, this celebrity had asked me to take pictures of her for her website. We went to a motel in Veracruz, where I spent hours photographing her in a series of unspeakable but rather amusing poses. Meanwhile, Deisy took pictures of me taking these pictures, making a sort of photo documentary.

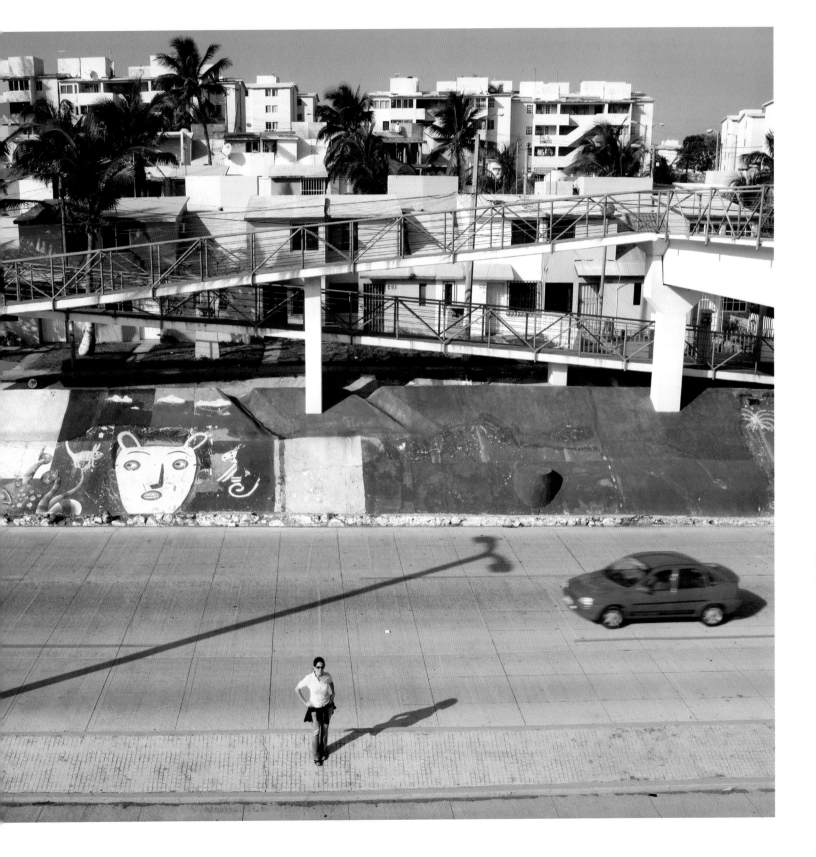

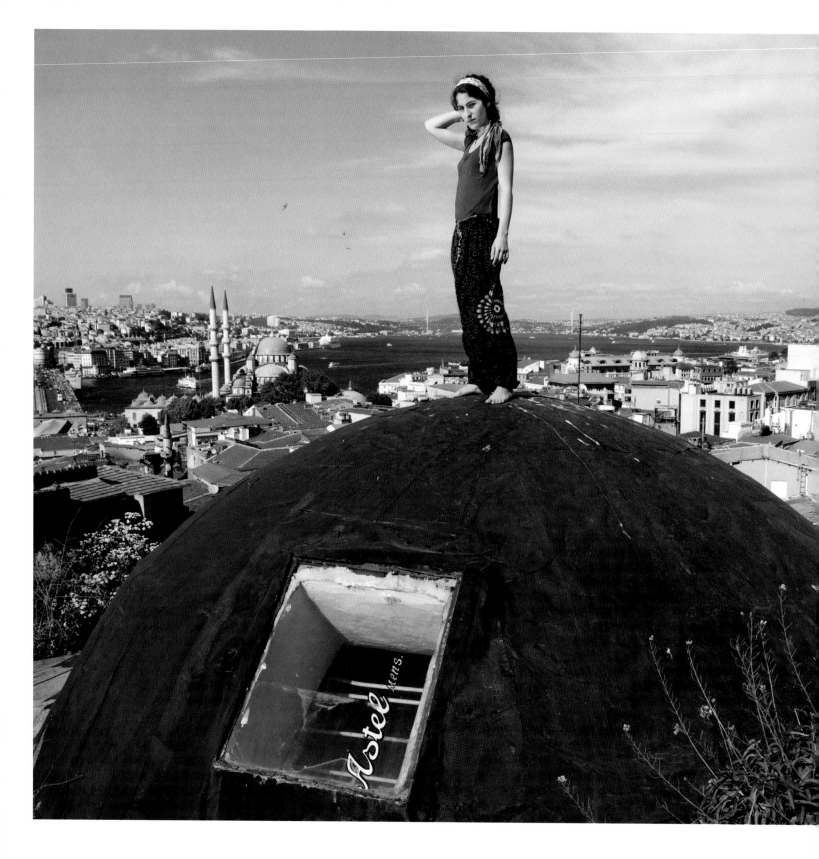

ISTANBUL
—
TURKEY

TUNA GÜNGÖR, 22

The morning I rang her doorbell in Istanbul, Tuna answered with half-closed eyes, mumbling that she'd just gone to bed and needed a few more hours' sleep. She disappeared into her room, leaving me in the sitting room in the company of the cat and some ashtrays in need of emptying, and then reappeared at five that evening.

That first meeting was emblematic of the type of person she is: straightforward, direct, and so busy that she has to take her sleep whenever she can get it. Tuna, a busy working woman, is the daughter of political activists. Her father was a director of the local Communist Party, an illegal thing to be at the time. Her parents were not in Turkey when Tuna's mother became pregnant with her; they'd met abroad. In that period, they moved first to Russia, then to Germany, and finally to Austria, where Tuna was born in Vienna. She spent only a few months there, but has since returned every year to spend vacations. These experiences influenced her development and played a part in forming her attitude, which is more laid-back than that of most Turkish girls. "Maybe it's because of my eccentric family," Tuna told me. "I don't feel one hundred percent Turkish, and the way I've chosen to live my life has nothing in common with my girlfriends' choices."

Tuna's hosting of numerous couchsurfers in the apartment on Istanbul's Asian side that she inherited from her grandmother is an example of one such uncommon choice. Here, she has lived alone since she came to Istanbul to study art and photography at the age of eighteen. She has two bedrooms plus the sitting room, all with floors of warm parquet, and a tiny kitchen, where she boils up generous pots of coffee for herself and her foreign guests, whom she loves to give tours of the city. When I was there, she promised to show me the best view in Istanbul. "I bring all my couchsurfers to a special place," she said. On the appointed day, I followed her into the center of town, up and down flights of stairs outsiders never see, to the dome-shaped, terra-cotta roofs that top the city. I thought she had been exaggerating, but when she rang her friends' doorbell and took me up onto their roof, I knew she hadn't. I had to take this photo.

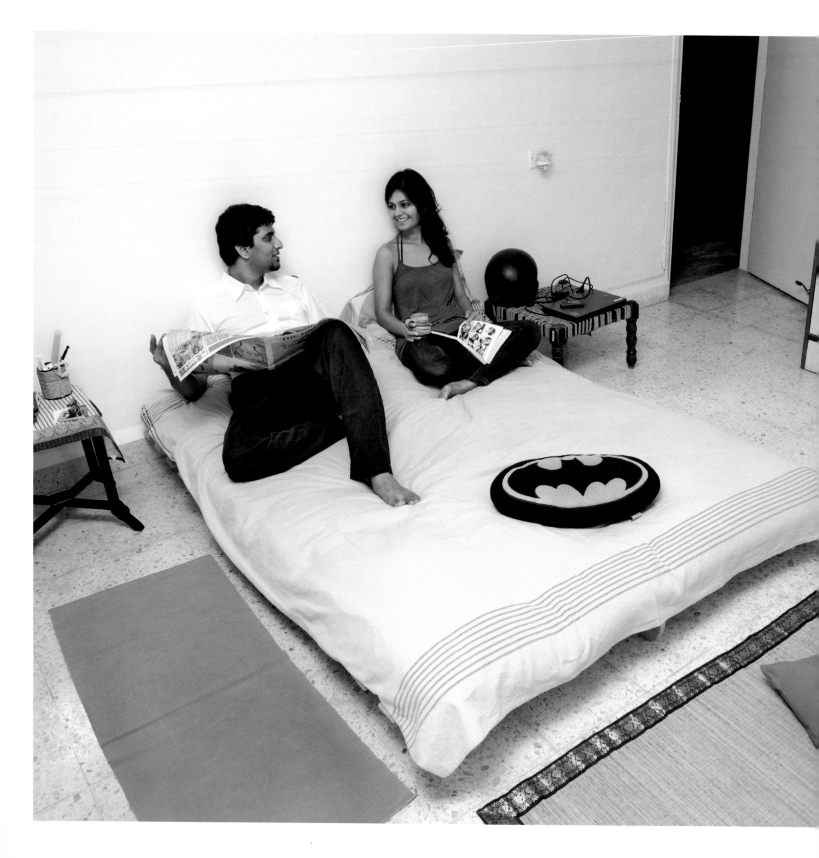

ALYSHA AGGARWAL, 29, and KARTIKH PERUMAL, 31

Twice married, never separated, Alysha and Kartikh are a prime example of modernity in a country of traditional values and considerable religious divides. To overcome the differences between their families, they got married twice in one week. The first ceremony, the Hindu one, was held in Bangalore, where Kartikh's family lives. "I kept quiet the whole time," Alysha says. "The priest was speaking a language I didn't even understand. I had to put on three different saris and I don't even know how many times I had to light incense. Still, it was beautiful, and a lot of fun." Five days later, they were married again, by a Portuguese Catholic priest, exchanging rings and vows of eternal love.

It is not the double ceremony that ensures the success of their relationship but, rather, the quiet, fulfilling, and happy life they have together. Their home, where they welcome couchsurfers, reflects this happiness. They live in a neighborhood in northern Mumbai where the artists and stars live, an area that has become a refuge for many Bollywood actors. The place is mostly modern, with the occasional piece of ethnic furniture serving as a reminder of their roots. It has two bedrooms plainly furnished, a living room, kitchen, and bath.

Both Alysha and Kartikh are well educated, speak multiple languages, and have good jobs. Alysha works for the Disney Channel, while Kartikh, whose specialization is marketing, is employed by an Indian multinational. While I was with them, they took me to eat great Indian food and to Alysha's grandmother's house, where I met the rest of her family—including her sister, a very pretty girl who, for one crazy moment, I imagined I might marry.

Kartikh says, "The world is divided into people who are fans of Barcelona and people who are fans of Real Madrid." To those who live on the other side of the planet, knowing about those two soccer teams is proof of a profound knowledge of the world.

KEKAVA

LATVIA

ELEINA PRIEDE, 22

The family tree fills almost an entire wall of the large living room. Yellowed photos and clippings and handwritten names cover almost every inch. Branches have been added over the years as the family has expanded. Eleina started the tree as a gift to her grandparents when she was still in school. Now the elderly couple continues her work, noting each new family birth with good-natured grumbling about their granddaughter's failure to finish what she started.

Eleina hasn't lived in this big house in a while, but she occasionally still hosts couchsurfers here. She was seventeen when she packed up and left the Latvian village of her ancestors to study photography in London. Now she divides her time between the two countries, accompanied by one constant companion: her childhood teddy bear. "It has to be in the same place I am," she told me; "otherwise I don't feel at home."

The other thing that makes her feel at home in Latvia is walking through the spacious rooms of her grandparents' house, where every object is a memory. She also loves their greenhouses. "I am more at ease here than anywhere else," she explained. "I love to help my grandparents with their tomatoes and vegetables. It makes me feel close to nature." Nature is all around us here, and not only in the lush greenhouses behind the family home. Kekava, though only thirty minutes from Latvian capital of Riga, is known as the "chicken village," for its hundreds of chicken farms. One evening, Eleina's grandparents roasted a delicious one in my honor. They were exceptionally hospitable, giving me a room on its own floor, with a private bath.

Eleina and I had long talks about life and photography, the career we have in common. "I'm proud of my country's dramatic history," she told me during one of our leisurely sightseeing strolls. "I'm proud to come from a nation that's small and strong."

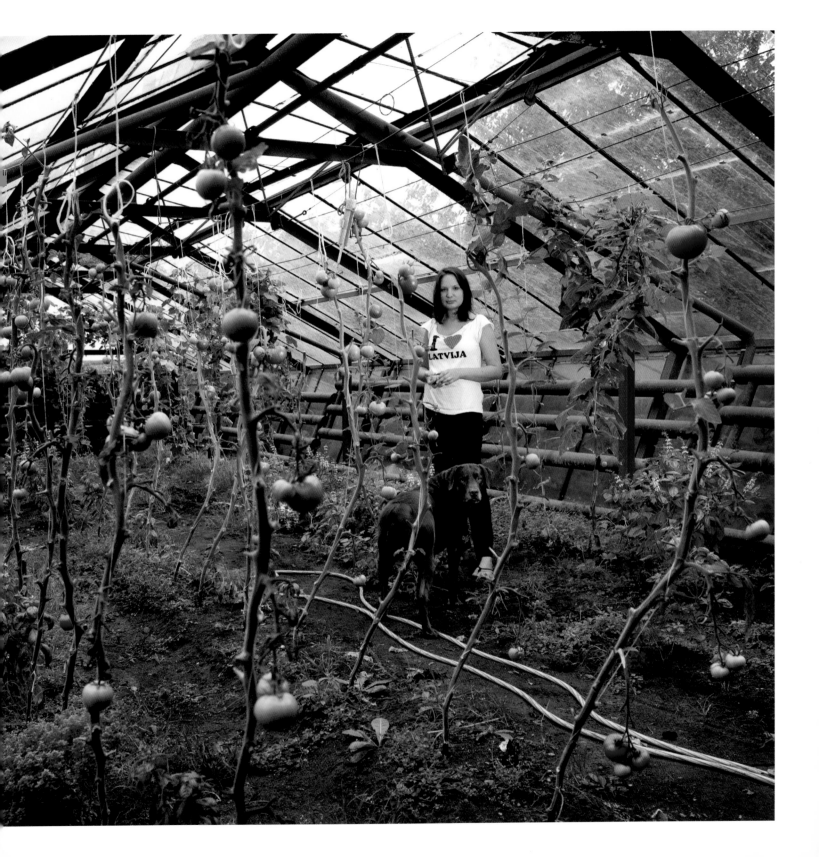

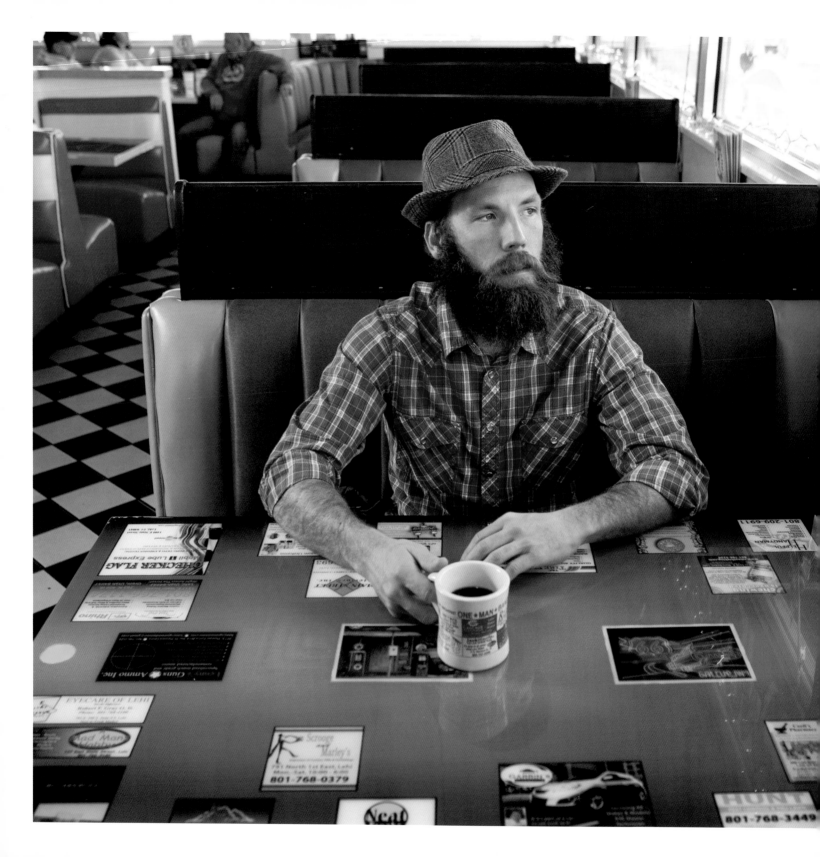

AMERICAN FORK
— UTAH

BUCKLEY BARRATT, 32

When I first arrived at Buckley's house, I didn't know that I'd find a friend. Buckley has an unusual story. He was born into a Mormon family in Utah, but at the age of twenty-three he decided to break ties with his community and his religion to move in with his girlfriend, who later became his wife. He is an elementary school teacher, but his passion is music. During my stay, we spent a long time with his record collection, listening to Tom Waits and exchanging artist recommendations.

The house where Buckley lives is spacious and bright—tastefully decorated, but without too many frills. Time moves slowly there. In the basement he's built a little rehearsal studio with a few guitars, a bass, some other instruments, and, naturally, sofas for couchsurfers (two of them). His dog is a constant presence and an essential part of his life. "She's always there to keep me company, cheer me up, and give me the strength to go on," Buckley told me. Over a beer and a good meal—his home has a large kitchen and Buckley loves to cook—we got to know each other better. He was a big help during that trip and has been on all my visits back to Utah since.

I asked him what message he'd like to send to the world. "We're all the same, so let's treat each other with more respect," he said. It's not a coincidence that his heroes are Martin Luther King Jr., Abraham Lincoln, John Muir, and—there had to be at least one musician—Bob Dylan.

The last time I showed up at his home in search of a couch, having completed my trip around the world, I found out that Buckley and his wife had separated after ten years together. "Trouble brings truth, adversity brings appreciation, and sorrow brings sunlight," he said with a smile. It's a lesson worth learning.

TORONTO

CANADA

LIONEL BELMAN, 68, and BARBARA NIELSON, 61

The home of Lionel and Barbara is a reflection of their story. Inside, there's a little bit of everything, from exotic souvenirs to rare animals. Goldfish splash in the fountain in the garden, reptiles peer from glass tanks, and Dagen, their big dog, rolls all over the couches.

The couple first met in their early twenties, when Lionel was running a rehab center and Barbara came in for a job interview. Although the two clicked immediately, not only did she not get the job, but Lionel was already married. They met again at a party eleven years later. He had separated from his wife in the interim, so his and Barbara's relationship was finally able to take off.

Lionel and Barbara's lives are no less full than their home. Both have devoted themselves to helping others, and neither has ever really grown up. Barbara is now a nurse at a children's hospital. She travels a lot for work, but instead of staying in hotels, she always chooses to sleep on the couches of strangers. "Couchsurfing bridges the age gap," she says. That's one reason their basement is always open to kids passing through. "Having a lot of young people coming and going makes me feel young," she told me.

Listening to her stories, I found it easy to imagine that Barbara was younger at heart than a lot of teenagers. Before I left, she told me—over a delicious barbecue dinner prepared by Lionel—that she would be leaving with her son in a few days to go to Burning Man, the giant gathering of artists, musicians, and hippies that takes place every year in Nevada. The plan was to drive there in their Volkswagen van painted with flowers. After the festival, however, her son would keep driving south until he hit Argentina. Barbara, meanwhile, planned to hitchhike home.

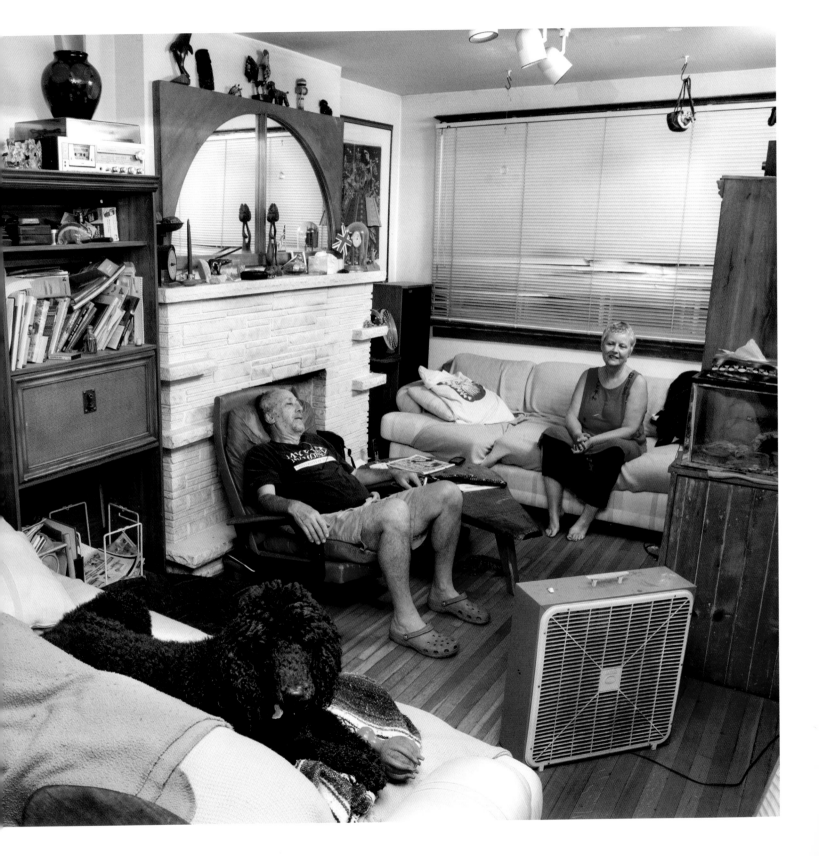

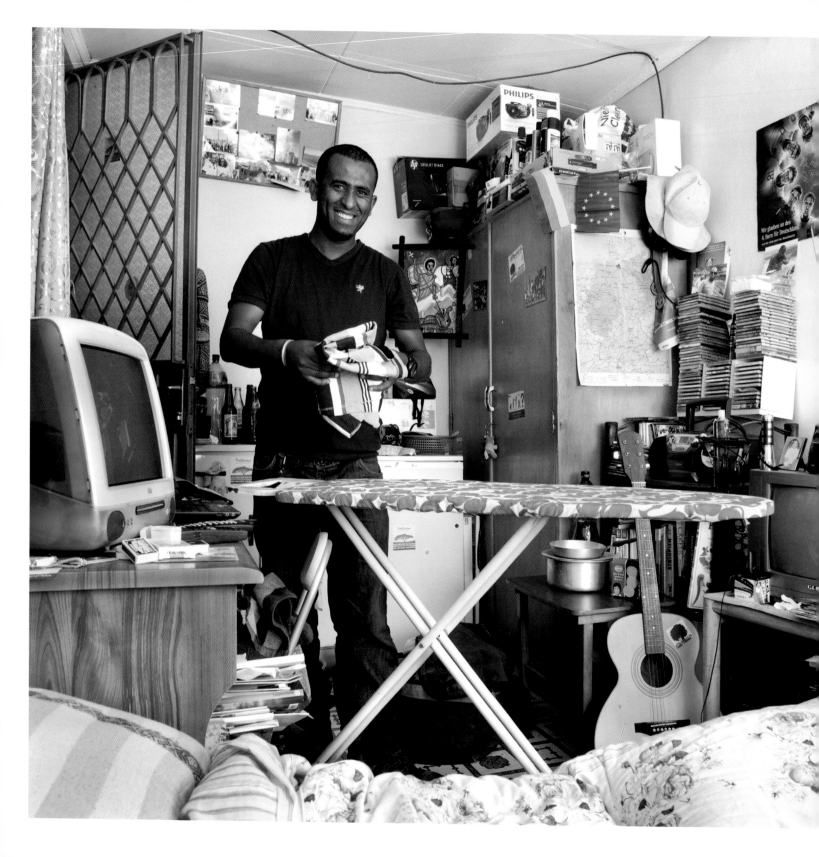

ADDIS ABABA
—
ETHIOPIA

WAKO WONDIMU, 32

There are roughly one hundred square feet to cook, eat, sleep, iron, watch television, connect to the Internet, and store memories—basically to do everything except wash; that you do outside. The little bathroom on the landing, the sanitary conditions of which are best left unmentioned, is shared by all nine inhabitants of the building's four micro-apartments.

This room belongs to Wako, a tour guide for a German agency in Addis Ababa. In his home there is certainly no space for a sofa or a spare bed—his possessions barely fit—so when couchsurfers come, he lends them his bed. During my stay, he slept on the floor, a mattress sandwiched in. I was moved by his hospitality.

For Wako, the lack of space isn't a problem. He really does have everything he needs. His iMac is so old that it's almost an objet d'art. With it, he accesses German radio and polishes his language skills. He's very proud of knowing how to speak German as well as English. A map of Germany hangs on his closet door, along with a flag and a poster of the country's national soccer team. In his spare time, Wako plays the guitar that leans against a table by the television. He loves music and collects CDs, which he stacks on top of the stereo that sits on the same little table that holds his pots and pans for cooking in the kitchenette that's stuffed in the corner. Notebooks, packages of cookies, and other odds and ends vie for the remaining space.

"I dream of doing something important for humanity," Wako tells me with a smile. The secret to his happiness is "feeling like I'm useful to someone." It's not surprising that his greatest satisfaction is when couchsurfers come back a second time or recommend him to their friends. Wako is certainly to be recommended; hospitality is guaranteed.

CASTIGLION FIORENTINO
ITALY

PAOLA AGNELLI, 58, and ROBERTO GALIMBERTI, 63

It's been thirty-seven years since I first met Paola and Roberto, and over the years we've spent a lot of time together. We've also done quite a bit of putting up with each other, especially when, along with a fourth person, we shared an apartment in Castiglion Fiorentino and everyone had a different schedule. I, for instance, stayed on the phone for hours with my various girlfriends, tinkered on my bass, or blasted my music at full volume. Sara, a diligent student, spent hours chatting with her girlfriends, either closeted in her room or in front of the TV. Paola and Roberto, for their part, were busy with much more important things: she is an elementary school teacher and he a surveyor. Incidentally, these people are my sister and my parents.

Before I decided to stop monopolizing the living room TV and go my own way, taking with me my bass, its cumbersome tangle of wires, and all the rest of my clutter, we lived under the same roof for twenty years. While they surely enjoyed the newfound tidiness after my departure, I imagine that it was still a shock for my parents, at least in the beginning. Yet it is thanks to the things they taught me and the strength of our relationship that I found the will and the courage to embark on my couchsurfing adventure.

After a year spent gallivanting about the five continents, staying with practically every sort of person and in every condition imaginable, I came home to spend Christmas in Italy. It was time to couchsurf on my parents' comfortable sofa—but not before eating a massive portion of the homemade stuffed cannelloni my mother always makes to welcome me home from my latest journey to some faraway place. To fall asleep on that couch, nearly bursting, had never felt as sweet as it did that Christmas Day.

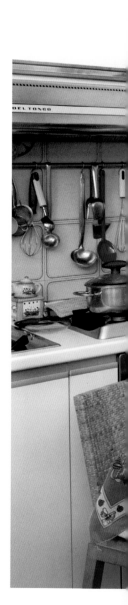

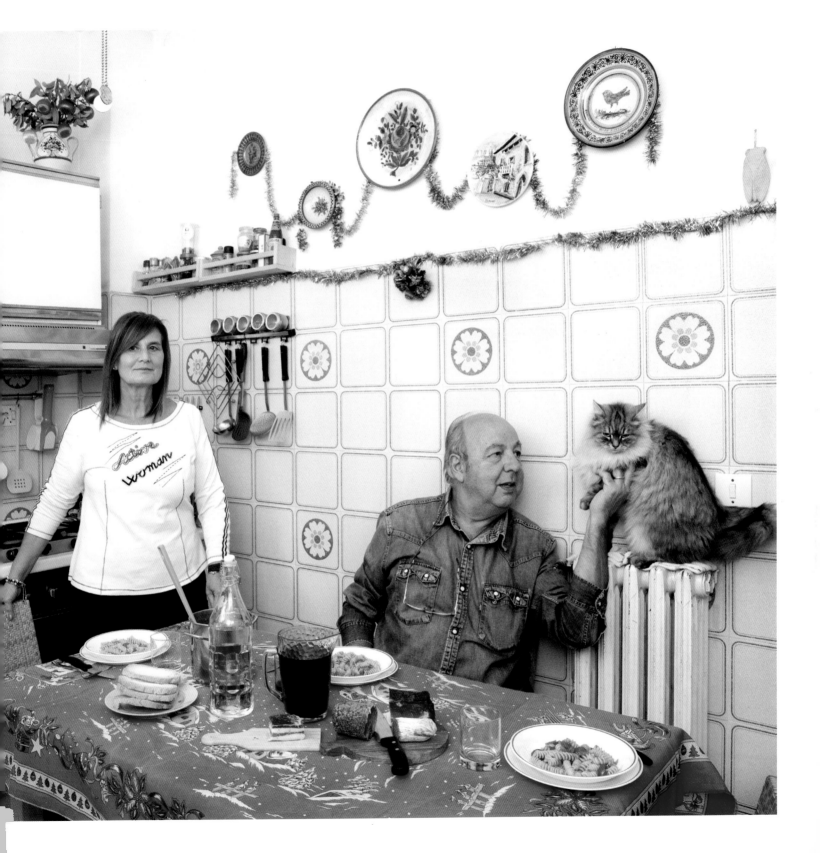

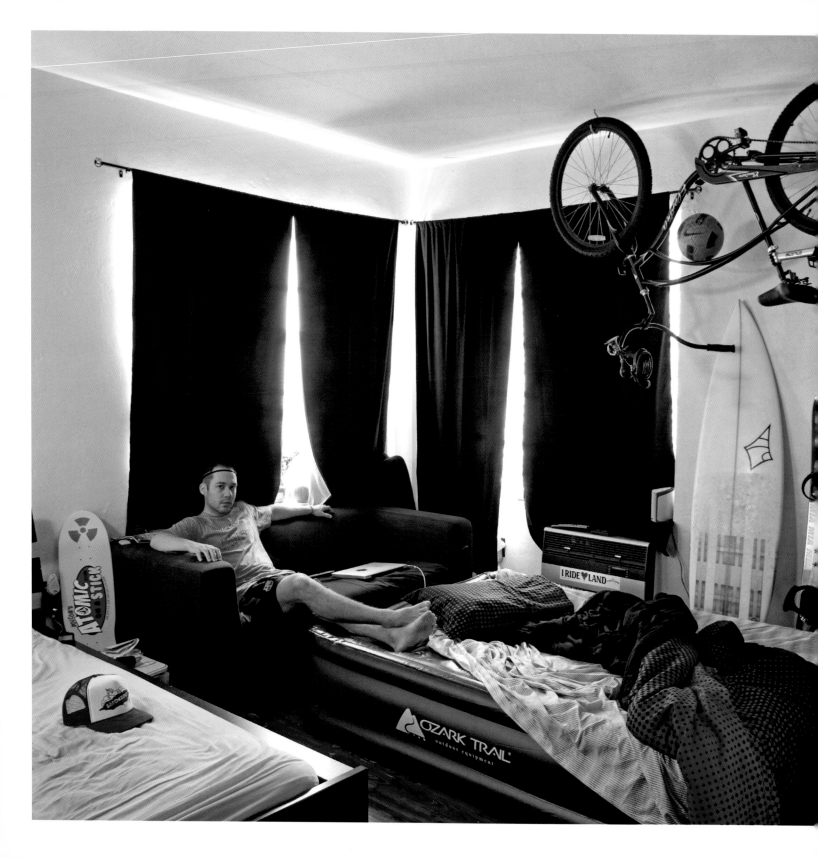

DANIEL DAJUSZ, 24

In a single room, and not a very big one, Daniel has managed to fit all his passions. Never mind how many Americans have a garage full of space to hold their dreams and the equipment they require. In this tiny apartment in South Beach, Miami, close to the shore, a bicycle (the kind that can carry a surfboard) hangs from the ceiling. When Daniel goes surfing every morning, the room is immediately freed of two of its bulkiest objects. "What single item do I need to be happy? My surfboard," Daniel told me. "The first thing I ask when I wake up in the morning is whether the waves are big." Even with those two things gone, though, the apartment is still pretty crowded. There's the snowboard, the skateboard (Daniel's philosophy: "The world is divided into skaters and police"), the soccer ball, and Daniel's camera, which he deems "the most important object in the whole house."

In addition to being an accomplished sportsman, Daniel is also a student of photography and art direction. I went along with him and some of his friends when they were filming one evening. Sitting on our beds at night, we talked at length about photography. Daniel had inflated an air mattress for me, but it wasn't much different from a real bed. He was extremely accommodating, especially considering that, as I must confess, he hadn't been my first choice for couchsurfing in Miami. The couple who had been meant to host me had had a last-minute problem, and I had found myself sitting in a café with Wi-Fi, e-mailing Daniel in the hope that I wouldn't be couch-less for the night. He got back to me within half an hour—God bless the smartphone—and it was with relief that I showed up on the doorstep of his home-cum-amusement park.

What he says about himself is as good a description of his personality as any: "What I like most about myself is that I'm happy ninety-five percent of the time."

CHONGQING
—
CHINA

ZHANG YUE, 22

There were two double beds in the large, unadorned room, but there were three of us. Yue was quick to tell me where things stood: one bed was hers, and the other belonged to her roommate. I could sleep either on a mat on the floor or share her bed. I'll admit, I wasn't sure if her intentions were pure. Still, after months of couchsurfing my way around the world, I was willing to deal with the risk. I decided it was better to sleep next to a strange girl than to make my bed on the floor yet again. As soon as we began talking, however, lying there next to each other, it became clear that Yue wasn't thinking any funny thoughts. She was as straightforward and pragmatic as her almost-empty room seemed to indicate. It had just the bed, a little desk, and a small closet.

Yue studies film directing, and shares a room with a friend in a student residence in the center of Chongqing. The residence complex is built on multiple levels, with six rooms laid out around a communal kitchen. The rooms are austere but fairly large. The only "furnishings" in Yue's room, other than the bed and desk, are the piles of books stacked against the walls. The worst part about the building is the bathroom. Cleanliness isn't exactly a priority, so taking a shower, for me,

required a lot more courage than I needed to get into bed with a stranger.

On the morning after our first night together, Yue took me for a walk along the river that runs through Chongqing, a megalopolis that is considered a driving force for Chinese production. (Speaking of driving, the pollution here makes the air nearly unbreathable.) We came across some large metal letters—the ones on which I would later take her picture. They seemed to include her given name, Yue. She explained to me that, in Chinese, *yue* means "moon." So the sculpture reads, "Shining Moon." "I feel a lot more like the sun, though," she told me. "It's a shame that here we almost never get to see it."

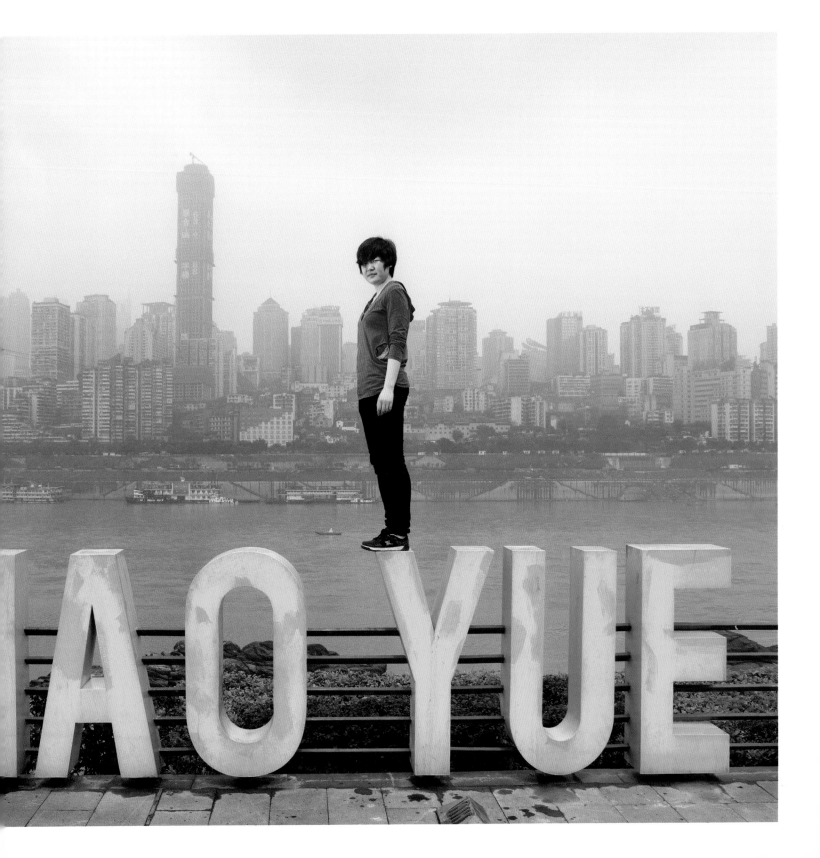

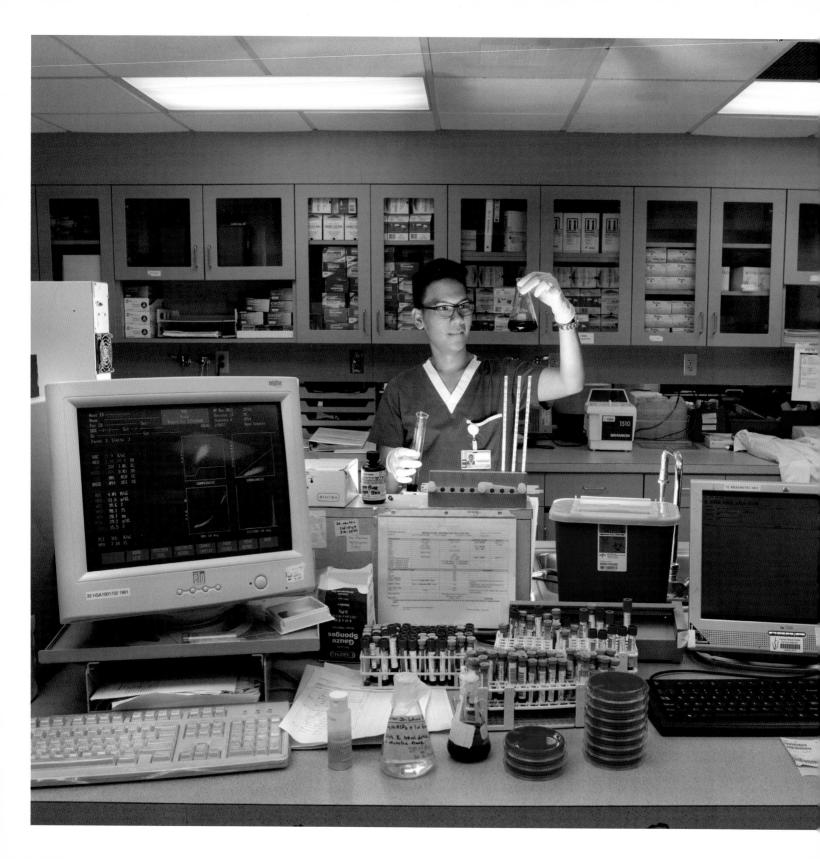

GEORGE TOWN
THE CAYMAN ISLANDS

ED CATANDUANES, 27

The government of the Cayman Islands granted Ed seven years on his work permit. Two of them are already gone. When the remaining five are up, he'll have to move somewhere else. In the meantime, he's living life to the fullest.

Ed is originally from the Philippines. "Coming here was the biggest decision of my life, mostly because everything I knew about this place I'd read on Wikipedia," he admits. In hindsight, his bet was well placed. With his degree in biology, he found a job as a laboratory technician in a hospital in the Caymans, with a salary that allows him to do things that otherwise he might never have imagined. Every month, he not only pays his rent but also manages to put money away for travel, his great passion, and send some of his savings home to the Philippines. Using what he's sent them so far, his family has already been able to buy a house.

Ed's a very funny guy and enjoys hosting. When I arrived in the Cayman Islands, I had a friend with me. We were supposed to stay with Ed for only one night, but a last-minute change of plans forced me to beg him to let us spend two nights on the two sofas in his living room. He invited us to stay

for the entire week! And then we were four: Ed, my friend and I, and Ed's Filipina friend, who had come to visit and was staying in the guest room.

Ed's home is just a short walk from the beach and surrounded by a lush garden where iguanas grow and multiply much in the way ants do elsewhere. The important thing is not to startle them. Luckily, even though they look frightening, they're harmless. Ed brought us to the local clubs in the evening, and to repay the favor, we cooked him some Italian specialties. The high point of our trip, however, was when he took us to swim with stingrays. It was a once-in-a-lifetime experience that left me as excited as a little kid.

REYKJAVIK
—
ICELAND

BERGLIND GUNNARSDÓTTIR, 33

Berglind had no intention of staying home on Saturday night just to wait for my arrival. She had written me an e-mail arranging for us to meet in a nightclub instead. I asked how I was supposed to recognize her amid the expected chaos. Her reply was "It's easy. I'm all red."

She was right. I picked her out the moment I walked in. For Berglind, the color red is a real obsession. She dresses in red from head to toe. Her hair is red, and naturally, being an interior architect, she'd made the interior of her house red, too. (Maybe she needs it to contrast the gray exteriors that dominate her neighborhood.) Curtains, sofas, lamps, armchairs, and even the objets d'art (a few of which, like the light-up deer, are just a tiny bit kitschy) are red. Even her two cats have reddish hair.

The atmosphere of quiet warmth all this red creates clashes with the disturbing noises that come from the guest room, which, when she's not hosting couchsurfers like me, has become a laboratory for her

boyfriend, Hilmir. A video-game designer, Hilmir divides his working time between his office, where I visited him one day, and Berglind's guest room. From behind the door come the sounds of laser swords clashing, spaceship engines whirring, and interstellar shields impacting, plus artillery fire of all sorts—the usual video-game repertoire, all at an extremely high volume.

The surreal atmosphere created by these noises (which are actually quite funny) is only one of the many reasons I found Berglind and Hilmir such likeable and obviously original characters.

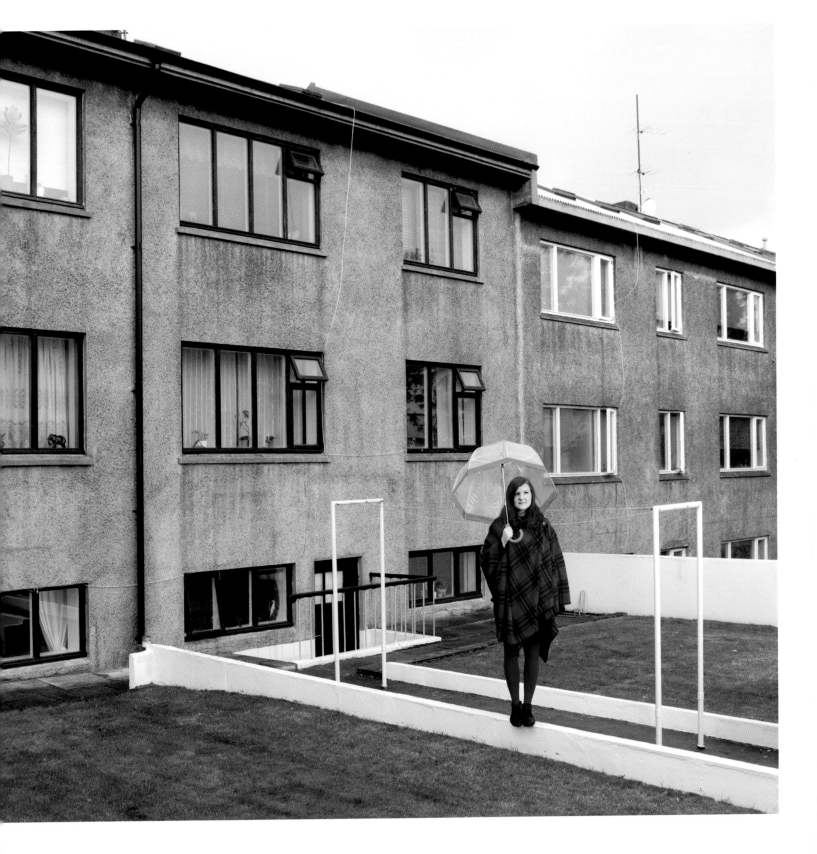

BANGKOK
THAILAND

MAI, 24, and BOX, 36

Two hours of conversation in a gay chat room was all it took to convince Mai and Box to meet face-to-face in a bar in central Bangkok—and that meeting was all they needed to decide they wanted to be together. In order to do so, however, they had to overcome a few hurdles, most important, their very different pasts. Mai (pictured in the white T-shirt) has always known he was homosexual. Box (in the black T-shirt), on the other hand, spent eight years married to a woman. It was with a great calmness that he told me, "My new life began when I admitted that I was gay without being ashamed."

These days, they both work in a shopping mall in the capital. Their home is a studio apartment they have transformed into a love nest, though there isn't room for much. There's a television; a nightstand, where their photos are displayed; and a bed, which also serves as an ironing board, when Mai feels like doing that chore. On the floor is a hot plate on which they can cook only the simplest of meals, and a full-size mattress, where I slept.

Well, not just me. Mai and Box are very hospitable people. During my ten-day stay, another couchsurfer arrived, and shared the mattress with me. The whole setup, though not unpleasant, doesn't allow for much privacy for guests or hosts. One afternoon, I found myself caught in the midst of a furious lovers' quarrel. I tried to ignore it, fiddling around on my computer and pretending that everything was normal, until Mai started to cry. That's when I decided to give the couple a little space. Over the course of the following evenings, although we drank quite a few beers together in different bars and clubs around Bangkok, I never found out why they were fighting. Eh, it happens.

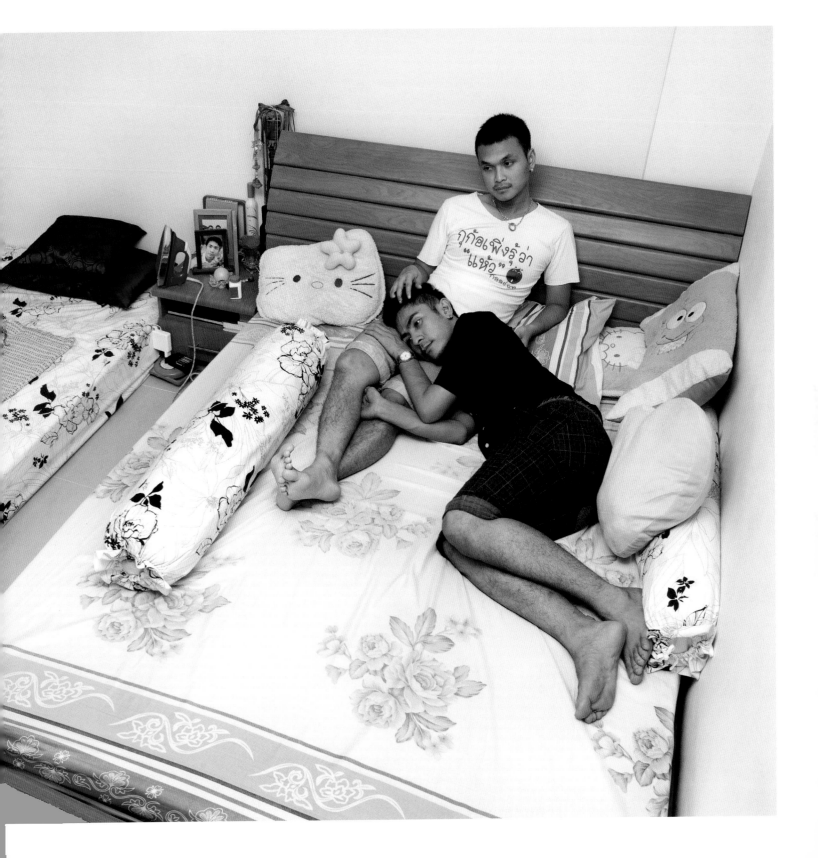

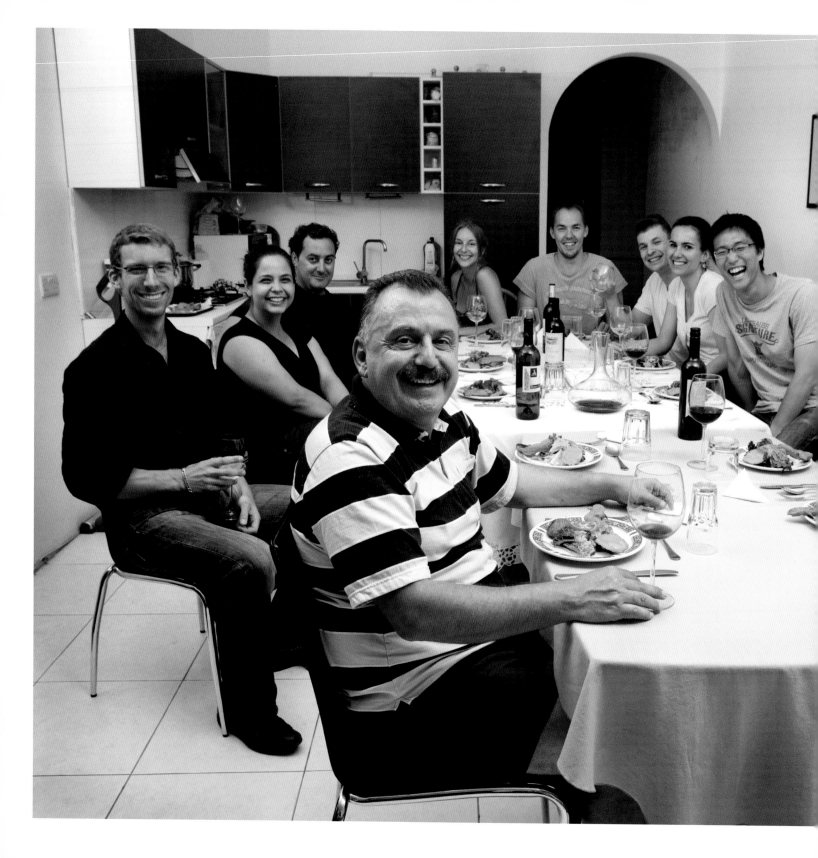

FRANCESCO CACHIA, 54

Three rooms, three couches, ten guests—the guests come and go, in constant flux, every day, every week. They come from all over, in search of a couch or simply for the company, staying long enough for a Lucullan feast or a jaunt around the island with new friends.

Francesco is jovial and sports a dark little mustache on his friendly face. When I visited him, he told me, "I like having people around me. I have no children of my own, and spending so much time with young travelers keeps me young, too."

He works at Sharma Ethnic Cuisines, a restaurant that combines Mediterranean, Middle Eastern, and Indian foods. At home, he sets the table for visitors from practically every corner of the world. Sitting around it on the evening I took this photo were travelers from France, Brazil, Poland, Malta, Latvia, Germany, Kazakhstan—and, of course, Italy. They were that week's guests, the ones staying in Francesco's house. Then there were the globe-trotters who slept elsewhere because there was literally no space left. Francesco cooks for them as well, once a week and entirely at his own expense, in fulfillment of what he sees as

his mission: "To try to make other people happy but, most important, to succeed in being exactly who I've always wanted to be." The computer situated in his small study is a great help in achieving this aim. It has allowed him to open himself up to the world, and has become a point of reference in the process. On his own, Francesco has hosted more couchsurfers than anyone else in Malta. Then again, as he says, "If I weren't here, I'd be a missionary."

He keeps the postcards his couchsurfers send him from their travels (or their homes) around the world. The collection is a small treasure that helps Francesco to not only remember his visitors, but also know the world better.

TOKYO
— JAPAN

MAYU SHIMURA, 23

When she went to study in England at age eighteen, Mayu had never been hugged. Her life up to then had not been sad—on the contrary, she has a loving mother, father, and younger sister. But people in Japan simply don't hug each other, and even if they were huggers, no one in Tokyo has time to stop to embrace. When Mayu was studying in England, however, the Spanish friends she met in English class always greeted her with big hugs. "They made me feel warmth, kindness, and happiness," she told me.

It was those foreigners in a foreign land who piqued her curiosity with their possibilities of blond or red hair or black skin. To get to know different kinds of people better, she became a couchsurfer and began hosting in the two-story house she shares with her parents and little sister. The family lives in a neighborhood in North Tokyo. I arrived there a year after my first trip to Japan, which had taken place after the terrible tsunami that devastated the country (see page 90). Everything in Mayu's house is white, bright, and ultramodern, from the big kitchen to the television that dominates the living room—that room is also home to the giant couch where I slept.

Mayu loves comic books. Her sparsely furnished bedroom is a veritable museum of action figures and stuffed toys inspired by characters from comics and cartoons. Even Mer, her dog, is something of an expert in the genre. You might see him walking around the neighborhood dressed as Godzilla or Mickey Mouse.

Hosting foreigners has encouraged Mayu to open herself up to the world. She now works for an Indian company that exports diamonds to Japan. She uses all her vacation time to travel the globe, getting to know new cultures—and giving out hugs. I was the recipient of a very warm one when I arrived at her home. Mayu's new mission, I discovered, is to import the custom of hugging to Tokyo.

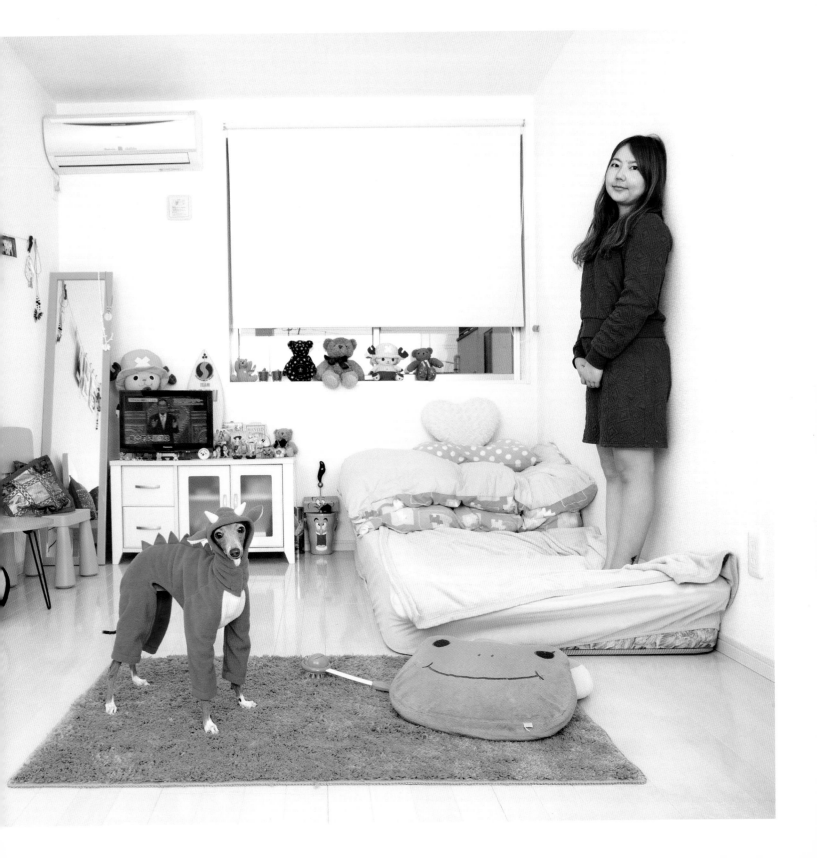

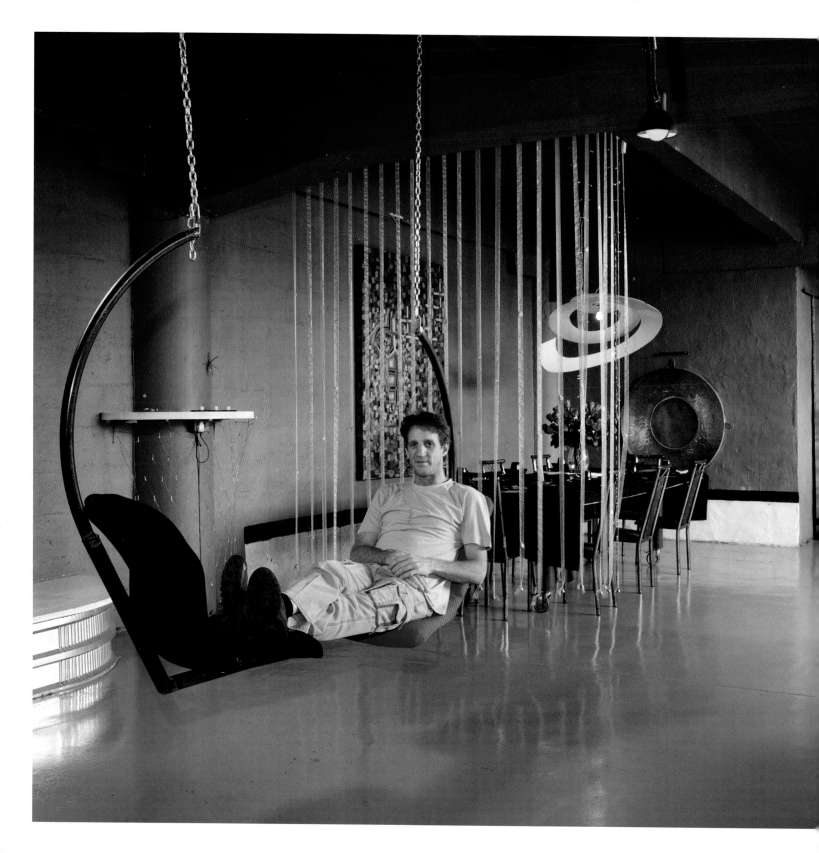

JOHANNESBURG
SOUTH AFRICA

JOHAN SMITH, 50

With a metal detector at the entrance, a ticket booth, electric-blue walls, deep-cushioned swings suspended from the ceiling, and a dark back room hidden behind a curtain, Zero looks just like any other gay nightclub in any other corner of the world. The difference is that Johan lives here. He was given the property by some clients who couldn't pay their bill for his software programming services.

The space hasn't changed much. Johan has done only the bare minimum to make the club into a home for himself and Serafina, the woman who helps with the household chores. She irons his shirts behind what was once the club's bar and is now the kitchen. Zero had only love seats (like the one Johann is relaxing on in this photo). These were located in the dark room where, once upon a time, boys sought one another out for fleeting, passionate encounters. Nowadays couchsurfers spend the night on them instead.

Johan is extremely hospitable and opens his doors to numerous visitors. "Guests are what I love most about my apartment," he tells me. It's all part of this new chapter in his life, which began after his marriage ended badly and he quit his job as a computer programmer. He had made a lot of money but had never had a moment to enjoy it. When did his new life begin? "On the day when it first dawned on me that it was my turn."

PORT-AU-PRINCE
HAITI

NATACHA MARSEILLE, 29

Natacha's principal occupation is doing good. The form this takes is fighting a daily battle to give the children of her tormented homeland a future. Orphaned when she was only a few months old and raised in an institution for foundlings, Natacha understands their plight. Her life changed when, at the age of five, she was "adopted" by a German family. It was the beginning of a lifelong journey made possible by their material and emotional support.

At first it was almost impossible to communicate with her new German "parents," so Natacha studied English. After just a few years, the three were having long daily phone conversations. Her adoptive father encouraged Natacha to continue her studies, and eventually she became a teacher at a Montessori school. A few years later, in love with her work and determined to devote herself entirely to children, and with the financial backing of her German family, she was able to build her own school in Martissant.

Gangs control this unsavory neighborhood of Port-au-Prince, but everyone here knows Natacha and respects her. The terrible 2010 earthquake destroyed part of her school, even burying some children and teachers beneath the rubble. It was a terrible tragedy, but Natacha rebuilt. Every day, she takes in orphans and gives them a chance. It was with them that she wanted to be photographed for this book.

Her entire life, not just her work, hinges on helping others. Her house—in an old villa perched on a hillside in Delmas, with a view of the whole city—is home to an apparently permanent encampment of penniless journalists who are determined to tell Haiti's stories but who don't have money for hotels. When I was there, I was in the company of five other couchsurfers. Natacha shares the place with a girlfriend—and all the other people you can always find camped out on beds and mattresses the two women put down for them, helping those who have nowhere else to go.

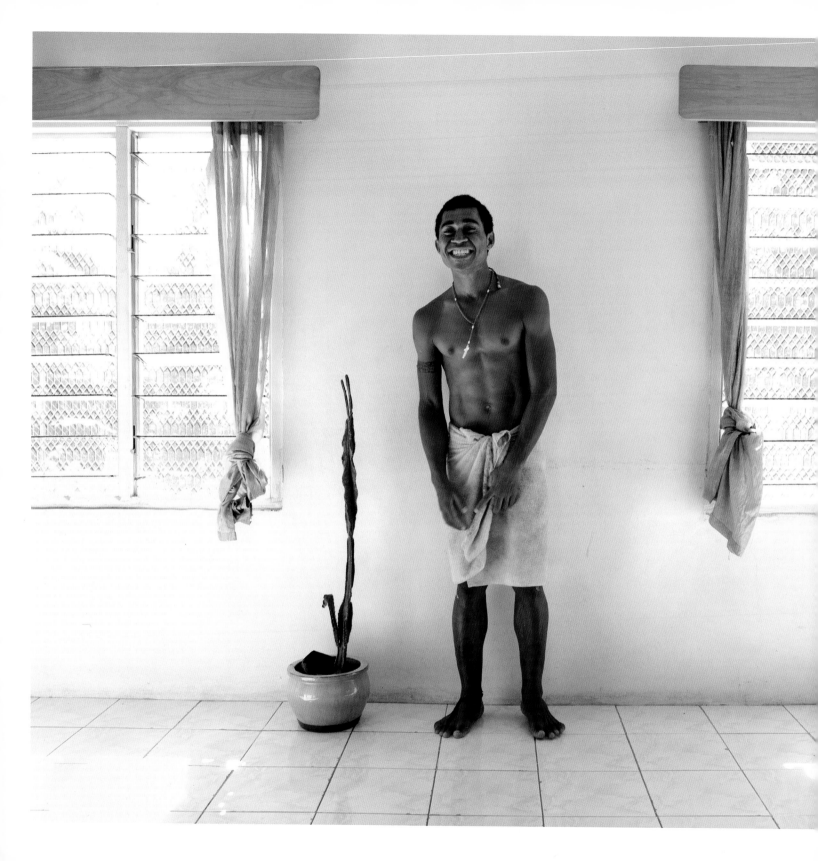

RATU SAVERIO SELIO RALULU NASILA, 20

When I arrived at Ratu's home in Namaka on the island of Viti Levu in Fiji, I found not only a couchsurfing host, but also his entire family ready to bend over backward for their guest. I had already learned that hospitality is typical of the Fijian character, regardless of where they live or how they spend their days. Ratu, his siblings, and his grandmother are living proof of this.

Ratu recently went back to school. For years, he worked hard in a fresh produce market, from dawn to dusk. As soon as he'd saved up enough money, he enrolled in a design course. His dream is to turn the ideas of Fiji's entrepreneurs into magazine advertisements, using graphic design to help businesses on the archipelago grow.

He shares a home on the outskirts of the capital of the island with two of his five siblings. Their apartment, in a brick building with a pleasant garden encircling it, is large, with a room for each of them and one for guests. The space is simple and sparsely furnished, but its inhabitants' care and kindness lend it warmth.

Ratu, his brother, sister, and I did a lot of fun things together. We went snorkeling in one of the most beautiful seas I have ever seen—in fact, this photo was taken at the end of that day—and we went to see their grandmother, an excellent cook whom I photographed while she was grappling with a giant fish and some coconuts. After dinner one evening, I tried to topple Ratu from a particular pedestal he occupies: he's a celebrity in a pool hall not far from his home because, apparently, it's been two years since anyone has beaten him. I tried but was unable to end his winning streak.

PANAMA CITY
PANAMA

ELISA JIMENEZ, 30

To stay at least once in a home like Elisa's is probably every couchsurfer's dream. I realized as much before I even set foot inside her two-story villa in central Panama City. Parked out front as if to welcome me were a Porsche, an Audi SUV, and a couple of BMW motorcycles—all signs of a level of wealth that, even in a place where dollars and business deals are easy to come by, is above the ordinary. Then again, the story of Elisa, whose home this is, is equally unusual.

Elisa's father is a businessman who has made millions working with Jamaica. Her mother spends her days drinking coffee with girlfriends in the villa's enormous garden and going on shopping expeditions to the city's malls, choosing more designer furnishings and paintings to match those that already fill the house. Elisa studied international relations in Europe. She discovered couchsurfing when she was in Berlin and, ever since then, has been repaying the hospitality she's received on the sofas of the Old World.

Although there is no shortage of rooms in the main house (a white marble villa with gold-plated faucets), the day I arrived, Elisa showed me to a private guesthouse. It is an entirely separate building where her father has installed a library with tens of thousands of books, a gym, and a home theater complete with plush seats directly from a cinema. It was a little like being in a five-star hotel, but Elisa seems not to pay much attention to that. "It's attitude that determines your quality of life," she told me. "You can always choose to have a positive outlook."

She certainly does not lack positivity. Although her studies focused on something completely different, Elisa has recently begun making jewelry using materials she has shipped to her from all over the world. Her next goal, she told me while we relaxed next to the pool, is to make her creations part of her father's business.

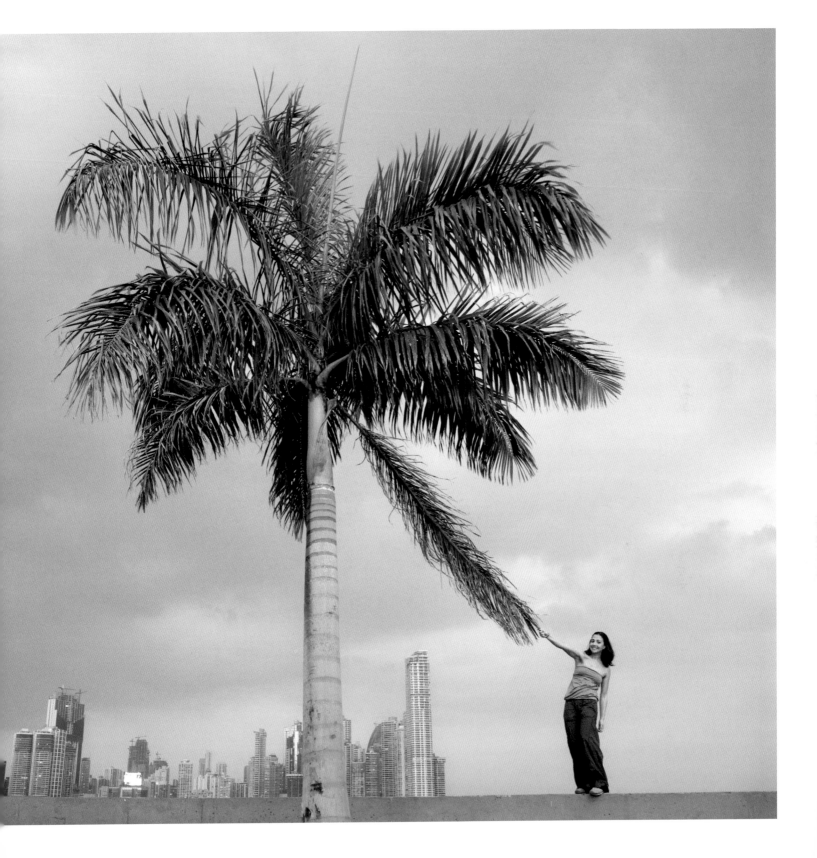

MUMBAI
INDIA

DHARMESH KURIAN, 18

Dharmesh is a couchsurfer who lives in a house too small to host anyone. Despite this fact, he wants very badly to spend time with people from far-off places. So, instead of a couch, he offers his time. He wrote a post to Couchsurfing.org inviting travelers to join his cricket team, which plays every afternoon. All I had to do was respond and show up—no prior experience required.

It was clear to anyone with eyes that it was the first time I'd ever played. I was a complete disaster—not to mention the fact that, between the heat and the humidity, I had zero energy to begin with. It didn't matter, though. Dharmesh and his friends pretended not to notice my weaknesses, lack of skill, or total ignorance of the rules. Dharmesh made a valiant effort to help me understand the game and feel like part of the team. He tried to explain how to grip the bat and which were the best positions, and taught me tricks to hitting the ball right and then running. The truth? I still don't really get it. Maybe it was the heat or simply that I was out of shape, but for every ten minutes of play, I had to take half an hour to rest. Dharmesh and his friends, on the other hand, went on for three hours straight—no breaks at all!

My experience with Dharmesh and his friends was one of the most authentic I had in India. I learned a lot from it—beginning with the fact that I should exercise more often than I do.

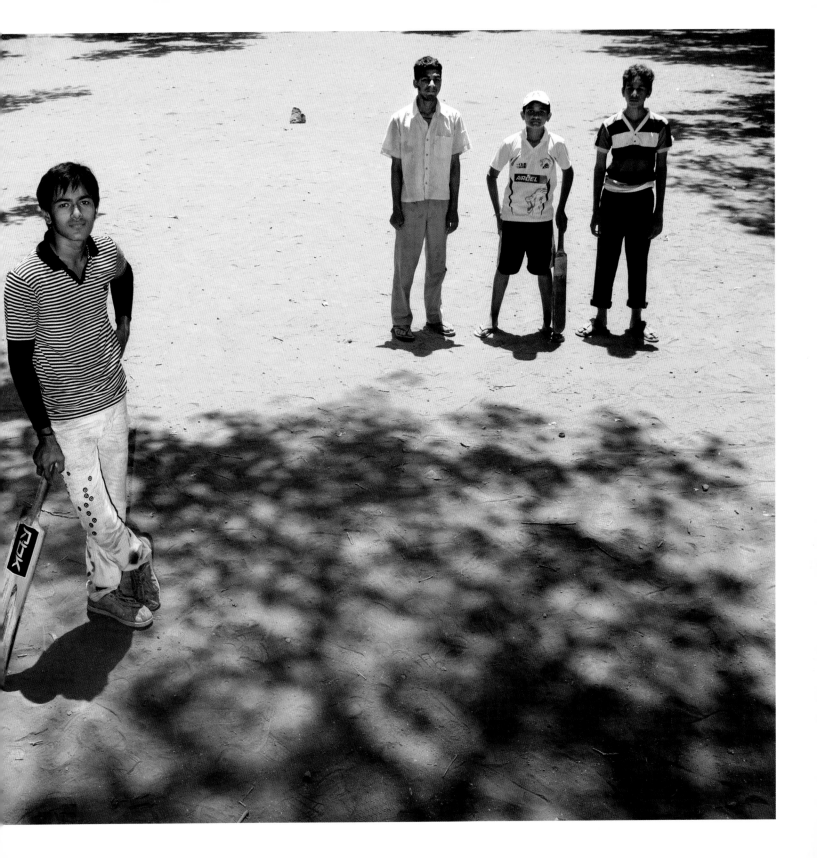

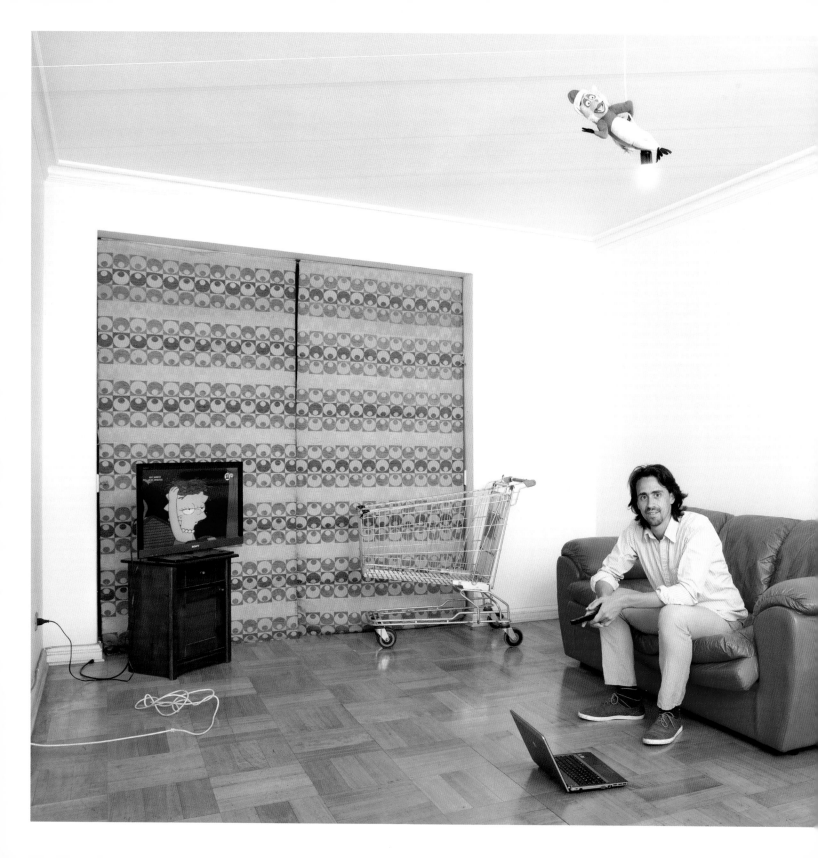

FELIPE ANDREAS CALDERÓN PASCUAL, 29

Felipe's home in Santiago's trendy Lastarria neighborhood is as large as it is sparsely furnished. The living room holds nothing but a red leather sofa, a TV, and (for some unknown reason) a supermarket shopping cart. The kitchen's meager contents consist of a little junk food for midnight snacking and a few beer bottles—some empty, some not. The room where Felipe sleeps is just as basic, furnished with a bed and, when needed, a mattress thrown down on the floor next to it. It's for guests who are too tall to fit on the couch—like me, for instance.

Felipe gave me an explanation for the Spartan décor of his home. "There's nothing to steal in this house because I have no interest in material objects." These days, his life is made up of other things: friends, doing the things he enjoys, being in love, and working at a rewarding job as sales manager in an Italian fashion house. It was not always like this, however. As a child growing up in Concepción, where his grandmother raised him, the hyperactive young Felipe let his academic successes lead him to believe he was better than his peers. "That was a problem when I was a teenager. I felt superior, more intelligent than the others. My friends started avoiding me, and I was alone most of the time."

His life took a new turn when he visited New York. "The variety of people that I met there slowly tore down my prejudices, and my life began to change." The earthquake that struck Chile in 2010, killing more than five hundred people, did the rest. Felipe returned from the United States to help, and ended up staying. He eventually settled in Santiago, in the nearly empty house whose keys he held out to me on a warm Chilean autumn morning. He had known me for only about five minutes, but he had to leave for work. In my personal experience as a couch-surfer, this set a new record for blind trust. Still, there was nothing there to steal, even if I'd wanted to. That fact must make it easier for Felipe to trust strangers.

TOKYO

JAPAN

MOCHAN, 44

My plane to Tokyo was nearly empty; there couldn't have been more than ten passengers aboard. Now that I look back on it, it's a wonder there were even that many. I arrived in Japan just a few days after the devastating 2011 tsunami. I had planned a ten-day trip, staying in the homes of different couchsurfers. On that March 11, however, the lives of Japan's people had been turned upside down. The couches I should have camped out on had become sanctuaries for relatives fleeing the tsunami's horrific devastation. When I realized that my original plans had been scuttled, I had sent out a plea for a place to stay, although without any true hope of a reply. Mochan answered, offering me his couch for a couple of nights.

Tokyo after the tsunami was nothing like the place that exists in the popular imagination—a city of overwhelming sights and sounds and fastidious precision. The metropolis now had a spectral feel to it. The buildings were still swaying from aftershocks, and the few people on the streets seemed in shock themselves. My last-minute host was not one of these. Once I finished thanking him profusely for his hospitality, I asked if he was worried or upset. He shrugged. "We're Japanese," he said. "We're good at rebuilding."

With his uncommonly flamboyant clothing, Mochan seemed out of place among his fellow citizens. I took his picture in the center of Shibuya Square, whose usual dazzling array of neon signs had been almost entirely extinguished to save electricity, making him the brightest element of the scene. Mochan believes that he derives a lot of his energy from contact with other people. For years, he and a friend managed a bar together. Eventually, he got tired of it and decided to get involved in tourism. Now he ferries visitors from all over the world around the city in his minivan. In his tiny home in central Tokyo, there is always a store of clean sheets ready for couchsurfers.

Staying with him in the aftermath of the tsunami was surreal but informative. During those days especially, when giving in to despair might have seemed the only possible reaction to the tragedy, his determination and positive attitude helped me see Japan in a new light.

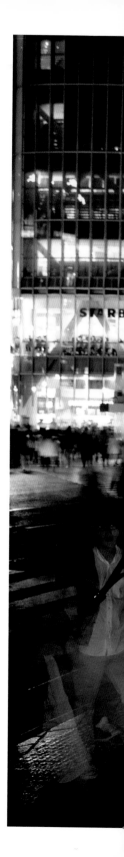

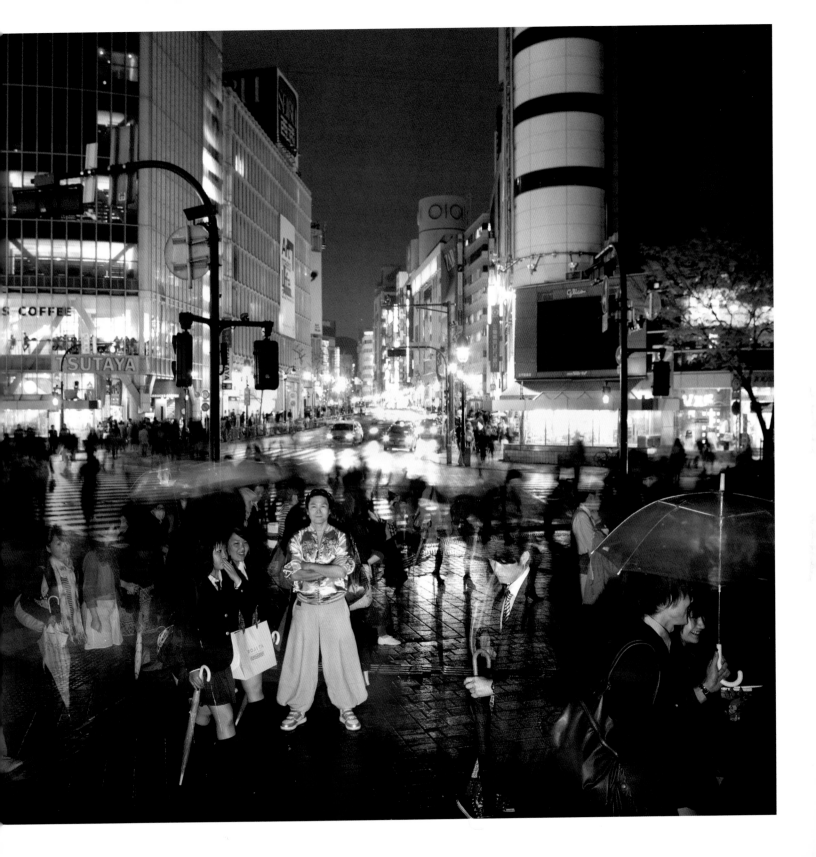

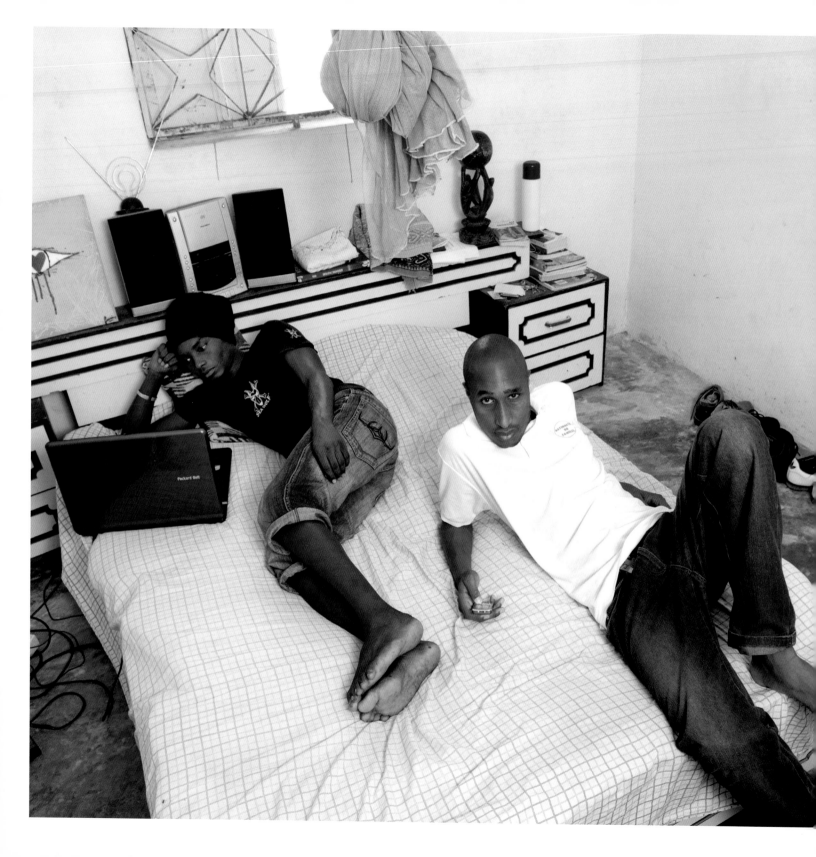

GUÉDIAWAYE
SENEGAL

LAMINE AMADOU, 27

I had been riding in the taxi for at least an hour as night fell and the buildings of Dakar started to thin out. I began to feel a creeping sensation that I was traveling through utter nothingness. The taxi driver finally let me out at a gas station in Guédiawaye, north of Dakar. I'd waited just a few minutes when my host, Lamine, and his brother, Karim, showed up. We walked for roughly half an hour to reach their village, along an overgrown path. We were lucky the moon was high, because its light was all we had to see by. "The electricity is turned off from ten p.m. to five a.m. every day," the brothers explained.

When we finally got to our destination, sometime around 2:00 a.m., I learned I wouldn't be sleeping in their house. In theory, my accommodation would be in the headquarters of the village's cultural association. In practice, it was one room in an empty building. The walls were bare concrete, and there was no mattress to be seen, no electricity, and not even a drop of water. "If you need some, you can get from the well at the end of the street," the brothers told me. It was clear sleep wouldn't come easy. I managed to drift off only because I was dead tired, just enough that I could forget the hard cement floor, barely disguised beneath a makeshift mattress I'd made from layers of my clothing. By some miracle, I'd

managed to hang my portable mosquito net from the ceiling using shoelaces.

That night in Senegal was my toughest couchsurfing experience and the one that left the deepest mark. I also remember my time in Senegal for the kindness of Lamine, with whom I spent the next day. It was a pleasant experience walking around the village and finally ending up at his house, which is much more like a "normal" home than the place where he puts up his couchsurfers. Indeed, though his family's house is modest, it is equipped with a few Western comforts. There are beds, a bathroom, and even a computer with a USB Internet key, which is how Lamine gets online.

I stayed to have lunch with his family. His mother served a noodle and meat soup that she had prepared over a brazier. "The best thing about Senegal is the *téranga*, the hospitality," Lamine told me.

MADRID

——

SPAIN

CARLOS BRAVO, 34, and INMA PRIETO, 35

Carlos, a computer engineer, and Inma, an English teacher, are two of the first activists of the Indignados, the movement that sent waves through Spain's political system in 2011. Back then, thousands of people read Carlos's long blog posts, and he and Inma were organizing all the activities in their neighborhood—meetings, protests, manifestations, and more.

Before settling in Madrid, they led very full lives and traveled extensively. They met in a bar one evening, when Inma was showing around a couchsurfer she had been putting up at the time. Two months later, she had a new home in which to host her visitors—the one she and Carlos had moved into together.

When I arrived at their home, the protests were over (or temporarily on hold, at least), so we were able to spend a lot of time in one another's company. Their apartment, a pleasant space with large, bright rooms, is in the city's center. The guest room has its own bathroom, which is quite a luxury for a couchsurfer. The most notable objects in the house are the World War I-era radio and transmitter parts that Carlos loves to restore. He is passionate about them and works with intense patience to bring them back to life.

Inma, Carlos, and I shared many long conversations and meals that bordered on feasts. They introduced me to their friends, and together we sampled Madrid's tapas and the best of local nightlife. I asked them if, after all the politics and protests, they had a message they wanted to share with the world. It was Inma who replied: "Everyone, please be a little kinder and more aware of our planet. We don't have another one."

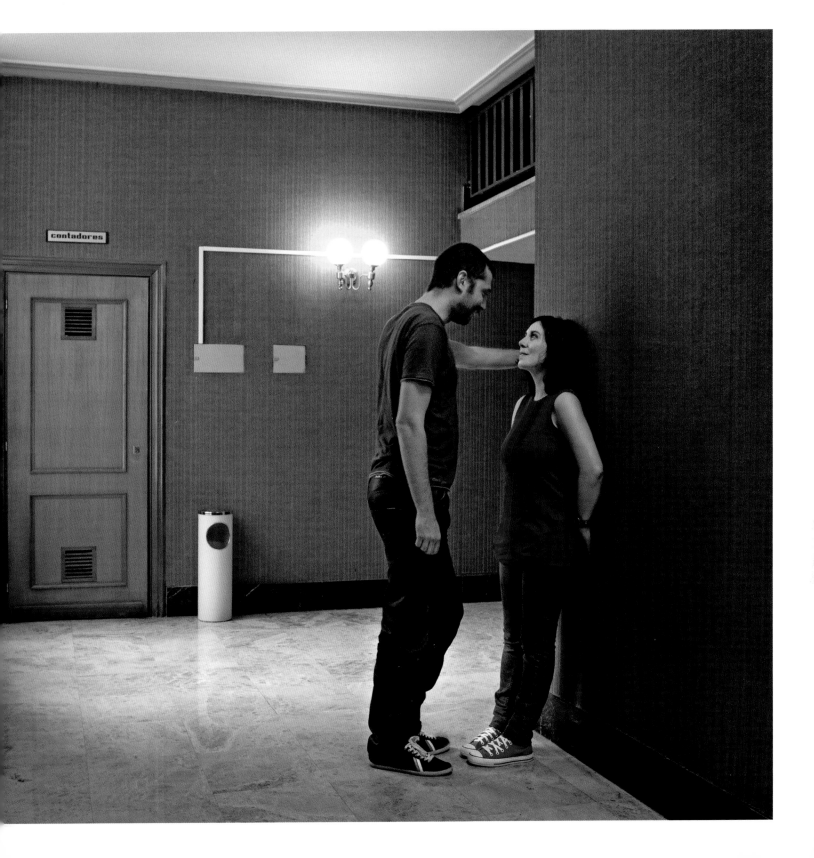

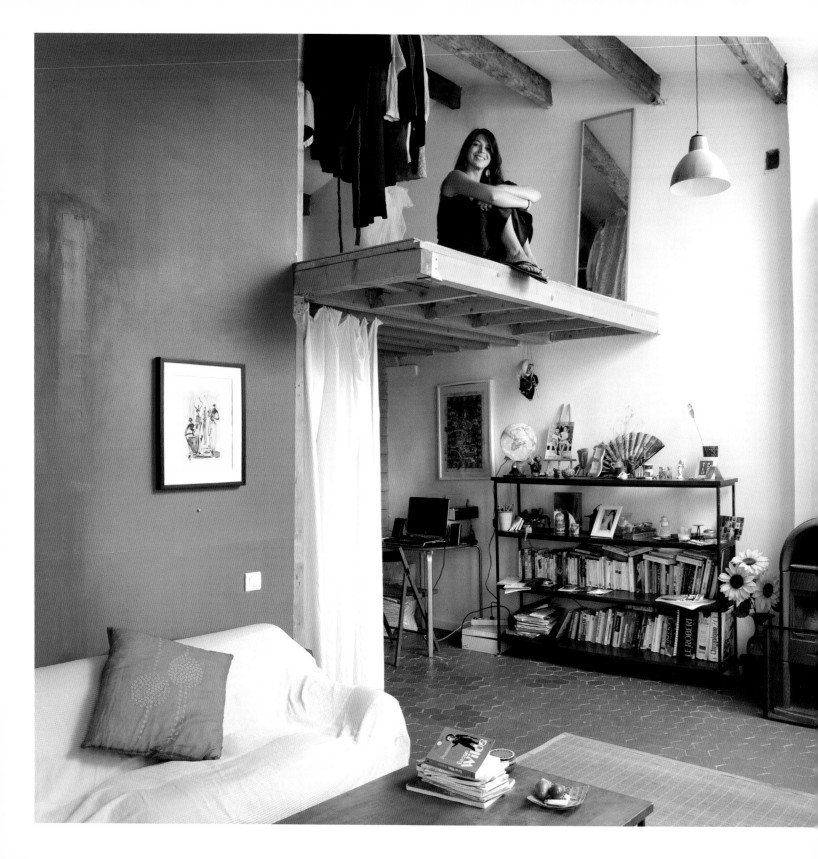

MARSEILLE
—
FRANCE

CAMILLE ROQUE, 33

It was my initial day of couchsurfing in Marseille when I saw Camille for the first time. She was descending the ladder between the loft and the lower floor of her small apartment, a graceful figure suspended in midair—and at that moment I believed I had come to the end of my travels. It wasn't meant to be, but at least my head was filled with dreams. Still, I spent several marvelous days in Camille's company, exploring the city, the surrounding countryside, and the local culinary specialties. We tried our hand at cooking some of them ourselves in the kitchen of her Provençal-style home near the sea, where she also collects recipes.

Camille is a French globe-trotter who was born in a little village in the Pyrenees, into a family whose Spanish origins have almost been lost in time. As a girl, she studied in London, and then returned to France for a short while before departing again, this time for Brazil. There she found an excellent job in the marketing department of a national television station. She came back to France again for love: her fiancé couldn't live knowing that she was so far away. "It's a shame he left me not long after I came back," Camille says with a note of irony in her voice.

Camille still misses Brazil (but not her ex). She soothes her *saudade* (a special sort of Brazilian homesickness) by playing percussion in two different samba bands, one of which I heard perform. These days she works in the marketing division of a big cosmetics company, and for the moment at least, she doesn't plan on going anywhere. She has books for company; among the phrases from them that she has adopted as mottoes is one memorable quote from Oscar Wilde: "The only things one never regrets are one's mistakes."

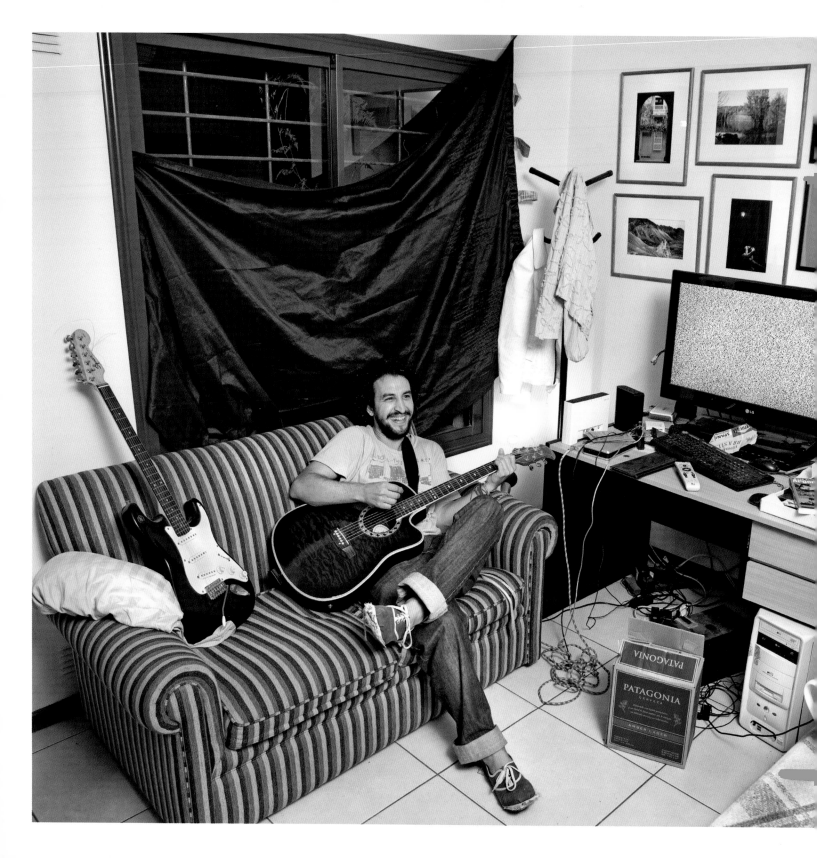

MENDOZA
ARGENTINA

JAVIER EDUARDO VARGAS, 34

Javier and his family came to Mendoza, a quiet town in Argentina's wine country, in 1984, after a devastating earthquake destroyed their countryside home and everything in it. They had no choice but to leave. "We moved and we built a new home," he told me. The entire clan still lives there, and once a week, they come together for a meal at his grandmother's lavish table.

Javier lives alone in an apartment whose three messy rooms tell the story of his three great passions: music, photography, and travel. In the sitting room, he showcases the pictures he's taken around Central and South America, above a computer that is always on. Javier is a Web designer, with a client list that includes a number of Argentine multinationals. His secret dream—still unrealized, for the moment—is to become a musician. "I have a lot of songs, and they get me through the tough times," he said, strumming one of his two guitars.

Following the earthquake and his family's forced exodus, Javier applied himself diligently at school. His efforts won him a scholarship, which led to an engineering degree. "Enjoy life, be happy, don't worry about money problems, and don't sweat the small stuff." That's the motto he lives by today, and he meets the first of its requirements by hosting couchsurfers almost every night. Short ones sleep on the sofa; the others, on an inflatable mattress next to it, with their heads practically under the table. Javier also takes his guests out with him to dance the tango, another one of his passions. Watching their clumsy efforts as they try not to crush the toes of the local ladies may well be part of the fun.

SIDI BENZARNE
MOROCCO

LAHCEN BAAHA, 28

In his whole life, Lahcen, a Berber, has almost never been more than about six miles from his house, and has ridden only a mule to travel. It's the same mule his family uses to go to the market in Sidi Benzarne, the little village in southern Morocco (about twenty miles from Agadir) where he lives. The family has been here for generations, cultivating the land, as the corn drying in the courtyard (shown in this photo) attests.

Thanks, however, to his own computer, Lahcen has become a part of the couchsurfing community. He sets his up on the roof of his family's white, cube-shaped cement home—there's better Internet connection up there. The house has four rooms, and the only decorations are the carpets on which we sat to eat *tajine*, the typical local dish. I was generously invited to share in this dinner ritual every evening I spent with them.

In our time together, Lahcen revealed his devotion to traditional values, but compared with that of his relatives, his life is completely modern. Not only is he a couchsurfer (the only one for many square miles),

but he also works as a guide in Souss-Massa, the recently established national park, so much of his time is spent in the company of tourists. He speaks French and a little English and has recently been learning to imagine the world beyond the confines of a village he has never left. "The tourists who come here tell me there are some beautiful places and that the food is good," he told me, summing up his thoughts about Italy, my homeland. Perhaps this explains why Lahcen's aunt tried to convince me to marry her daughter—the union of Italian pasta and Moroccan *tajine* might well have borne interesting fruits.

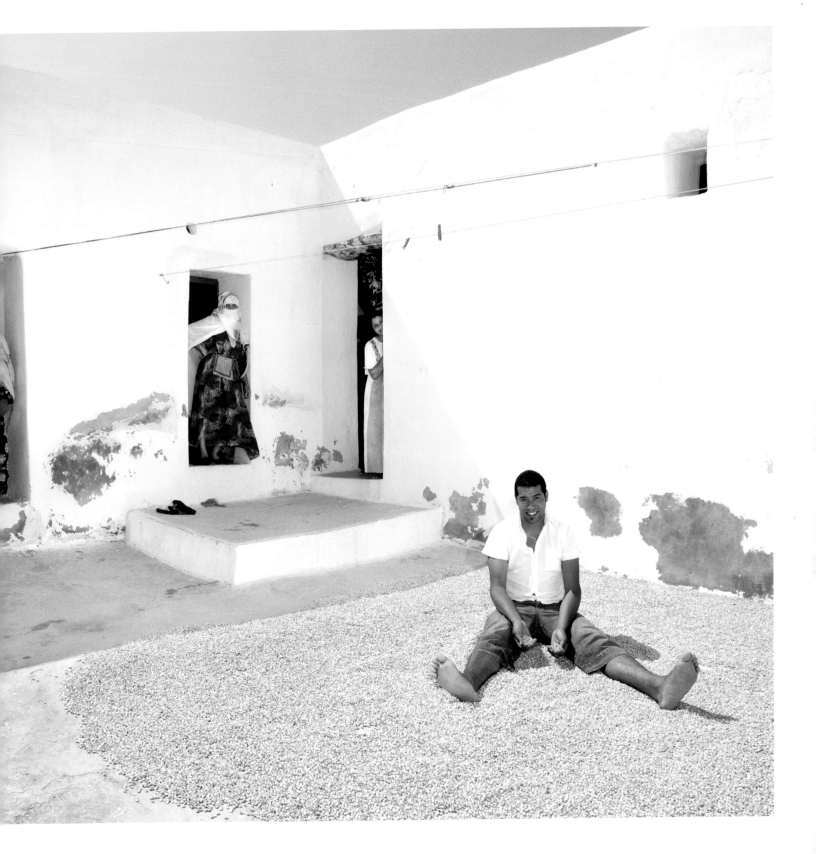

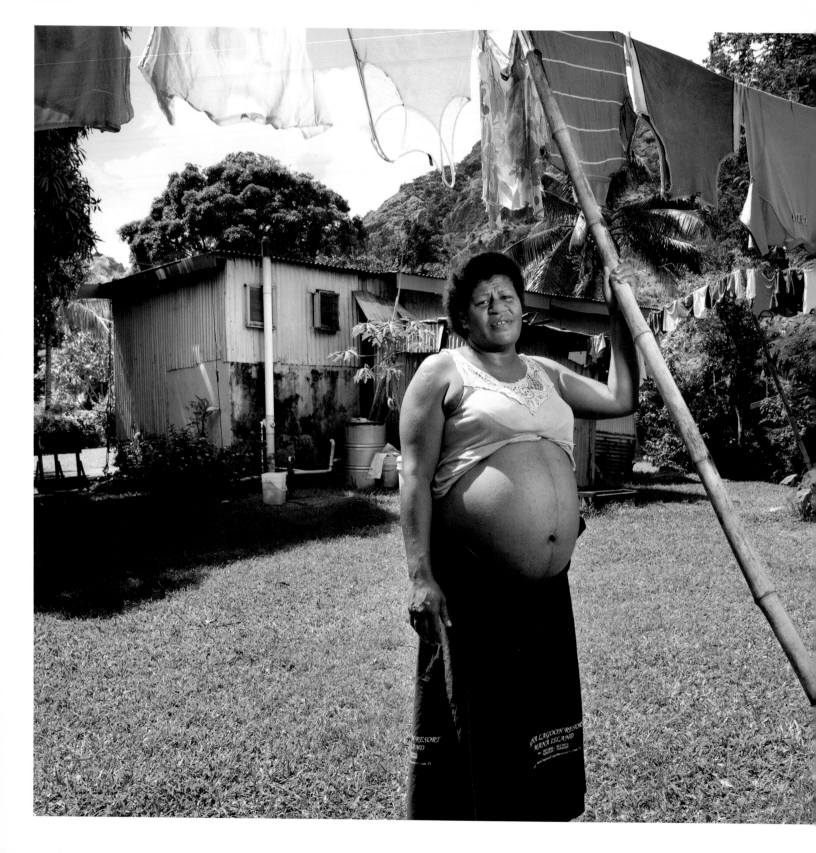

NANI MARQUARASE, 29

No one imagines that, having come to Fiji—believed to be a sort of paradise—he would dream of leaving. Yet I must confess that this was my first reaction upon arriving at the home of Nani and her husband in Barara.

A Westerner would have a hard time calling the place where the Marquarases live a "house." Within, it is divided up, like any normal home, into a kitchen, a small bathroom, and even a kind of foyer furnished with floral-patterned sofas and an extra mattress for guests. Yet because the structure is made entirely of metal sheeting, it is transformed by the midday sun into an oven, with a suffocating temperature inside even hotter than that outside its walls.

That said, I never expected my time with Nani and her family—which was due to get bigger any day—to be so pleasant. When I arrived, she and her husband, whose job is to take tourists around to the various little islands, were expecting their third child, and I later learned he was born shortly after my departure. Despite being in her ninth month of pregnancy, and in the face of overall conditions that few Westerners would be capable of handling, Nani was a powerhouse of energy, good spirits, and cordiality. I felt very much at home with her and her family. They showed me around and introduced me to Fijian customs, starting with the ingestion of kava, a root that, according to local legend, has a calming and slightly hallucinogenic effect. Nani and her husband prepared it for me one evening, mixing the powder form with water in a large basin made from a hollowed-out tree trunk. I observed the process, fascinated, before drinking two large cups of the mixture. Yet I couldn't feel even a trace of its supposed effects!

TBILISI
GEORGIA

WILLIAM KIRTADZE, 24

When I arrived in Tbilisi, William was waiting for me outside the airport, as we had agreed. I found him sitting on the hood of his car, a sporty but slightly dated Mazda that he had spray-painted himself, inside as well as out. The exterior was black and red; inside, it was all green, and a stereo that looked like a spaceship pumped out loud rock music. Lying quietly on the backseat next to an electric guitar was Chuky, William's big white Labrador and the most normal thing about the scene so far.

I'll confess, my first impression wasn't a great one, but it didn't take long for me to change my opinion. Beneath William's rough exterior, I discovered a person I had not expected to find. He's a hard worker (after having been a great student), and everything in his life is well organized. He shares an apartment with his best friend, in a giant concrete building just outside the city center. However, it was their third roommate, Chuky, with whom I spent real quality time; we shared the sofa bed for my entire stay. I would fall asleep alone, but in the middle of the night, I'd wake to find him next to me. In the beginning, I tried to persuade him to get down, but eventually I resigned myself. This couch where I slept was in the living room. The largest area of the apartment, it also had a huge television, weights, and a PlayStation that was always on—you could call his place a sort of man cave.

William was born in Germany to Georgian parents, and has lived in Tbilisi since 2006. He has a degree in marketing and works for an Israeli pharmaceutical company. In his spare time, he's studying to get a second degree. "I'm proud of the fact that I'm successful, even though I'm still young," he tells me.

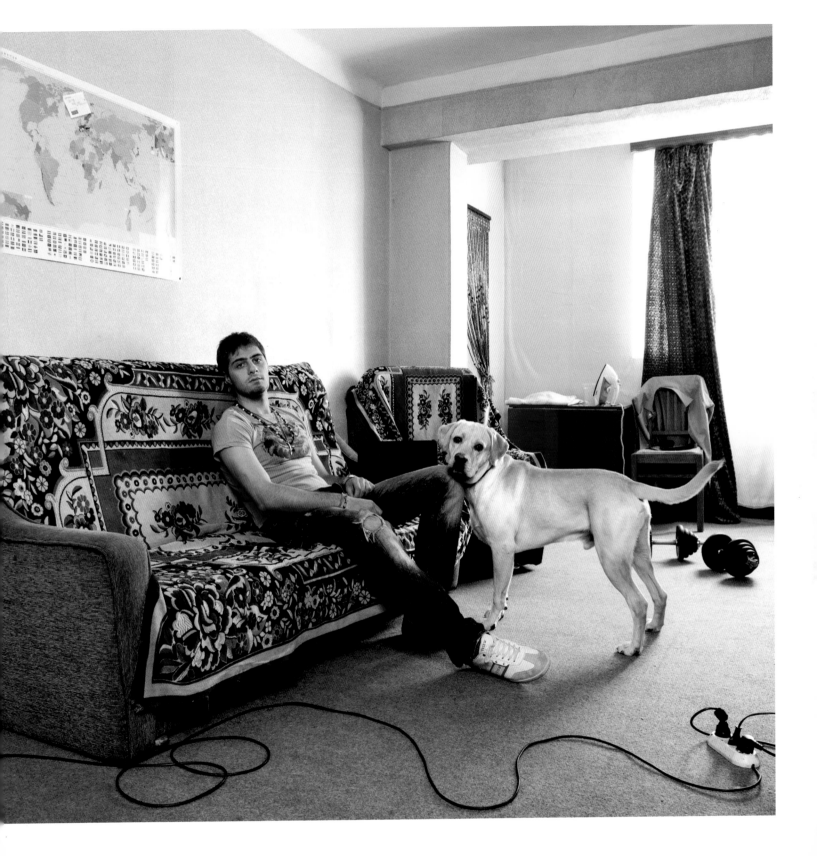

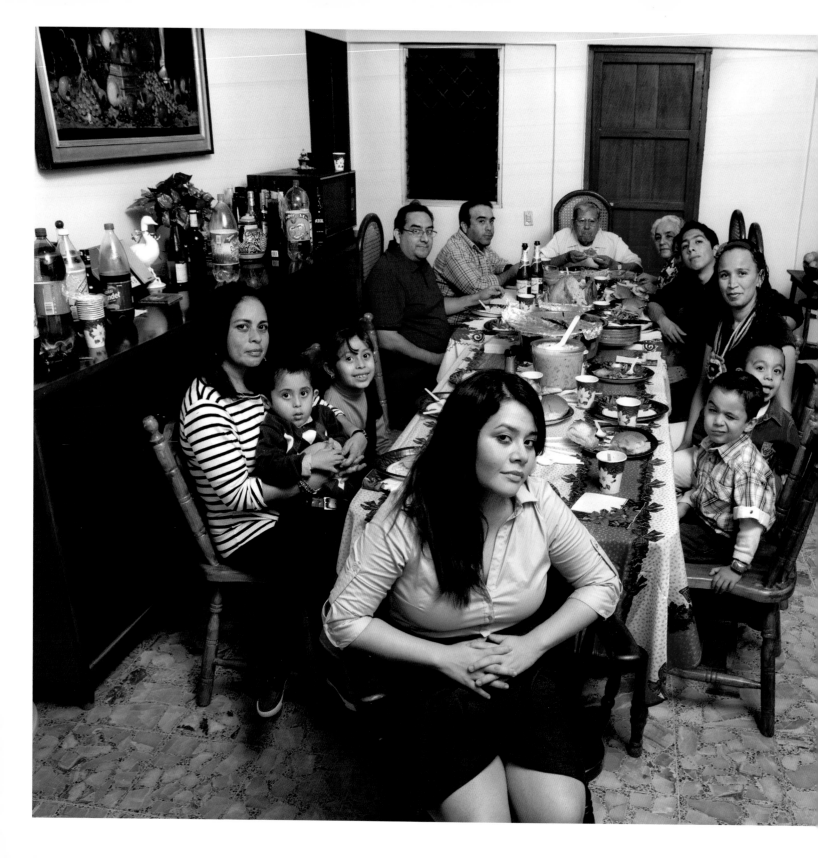

MARIA ARMAS, 22

Mother and father, their two children, aunts and uncles, nieces and nephews, grandfather and grandmother—it's Christmas dinner, Mexican-style, and the family belongs to my host, Maria. Just a few days after I arrived at her home in Veracruz on Mexico's eastern coast, I was invited to accompany her entire family to their house in Nopaltepec for the holidays.

I was treated as the guest of honor. I found myself persuaded to sing along to sappy ballads by Italian singers that I would never have listened to back home, but Maria's family played the Spanish versions for me, hoping to make me feel more at home. I'll admit, the tequila her grandfather kept generously refilling my glass with throughout the meal certainly made it easier.

Christmas dinner was a long meal—I'd helped make it, playing sous-chef while Maria's grandmother prepared the stuffed turkey—and was followed by a long siesta. Their house in Nopaltepec is one of those old, colonial-style homes you sometimes come across in Central and South America, nestled among the family's fields of sugarcane. There was a room for each of the guests, me included, but I wasn't alone often.

I spent a good deal of my time talking with Maria, who loves to think of herself as a rebel. While we strolled through the countryside around her home, she explained how difficult it is for her to get along with her parents and how different they are from her. I couldn't quite bring myself to believe her. She is a sweet girl and, despite the differences that arise between all twenty-two-year-olds and their parents, it seemed to me that she and her family had a loving relationship. Maria had spent hours straightening her hair and making herself look her best for Christmas dinner with the family—not exactly how you'd expect a rebel to behave.

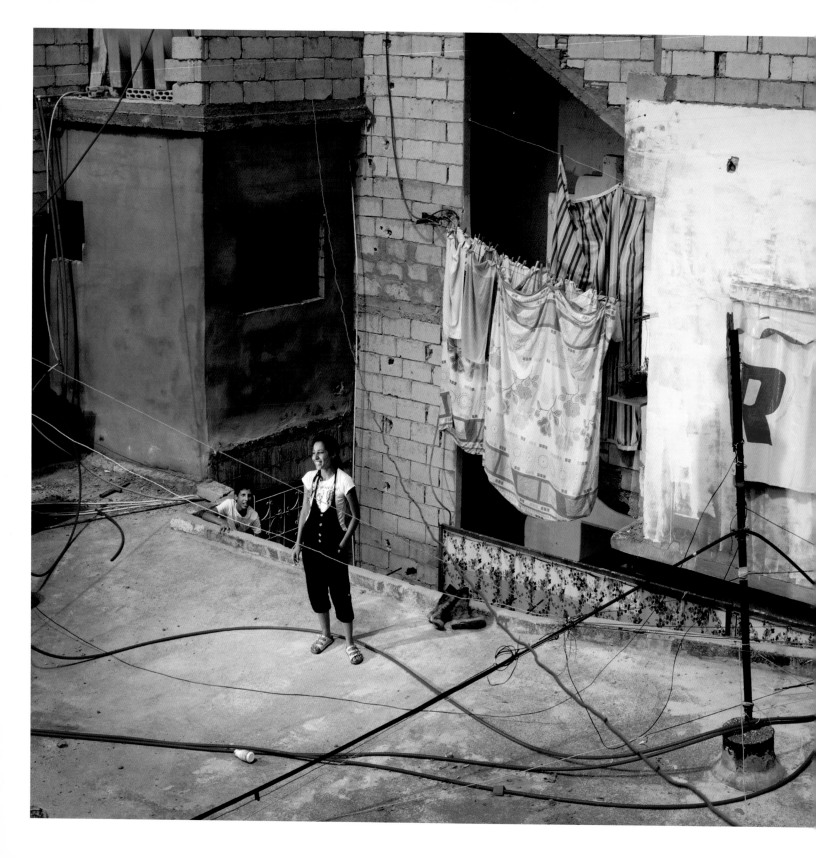

LINA KHOURY, 26

"I am always happy" is what Lina says about herself. It's hard to believe—unless you've met her. At twenty-six, Lina has already lived at least a couple of lives, while what she does for others has helped to cultivate dozens more. She is almost constantly in motion. In Beirut, a place where living is not always easy, she manages a rehab center, teaches French to children in the Palestinian refugee camps, and creates art projects for prison inmates. In her free time, she dresses up as a clown and does shows for the children at the Palestinian camps of Sabra and Chatila. (That's where I first met her and where I took her photo, just before she put on her costume.) On top of this busy schedule, she refuses to give up spending time with her friends from abroad or, for that matter, her couchsurfers. I don't know where she finds the energy to do it all.

Lina lives in a big house in Old Beirut, in the Ashrafieh neighborhood, comprising three bedrooms, a large living room, a kitchen, and a bathroom. It is always full of friends and guests. From there, they can look out the wide windows and watch neighborhood life unfold: women hanging their laundry out on the rooftops and children chasing cats in the courtyard.

Lina's openness is probably a result of her history. When she was sixteen, her parents, like all Lebanese who can afford to do so, sent her far away from her homeland (where, sadly, wars seem to come one after the other), to Geneva, to complete her studies. "I felt lonely and out of place," she tells me, "too far from the things and the people I love." So she decided to leave school and go to work, later enrolling in a course to become a children's entertainer. Finally, in 2008, she returned home to Lebanon, where she obtained a degree in educational sciences, and then a master's in social work, and eventually opened her own business with the goal of giving some happiness to the less fortunate.

"There are two kinds of people," she told me, "those who care and those who don't." Surely her participation in the couchsurfing community also reflects her giving spirit. By keeping a home large enough to host so many, she is constantly picking up more friends and, undoubtedly, combating the loneliness she herself used to feel.

SHENYANG
— CHINA

JOHN YENGEE SUN, 25, and LIU SI TONG, 23

When I arrived at the Shenyang home of John and Liu, their two-floor house was empty. There was no furniture at all, not even a mattress. They had just moved in, bringing with them only a bull's skull, two caricature-style portraits of themselves, and a couple of porn magazines, tossed carelessly on the kitchen counter. Space was not an issue for me during my stay, and neither was privacy, as the entire second-floor loft was mine. I slept facing the window, on my own makeshift bed, a layered construction of my T-shirts, looking out over a city where skyscrapers populated the night and the cement seemed endless.

That's the reason John came back to China. When he was seven years old, he and his family left Shenyang for California, where he eventually earned his degree in economics. "I remember, when I was little, there wasn't a single house more than three stories tall in Shenyang. Now there's almost nothing but skyscrapers and shopping malls," he told me in an English that made him sound more American than Chinese. Some of the buildings have gone up thanks to his company. When he first came back

to visit, he saw a golden opportunity. "In Shenyang, construction and expansion happen more rapidly than in any other Chinese city. That's why I decided to move back here and dedicate my energies to the construction industry."

Now he has a Chinese business partner with whom he owns a factory that produces bricks and other building materials. "I believe strongly in what I'm doing, and I'm certain that I made the right choice. I'm willing to bet that in a few years' time, we'll be rich," he told me with enthusiasm. Long before that happens, the house he shares with Liu will probably get a real bed for couchsurfers.

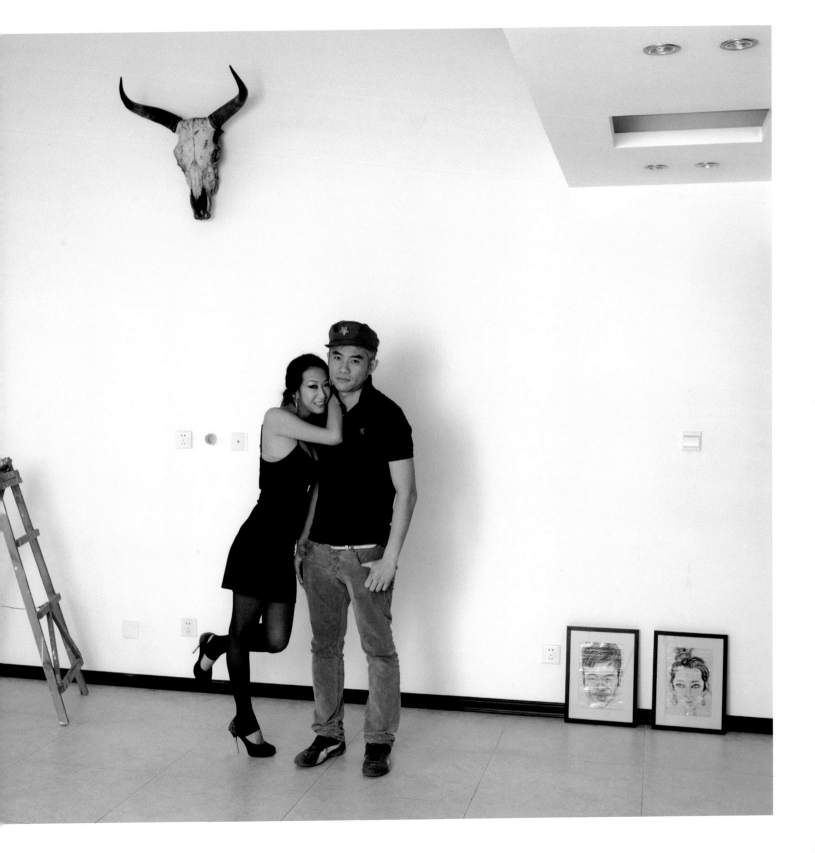

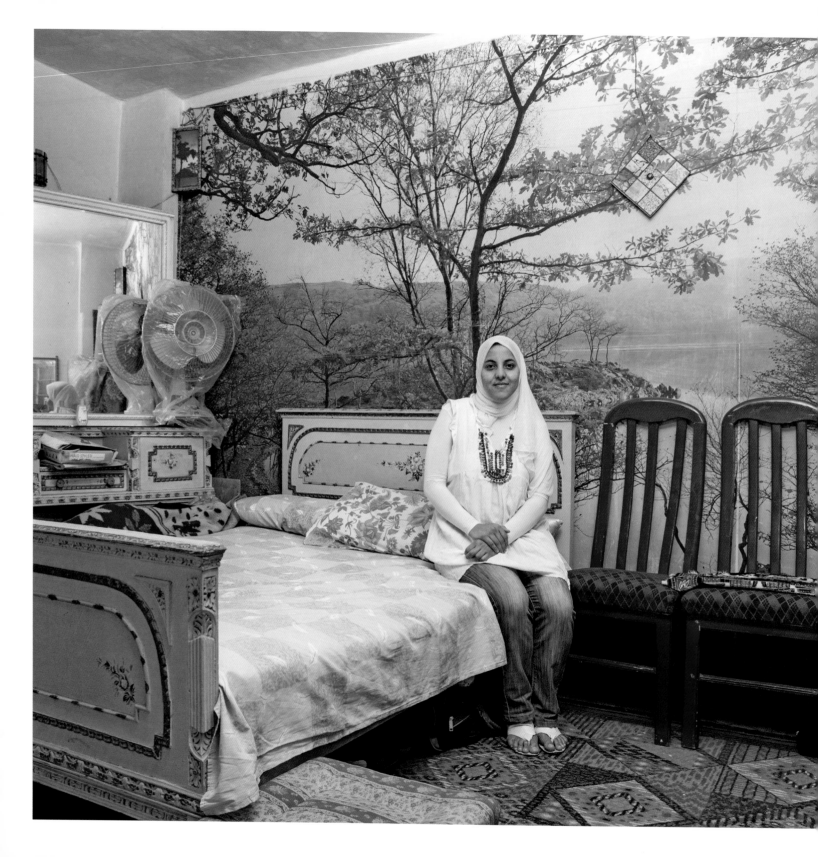

ENAS SHERIF, 22

Female couchsurfers aren't common in Egypt. Social and religious attitudes can restrict certain behavior. Nonetheless, Enas is one. She has a degree in computer science and a good job. She pays close attention to what is going on in the world—and the world is a place she'd like to know better. One of the most active members of the Cairo couchsurfing community, Enas participates in all their activities. That's how I first met her, when I was a guest in the home of Ali, a male Egyptian (see page 144). Ali took me to a get-together in which Enas and her Polish visitor were the only two women present. My curiosity was piqued, so I decided to spend some time with her.

Enas lives in a fairly large house nestled between markets and alleyways deep in the heart of downtown Cairo, the chaotic Egyptian capital. Inside her home, however, all is quiet and peaceful. Large carpets cover the floors of every room, and wide sofas invite you to sit down. There's a big table where Enas, her entire family, and I gathered the evening I visited to share her grandmother's famous noodle, rice, chickpea, and fried onion casserole. Enas hosts female travelers from all over the world. While she might spend a pleasant day talk-ing with male couchsurfers like me who are visiting Cairo, she doesn't invite us to stay.

Before the 2011 revolution, Enas worked for an airline. She was proud of her job, but with the advent of the global economic crisis, political instability, and the drop in tourism that followed, the company had to downsize. Enas was one of those who lost her position. When I met her, she was working at a shopping mall. It was a way to stay in touch with the world, though not to the same extent as when she was working at the airport. Being there had made her feel closer to what was beyond Cairo. A picture covering the wall above her bed shows a landscape of lakes unlike anything in Egypt, a testament to her dreams of see-ing that world.

WHITEHORSE
CANADA

IAN USHER, 47

Ian's story is so incredible that it could be a movie—in fact, Disney has already bought the rights. Meanwhile, you can read his story in his memoir, *A Life Sold*. Believe me, it's a page-turner. Here are the Cliff's Notes...

Ian is Australian. Once upon a time he lived in Perth with a wife he adored, in a house with every luxury. His perfect life fell apart the day he found his wife in bed with his friend. That's when he decided to sell everything on eBay. This was no simple auction of furnishings and bric-a-brac. Ian put his *entire life* up for sale: his job, his clothes, his motorcycle—everything that was part of his past. Then he made a list of one hundred things he wanted to do in as many weeks, and with the proceeds of the auction, he went for it.

"Race a dogsled in Canada" was number twenty-five. It could have been just another item on a bucket list, but instead it was the beginning of a new life—the one he was living when I met him. It was a pretty sled dog trainer named Moe who persuaded him to come back to Canada at the end of his trip. Their relationship would prove stronger than either cold or adversity.

In their home in the Yukon, they spend the very long winters without running water; with temperatures dropping to nearly minus sixty degrees Fahrenheit, it would freeze in the pipes. The first night I spent in their house, the stove went out after a few hours. I woke up, my face frozen, to find it was only forty degrees outside my sleeping bag. Staying with Ian and Moe was extraordinary; even going to the bathroom was an adventure. You have to use a hole in the ground outside the house, all the time worrying that a bear will show up—luckily, these come only in summer—or your legs will freeze. Ian and Moe keep basins of heated water indoors for basic needs, but to bathe or do laundry, they have to go to the nearest service station. While I was with them, we did a lot of activities together, including riding their dogsled, one of the most fun things I've ever done in my life.

Since my visit, Ian has persuaded Moe to move somewhere warmer—Panama. "The world is a lot smaller than I used to think," he told me, "and most important, it's chock-full of possibilities." Who knows? Their third life might be just around the corner.

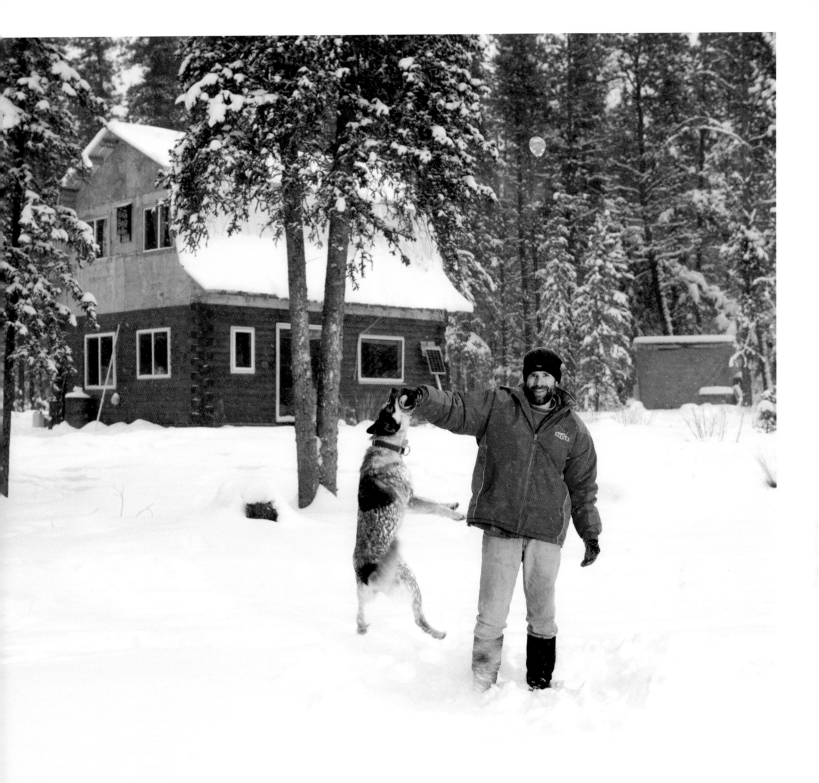

AIGLE
——
SWITZERLAND

CLAUDE BAECHTOLD, 42

Name an object, any object. Whatever it is, there's one in Claude's house. He'll collect anything—and has done so for decades. Hundreds of boxes of comic books, which have been accumulating since he was five, and pallets of pasta are just two examples. (He bought a whole ton of pasta once, convinced that prices in Switzerland were going to skyrocket. The pasta expired years ago, but he still eats it—and offers it to his couchsurfing guests (and no, I didn't get sick from it).

Stuffed into boxes and closets or crammed into the packed basement are books, nails, rolls of film, pieces of leather, statues, record albums, masks, bits of choreography written for the theater, paints, old appliances—anything and everything.

It's not all his. Claude's godmother spent ninety-seven years collecting tens of thousands of objects, mostly useless. He discovered them when he moved into this house after fifteen years of traveling the globe as a photographer and filmmaker, and he has cared for them lovingly ever since. Claude was twenty-five when his parents died, and Switzerland suddenly felt terribly lonely. To fill that emptiness, he began traveling the world, collecting experiences and adventures. He was living in a sunny house among the vineyards of the Rhône Valley when his godmother, whom he describes as "magnificent and very wise," fell ill. He decided to go back to Switzerland to take care of her, and her collection.

Alongside the worthless treasures she'd amassed over the years, Claude began adding pieces of his own life. He had come to realize, during his years of intense wandering, that "the more chaotic my surroundings, the better I feel." That sentiment has never changed. "This barn is like an island where I can breathe in the middle of all that suffocating Swiss tidiness," he tells visitors, who camp out on a sofa in his big house, carving out room among the odds and ends that cover every surface. "Sometimes my friends can't stand all the mess and [they] leave. As for me, I sit with my cheeky piles of stuff, defending my right to chaos and happiness."

DUBAI
UNITED ARAB EMIRATES

FAISEL NIZAM, 30

Faisel, wearing a dark, tailor-made suit, picked me up in downtown Dubai in his camouflage convertible jeep. Compared to all the men in their white robes, safely sealed behind their sedans' tinted windows, he looked almost like an alien. It's not altogether surprising, though, since Faisel, born in the United Arab Emirates, spent some of his formative years in the United States. His parents, hoping to make a businessman of him, sent him to Florida when he was seventeen. "But I hated school," he told me, "and I didn't learn anything in college. Everything I learned came from the wonderful people I met and the experiences I had."

Probably a few too many experiences, in fact, because when he was twenty-one, legal troubles led to his deportation. So, to his parents' great disappointment, Faisel ended up as a baggage handler at the Dubai airport. After a couple of years, he began to move up the ladder, and he now trains airport personnel. "I've changed. I have a lot of faith in the human race now," he told me—beginning with couchsurfers.

When he can't put them up, he still offers his time, as he did with me. He may be happier when his visitors are pretty girls—at least, that's the impression I got from clicking through the record of visits on his Couchsurfing.org profile—but he's equally hospitable when curious male photographers come calling. Then again, I did bring him a little luck with the ladies. After I'd had his photo published in a magazine in Italy, an Italian girl got in touch, insisting I put her in contact with him. Maybe he found a place for her in his apartment, a place filled with comic books, which he's been collecting since he was six years old. Today he has more than three thousand. "They're my most important possession," he told me.

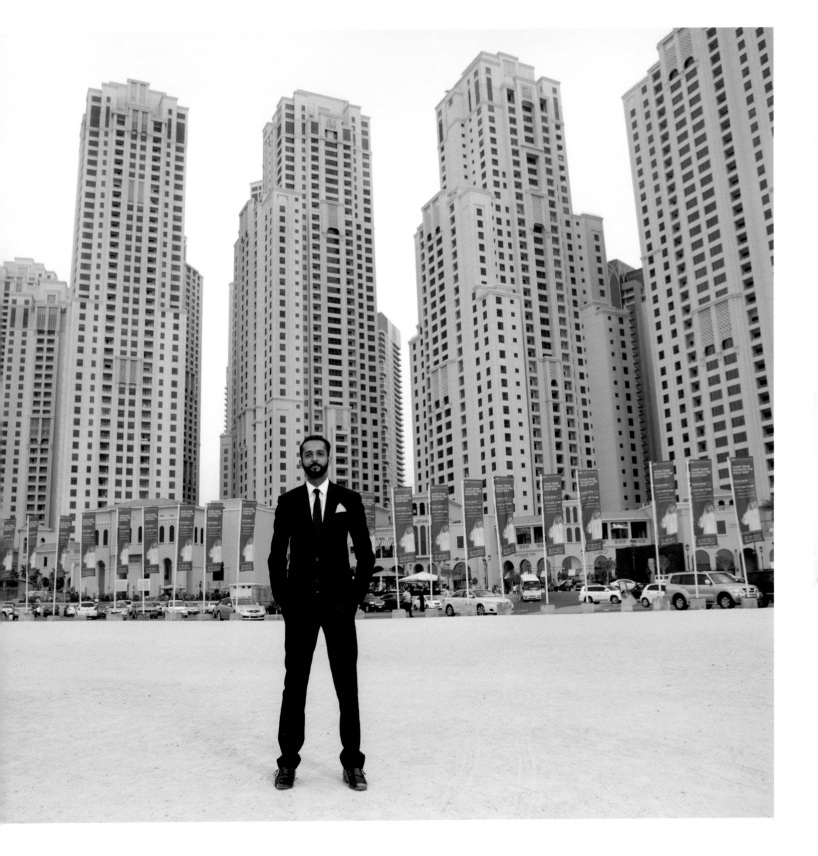

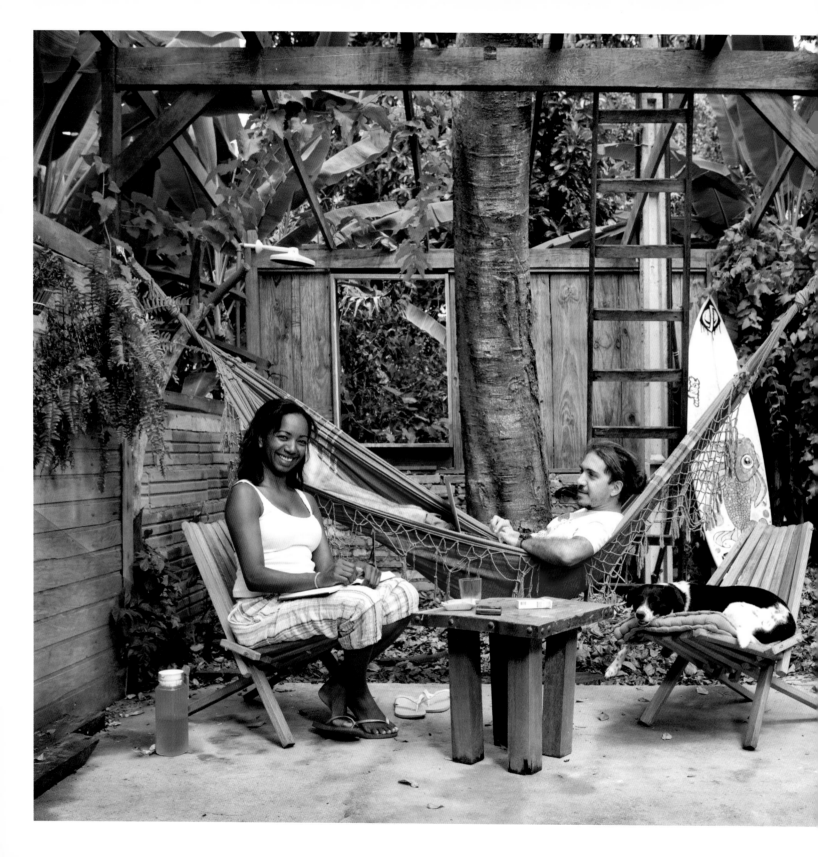

FLORIANÓPOLIS
— BRAZIL

NELY MARTINS, 35, and ANDREA BARCELLONA, 33

My stay with Nely, from Brazil, and Andrea, from Italy, was more of a reunion than anything else. Three years before I arrived on their doorstep in Florianópolis, I had hosted them as couchsurfers in my house in Tuscany. At that time, they were based in São Paulo, where they'd met while working on projects in the *favelas* for the same NGO.

Seeing them again in Florianópolis was a real pleasure, and not only because of the hours we spent cooking together and reminiscing about their trip to Tuscany. Their house, a wooden structure surrounded by green, is a haven for travelers—and for the soul. It is large and spacious, with a double bed reserved just for couchsurfers. In the portico hangs a hammock for lazily rocking, as Andrea is doing in this photo. "To me, the hammock is the most important thing in the house," Nely confessed to me.

Now, she and Andrea are both teachers. He teaches foreign languages, and she specializes in a new, experimental subject called edo-communication. At the time of my visit to Florianópolis, she was the only person teaching her subject in all of Brazil. In a nutshell, edo-communication deals with explaining face-to-face interaction to a generation that communicates only by means of cell phone, online chat, and social media. This hypertechnological transformation is a problem in Brazil, just as it is in many other richer (and poorer) countries.

Teaching the value of human relationships may be a mission in itself, but it is clear that Nely is meant to work with children. "I have a recurring dream of a little voice calling me 'Mama,'" she told me. The last time I saw the two of them, she and Andrea were doing all they could to realize that dream. We've kept in touch, and I know now that they have a daughter.

BUENOS AIRES
ARGENTINA

CARLA SGARBI, 26, and MARIANA BAYLE, 26

I waited in front of their house for two hours, maybe three. I was about to leave when Mariana finally showed up. Her justification for being late was a political demonstration downtown that she couldn't miss, not even for our appointment.

That's how I began my acquaintance with Mariana and Carla, the two couchsurfers who hosted me in Buenos Aires. Their apartment is a perfect reflection of their personalities and political commitment, and of their easygoing natures. Its three rooms are full of objects heaped up into mounds of creative clutter. It's cozy, in its own peculiar way. In their tiny bedroom, two bunk beds keep company with just about everything else imaginable, from a marijuana plant proudly displayed on the dresser to a vacuum cleaner stowed beneath a bed. Clothes are strewn about the room, along with bottles, bills, boxes of books, and bagfuls of . . . well, who knows? Between the beds is a single mattress where couchsurfers generally sleep. I, however, was lucky enough to have the living room sofa (usually occupied by Mariana's brother) all to myself.

Mariana and Carla are the sort of best friends who have known each other since they were very small. They grew up in the same neighborhood, their parents were friends, and they played together since they could walk. Back then, one was quite chubby and the other was too thin (although today it's impossible to tell which was which). This worried their respective grandmothers. Carla, who has a degree in law, is an activist in the Partido Obrero, a party on the extreme left, while Mariana is getting her degree in political science and hopes to join her friend soon. They are kind and friendly, and we had a very good time together during my stay. They showed me around the city, taking me to eat famous Argentine beef and even to dance the tango—though I wouldn't say I have a talent for dancing.

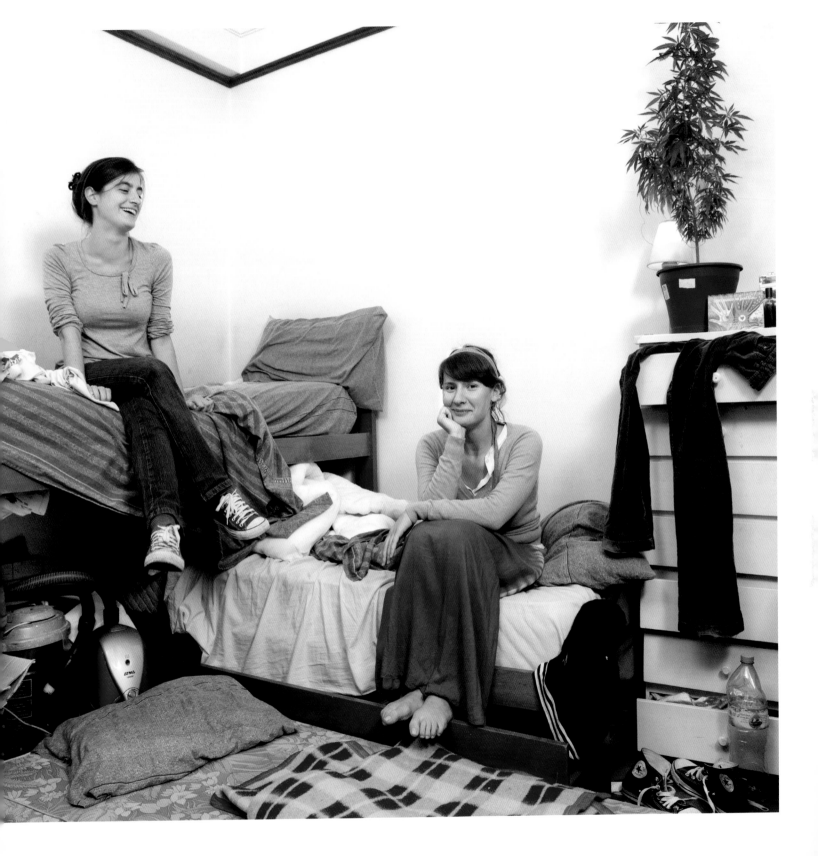

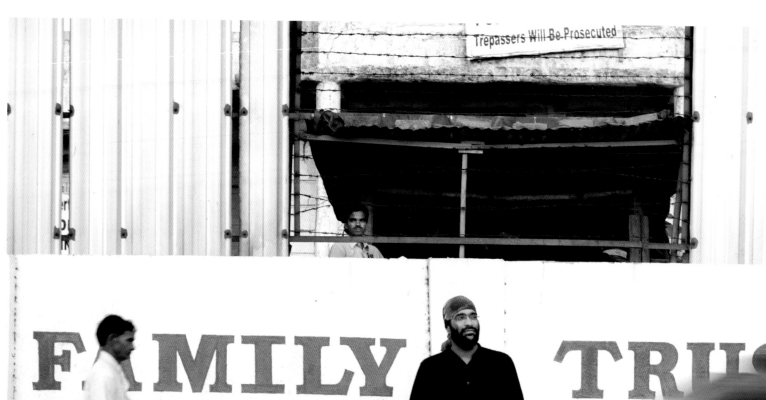

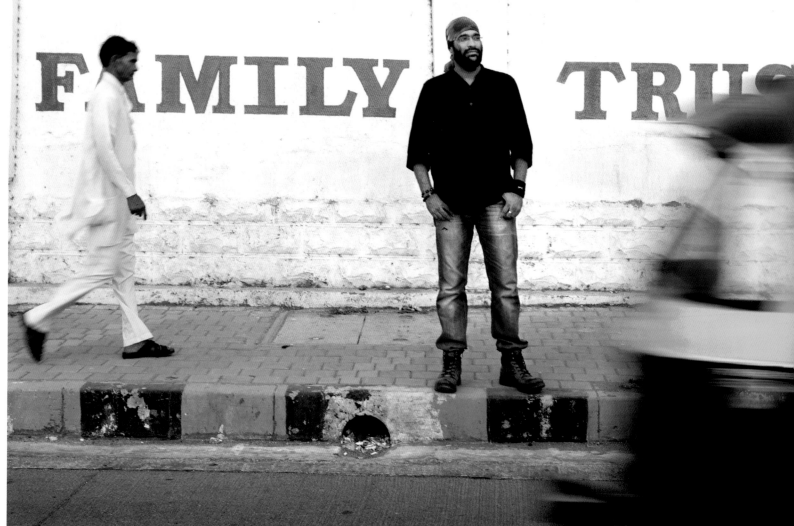

MUMBAI
INDIA

MAHENDER NAGI, 31

Maybe in a few years the song will become a hit and I'll have had the honor of being the one to whom it was dedicated. It's about couchsurfing, and Mahender wrote it especially for me. Mahender is the Sikh couchsurfer in whose company I spent two intense days exploring Mumbai. He is also a Bollywood actor and producer, a local celebrity, and a man who expresses his love for the world through a deep and abundant spirituality.

Not being able to host couchsurfers upsets him, but he still lives with his family, who won't allow it. He makes up for it by devoting a lot of his time to travelers passing through the city. I spent two days with him and felt as if I were hanging out with a star. Everywhere we went, someone stopped to say hello or even to embrace him. Mahender is very proud of his little bit of fame. He considers himself a representative of the Bollywood export market.

He told me his second life began when he quit the advertising agency where he had been working up to eighteen hours a day, sometimes not going home for days on end. After a break, he went back to work with renewed energy, this time at a Web TV channel, through which he made a lot of contacts in the local movie business. The next step was to move on to a traditional, national television channel, of which he became the director. After that, he finally took the leap into the world of cinema. He has written and produced his first movie and is currently working on his second. It's no accident that as soon as we met, he wanted to take me to the cinema where his film had premiered. Truthfully, it wasn't a great success, but Mahender doesn't let that discourage him—or perhaps it just doesn't bother him. "I don't need anything else to be happy. I've already been lucky enough," he explained.

Whether or not he becomes the Indian Brad Pitt, I'm still proud that he wanted to dedicate a song to me.

XI'AN
CHINA

BAI YONGLIANG, 28

Bai lives in Xi'an, the Chinese city famous for its Terracotta Army. His little room holds his story: it is as minimal and disorganized as Bai's ambitions are grand and clear. After obtaining a degree in languages, Bai decided also to study international communications. His hope is to get a good job that will allow him to travel the world. His family refused to pay for school, so Bai had to ask a friend for a loan. He now owes thirty-five thousand yuan (about fifty-six hundred U.S. dollars).

Bai studies from Monday to Friday, and on Saturdays he gives private English lessons, which earn him about two hundred yuan (approximately thirty-two dollars) each week. He uses most of that to pay installments on his debt, and not much is left over. That's why he lives in a room in a student residence near the university. It is home to about twenty people, all of whom share a single bathroom.

Obviously, the sanitary conditions were not the high point of my visit, nor was comfort. Bai's room is almost bare. Its only furnishings are a bed, a box containing a few personal items, and a backpack overflowing with clothes. For two nights I slept next to Bai's bed on a yoga mat covered with layers of blankets. It wasn't the most luxurious arrangement, and yet I was the fourteenth couchsurfer to use it. Ever since he discovered the existence of the website, Bai has been a very active member. He loves to have guests with whom to practice his English; and from each one, he learns a little more about a world he hasn't seen much of but longs to explore. "My dream is to have a business partner and to speak French well," he tells me.

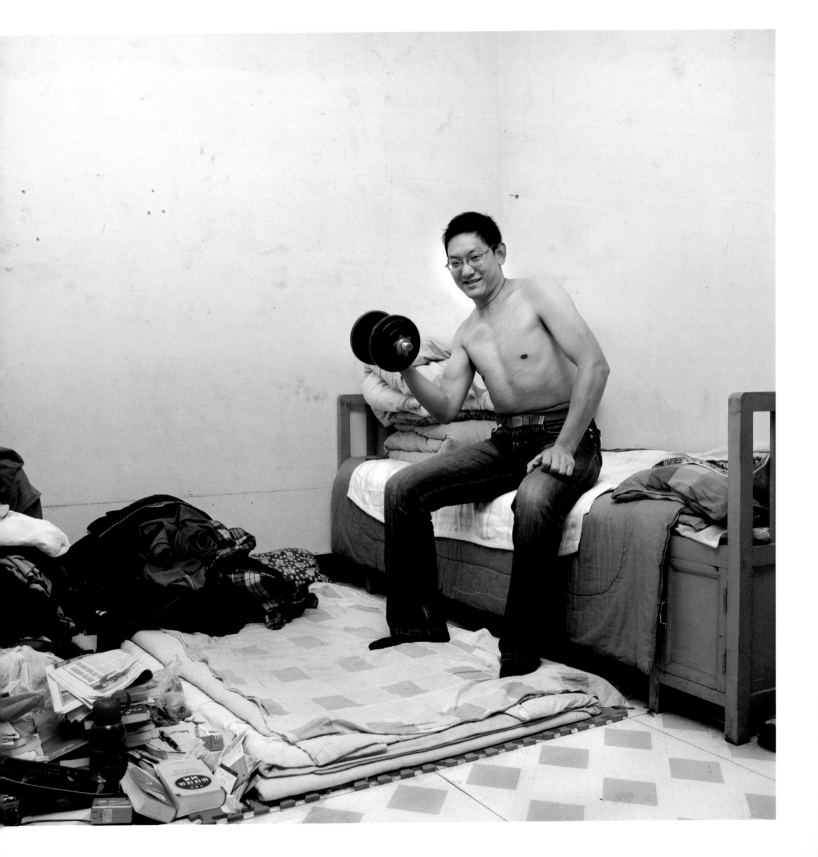

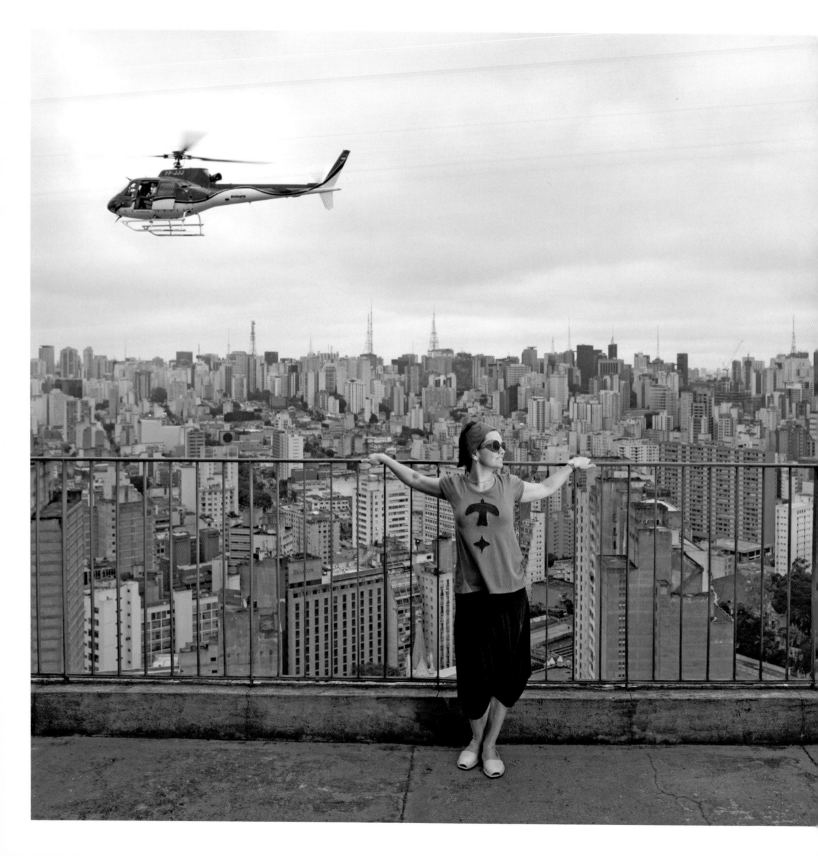

SÃO PAULO
—
BRAZIL

LETICIA MASSULA, 41

For a decade, Leticia, in her capacity as a "feminist lawyer," as she puts it, worked to improve conditions for women in Brazil—until she was struck down on the road to Damascus, so to speak. In her case, it was the road to the kitchen.

Cooking is a passion she inherited from her grandmother but hadn't taken seriously until, as she told me, "I started to really cook and chose not to stop." Several years ago she started a blog that is now one of the most widely read in Brazil.

Leticia's roots lie in Minas Gerais, one of Brazil's many states. Its landscape is lush and unspoiled, so when she arrived in São Paulo, her first impression of the city was as something very much like hell. She was shocked by the grayness of São Paulo. In fact, the golden beaches that people usually imagine when they think of Brazil don't exist. There are instead endless expanses of concrete skyscrapers, while the buzz of insects from her home state had been exchanged for the noise of the helicopters the wealthy use to fly above the city's infernal traffic. Now, however, she couldn't live without it. She loves her city and its contradictions, so much so that I chose to photograph her on top of one of its tallest skyscrapers.

Still, nature lives on in her kitchen. She has also, quite literally, restructured her life around it. Hers is the pièce de résistance of the house where she lives with her husband, Marcelo, in Vila Madeleina, São Paulo's youngest and most colorful neighborhood. It is an immense room, its brightly colored walls lined with shelves stocked with jars and bottles of every kind of herb and spice imaginable. On the counters, fresh vegetables spill out of bowls and baskets. These are the ingredients for the delicious dishes she prepares for lucky couchsurfers, and for the many strangers who sign up on her website and reserve a place for dinner in her parlor. It is clear that Leticia's quest for new flavors and her love for the fruits of the earth represent a return to her past.

LES CAYES

HAITI

SABALI MESCHI, 33

On the roof of her house, Sabali and her partner have built an outdoor cinema, or the closest thing you can find to one around here. Every week, they invite their neighbors over to watch a movie, usually in French. Some films they manage to find on DVD, but most are downloaded from the Internet. A few chairs, wicker love seats, and hammocks provide seating; a white sheet serves as a projection screen. This improvised cinema perfectly conveys their desire to create a rapport with their neighbors. Sabali was born in Tuscany to an Italian mother and a Beninese father. "In Italy, I was always the black girl. In Africa, I was white. Here in Haiti, I'm just a 'sister,'" she told me.

Work brought her here. She's an agronomist, specializing in tropical crops, and is heading up a program to relaunch Haiti's coffee industry. (The country used to be famous for growing and selling coffee, but production has fallen off in the last thirty years.) One day, she took me to see where she works, amid the groves of coffee trees clinging to the mountain slopes. She and her partner have explored the most remote corners of Haiti together. While I was with them, they brought me on long motorcycle rides through wild landscapes and down muddy, rutted roads. More than once I closed my eyes, praying nothing bad would happen to us along the way.

Sabali and her partner live in a big single-story house with a vast kitchen and a large central room where most of the household activity takes place. They enjoy cooking and usually have guests around. In the garden surrounding the house grow mango, papaya, banana, tropical almond, and other exotic trees whose names I can't recall but whose fruits we ate for breakfast. When Sabali rented the house, she learned that security guards would patrol her home day and night. It seems that, in Haiti, this is more a necessity than a nicety. Still, I found it a little shocking. My hosts explained that in order to adapt to a local culture, foreigners sometimes must behave how locals expect them to, and that includes having such protection. Later I noticed that the guards were unarmed, and that their biggest task seemed to be maintaining "backyard security"—that is, watching over chickens, goats, sheep, a horse, and a cow.

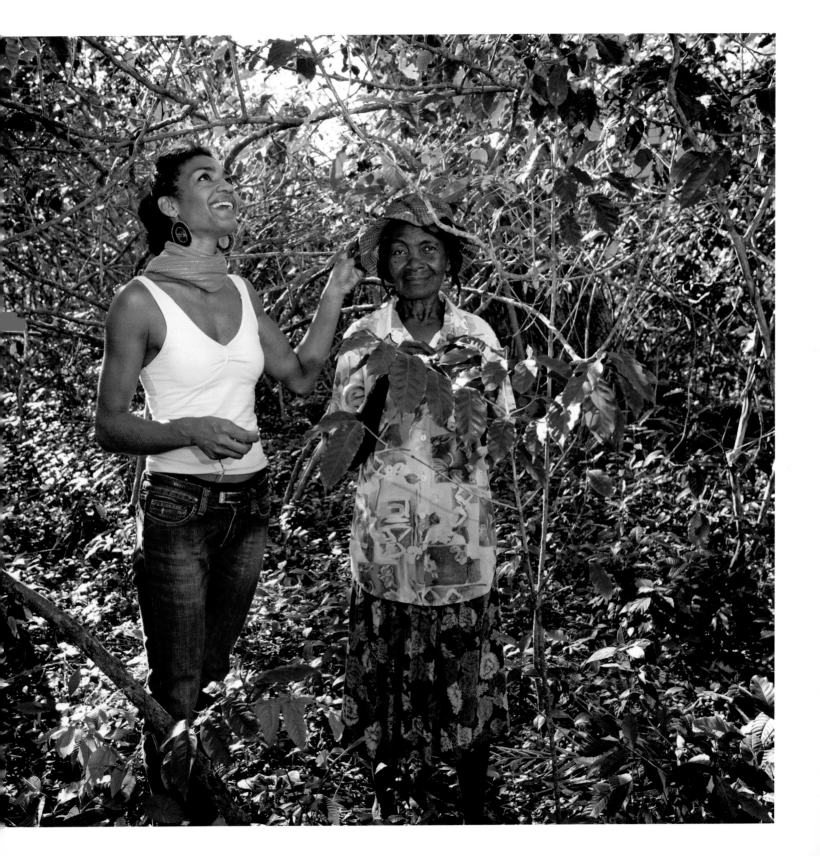

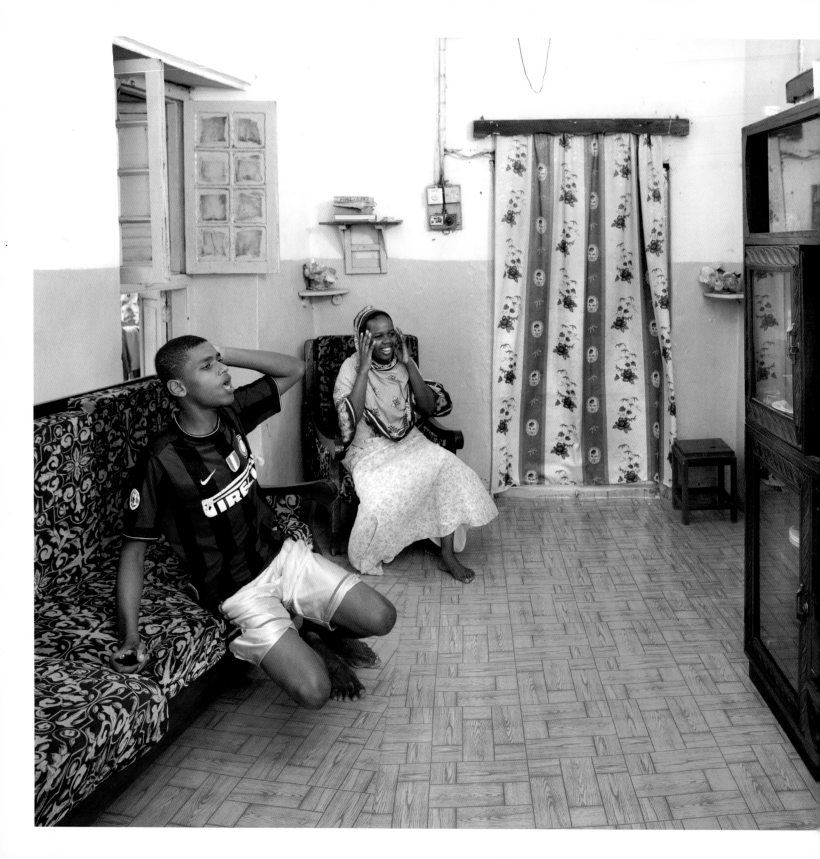

ZANZIBAR

—

TANZANIA

MOHAMMED AMID, 20, and MOSSI AMID, 22

The happiest day of Mohammed's life was when his parents brought home a satellite antenna. He no longer had to go to the café to watch soccer games, and instead, could enjoy those ninety minutes of joy and suffering from the comfort of his own couch—a frugal couch, but a couch nonetheless. When I visited his home in Zanzibar City, he sat me down next to him to root for Inter Milan, the Italian team he loves madly. Despite my origins, I didn't bring him any luck. They lost—as you can tell from the look of dismay he's wearing in this photograph.

One defeat, however, can't shake Mohammed's faith. In his bedroom, on the upper floor, almost all I can see in the closet are black-and-blue-striped jerseys, like those worn by the Inter players. Soccer is, after all, "the thing that's worth having pride in," Mohammed told me. His home is one of the richest I saw during my travels in Africa, despite the fact that it contains nothing that, to a Westerner, would signify wealth.

Mohammed has dragged his older sister Mossi into fandom. She watched matches with him, but she informed me that, for her, the antenna serves a more important purpose: "Perfecting my English." When the television, located in the hallway between the living room and the kitchen—where their mother always seems to be cooking something—isn't being monopolized by her brother, Mossi makes the most of her chance to watch foreign films. The TV also fuels her dream of traveling to faraway places, such as the United Kingdom. "That's where I'd want to live if I weren't here!" she told me.

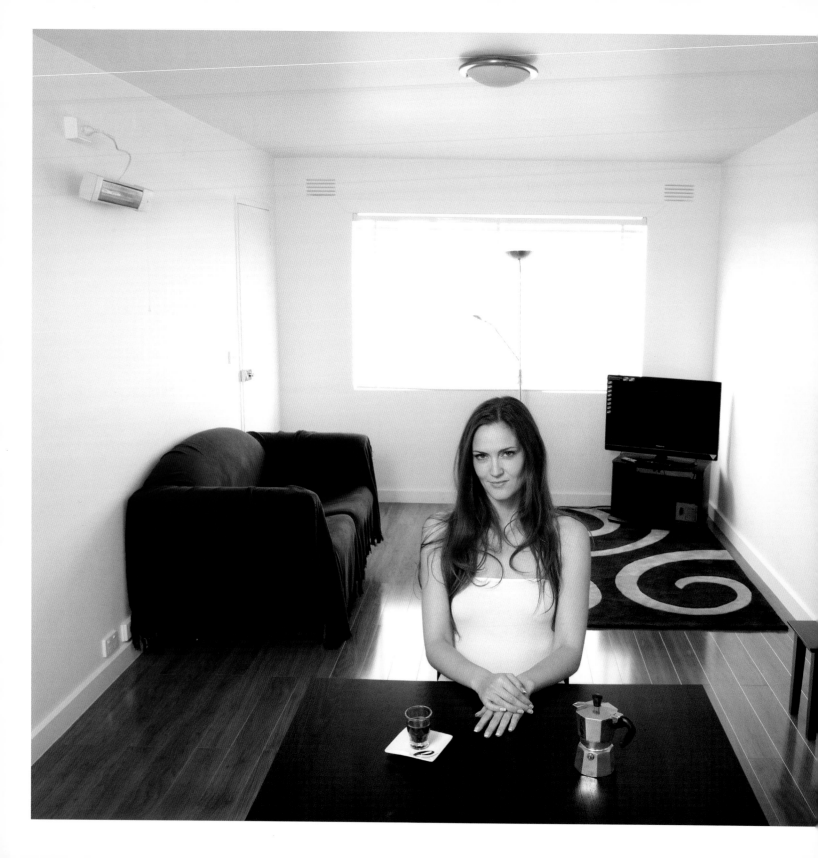

MELBOURNE
AUSTRALIA

DEBORA BARBAGLI, 30

Bizarre things can happen when you travel the world as a couchsurfer. During my travels, I found myself in Melbourne, on the opposite side of the world from home, as a guest of a former aspiring Miss Italy. It gets even weirder: Debora is from a town practically next door to mine.

At age fourteen, Debora decided she wanted to be a model, and after just one time on the catwalk, she knew she loved it. She won a regional contest and by age nineteen was competing on a national level. Although she didn't win, she could have continued. Instead, she says, "One day I thought about what I was doing with my time. I realized that I would never become a model, so I enrolled in university."

The rest of her story is about a series of successes. She has studied languages and traveled the world—initially in the company of a boyfriend, now an ex. It was after their breakup that she made her big move to Melbourne. Now she works for a transportation company, where she's made a great career for herself, one that often places her in exalted social circles. She even took me to an Italian diplomatic dinner during my visit.

Debora's home has pristine white walls, spare furnishings, and very few knickknacks or decorations. With its single bedroom, living room, kitchenette, and bathroom, it's not a big apartment, but it seems tailor-made for a career woman. I slept on an air mattress that she keeps for couchsurfers. When I offered to make a roast chicken with potatoes (a typical dish in our part of Italy), I noticed that Debora's oven had seen very little use. Still, like any self-respecting Italian, she has a stovetop coffeepot (or *moka*, as we call it), which she puts to great use; a whole lot of clothes and numerous photos also remind her of her Italian past. "Things go the way they're meant to," she says. This idea goes hand in hand with another of her sayings that is very Italian in nature—or at least I like to think is: "If you smile at others, then others will smile at you."

TIRANA

ALBANIA

FERDI BANDA, 33

Of the many things Ferdi taught me, one really sticks in my mind: you don't have to be wealthy to understand generosity. During my five days in Tirana, Ferdi treated me with the utmost consideration. He found me excellent lodgings, which he believed to be more comfortable than his own home. He showed me all around the city, took me to see the most beautiful sites, and wouldn't let me pay for a thing.

Ferdi was born and raised in Tirana, in a very Catholic family. All his actions and life choices have, in one way or another, followed the teachings of his religion. He told me proudly about how he first served as an altar boy during Mass one day in 1990, after the fall of communism. Once grown, he "enlisted" in the society founded by Padre Monti, an Italian missionary, and has since done a lot of work in the refugee camps in Albania. More recently, he began working for an Italian humanitarian organization that was setting up a project at the Faculty of Medicine of the University of Tirana.

Ferdi currently manages the office responsible for assisting visiting profes-

sors. He put me up in their lodgings (after obtaining proper authorization, of course). Basically, instead of the couch in his simple but dignified home, he offered me a place very much like a hotel, with a room and private bath all to myself.

During my stay, we spent a lot of time talking. He told me about the election of an artist, Edi Rama, as Tirana's mayor. (In 2013, Rama became Albania's prime minister.) During Rama's tenure, he covered the city's big gray buildings with colorful original artworks. Choosing one of them as a backdrop for my photo of Ferdi seemed a proper tribute to the place he loves so much.

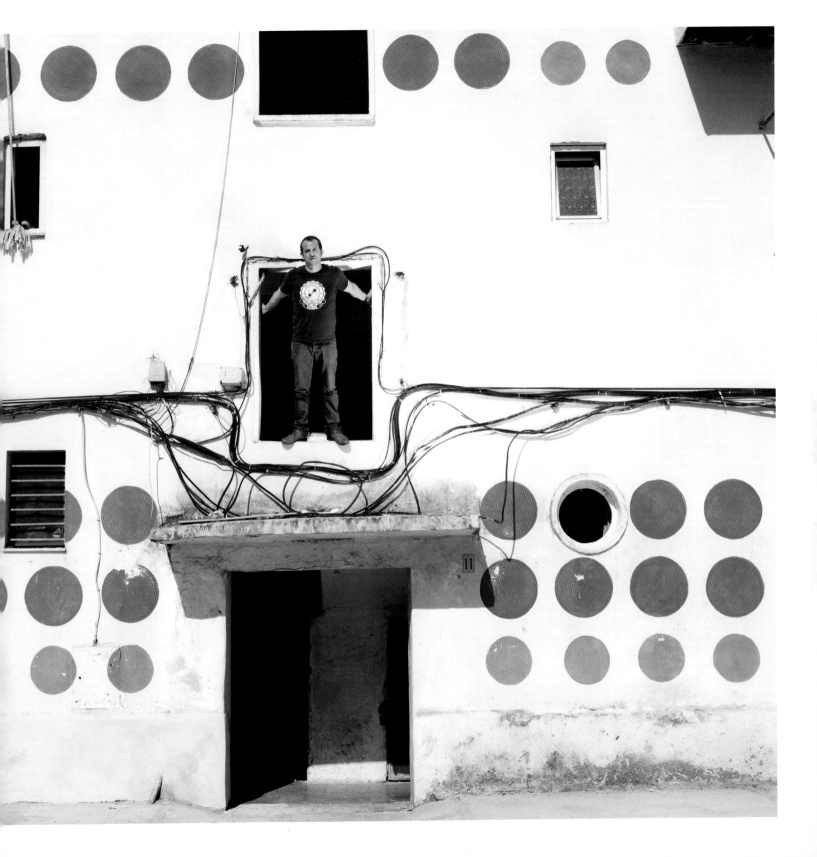

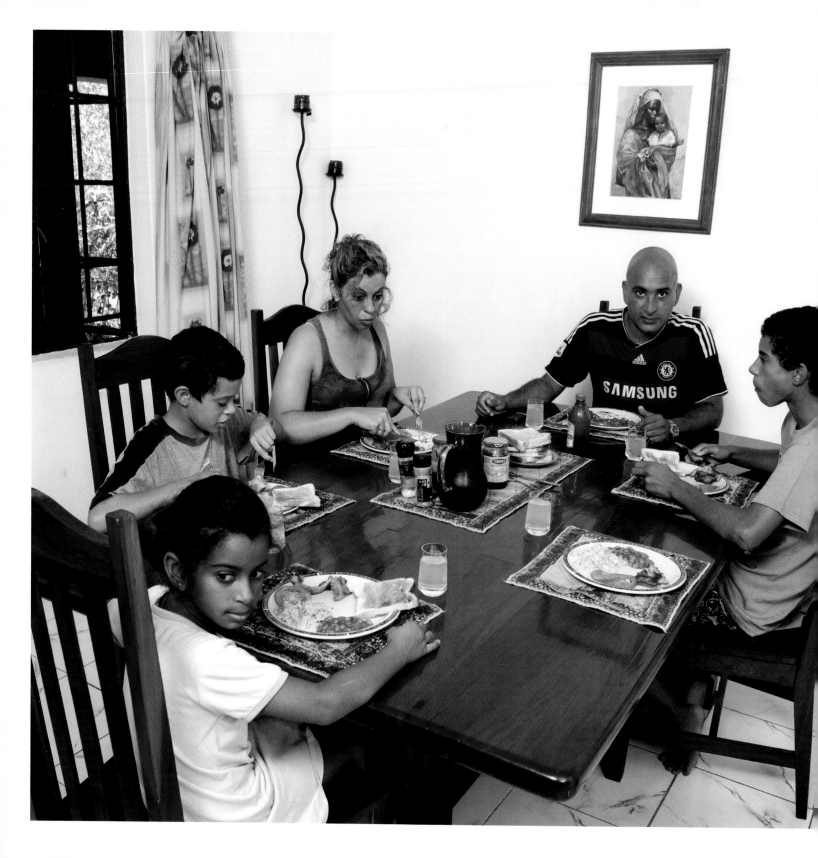

VICTORIA FALLS
—
ZIMBABWE

RYAN DHANA, 39, and FIONA DHANA, 41

My arrival at the home of Ryan, Fiona, and their three very happy children began with the delightful surprise of a private entrance to my bedroom and a bathroom just for me. Not only is their house just a short walk from the magnificent Victoria Falls, but it is also large and pleasant, with a lovely garden, a multitude of plants, and two guard dogs—well, one; the smaller of the two is more friendly than fierce.

Ryan and Flora work in the tourism industry. They both come from Harare originally, and their blood is a mixture of Scotch, Indian, and Irish. They moved near the falls because "it's the place where you can make the most money from tourism." Ryan is a real businessman. He left Zimbabwe at age twenty to work in finance in London, but moved back suddenly a few years later. Why? He had fallen in love with Fiona, the sister of the bride at his brother's wedding. Their marriage was the second knot tying their families together. Theirs, however, was the only one that would last.

Ryan and Fiona's three children are close in age: Jordan, Ethyn, and Amani, fifteen, thirteen, and eight years old, respectively. The three attend a boarding school two hours from their home. It's therefore rare to find the whole family gathered around the table, or even the children underfoot in the kitchen. When it does happen, though, it's always a party. I was lucky to be there during the school holidays, so I was able to see this for myself.

DALLAS
TEXAS

VANESSA PETERS, 32

Vanessa and I had been surfing couches together long before I ended up on the one in the foyer of her house in Dallas. In fact, she and I had traveled the length and breadth of the southern and midwestern United States. Our friendship began in 2001, when she came to Tuscany at the age of nineteen as part of a University of Texas exchange program. That's when she fell in love with Italy. For years she divided her life between there and the States. In fact, she still rents a home in Lucca.

Vanessa's a singer, and for a couple of years I was a member of her band, Vanessa Peters and Ice Cream on Mondays. With the exception of Vanessa, everyone in the group was Italian. When we toured the United States, we often depended on the hospitality of couchsurfers. Sometimes the whole band slept in one house. To repay our hosts, we would improvise concerts—which always ended up turning into very long parties.

Nowadays Vanessa gives back by offering travelers her own couch. When I knocked on her door during my trip around the world, she was in the process of recording a new album with her husband, who's also a musician. They've built a small recording studio in their home in Dallas—and in the one in Lucca—where they develop their albums before recording them in a professional studio. I hung out with them for a while, doing some strumming of my own while they worked.

Vanessa says her best quality is that she's "a pretty reliable friend." I'll testify to that.

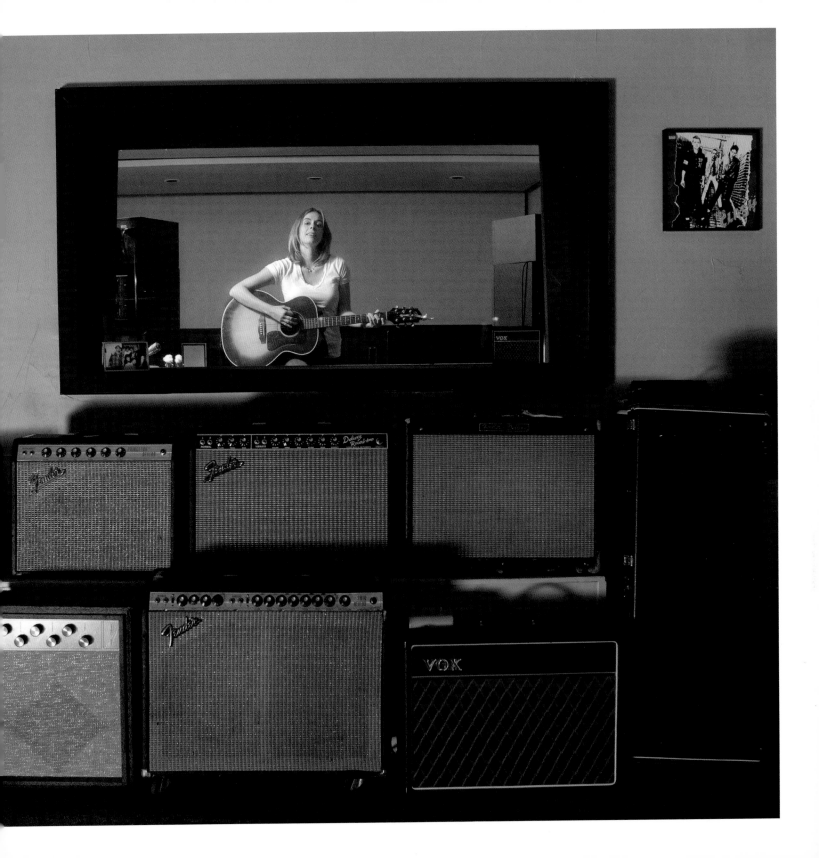

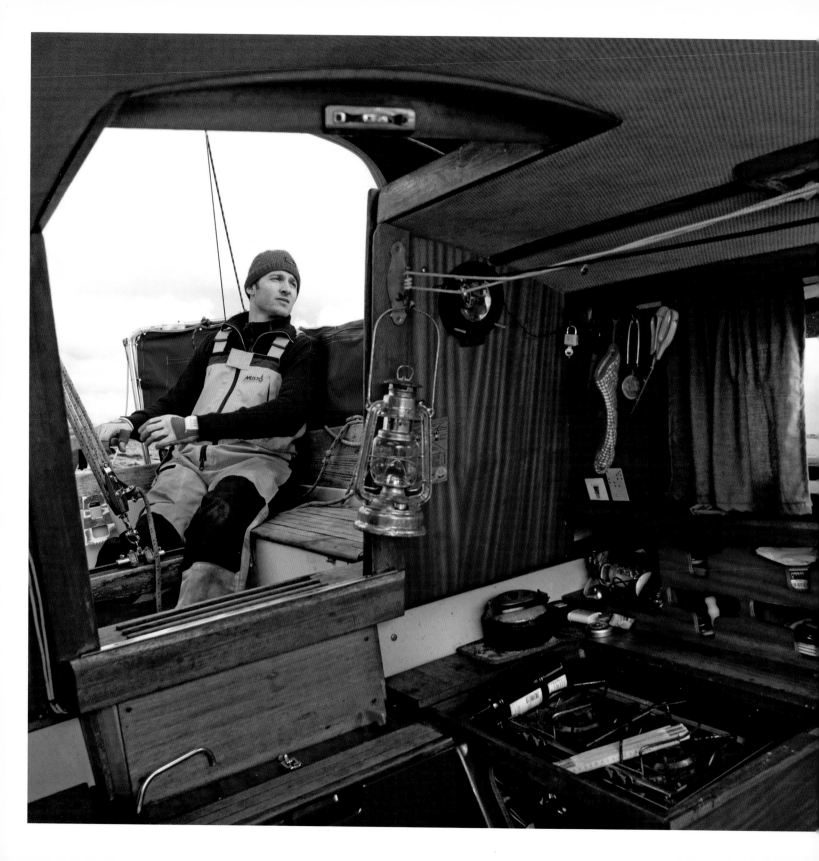

BERGEN
—
NORWAY

ANDREAS BACKER HEIDE, 31

Andreas hosted me in a little wooden cabin in the stern of a sailboat cutting through the Norwegian fjords in Bergen, a city on the country's western coast. We spent our days fishing (sadly, without success) in the winter cold of the Norwegian Sea. It was couchsurfing out of an adventure story.

It's fitting, as Andreas is, after all, the quintessential adventurer, the sort who fears nothing and lives in harmony with nature. Born near the sea in 1980 and active to the core, he has devoted most of his energy to the water. When he was younger, he enlisted in the Norwegian navy and spent two "wonderful years" during which, he says, "I found myself." He then had a long stint as a biologist at the country's Institute of Marine Research, a job that allowed him to travel the world and devote a lot of time to his favorite pastimes: sailing and deep-sea diving. His compass always points north, and his weather forecast never fails to be icy. When I was his guest, he had just quit his job and was planning a six-month sailing expedition to Greenland with some friends.

Andreas has a house on dry land, too. I spent two nights there before asking him to take me sailing on the fjords—when he told me he had taken other couchsurfers out on the water, I couldn't resist. Not that I didn't enjoy experiencing his life in Bergen. On the contrary, his apartment is new and comfortable; he is surrounded by friends; and he loves to cook. In fact, during my stay, we took turns preparing our best fish specialties for each other. Of everything we did together in Bergen, going to bars and clubs was the most amusing. Maybe it's because of Andreas's *physique du rôle*—ladies tend to fall at his feet. Indeed, a guy out on the town with Andreas runs a high risk of ending up as a fifth wheel. That may be one reason he likes to host couchsurfers on his boat, where he can devote more attention to them without unexpected female intrusions, pleasant as those might be.

CAIRO

EGYPT

ALI HASSAAN ALI ELARABI, 26

The best thing about Ali's home is the welcome: very friendly and accommodating. His three-bedroom apartment, situated in a neighborhood in the eastern part of Cairo, is not for the squeamish, however. Sanitation is not high on the list of priorities. Ali splits the rent with a friend, and one of the bedrooms doubles as a living room. Two mattresses on the floor there provide hospitality for a number of couchsurfers, not many of whom are bold enough to test out the kitchen. The stovetop's two encrusted burners haven't seen a sponge in a very long time. (I, for one, ate every meal out during my stay.)

Hygiene aside, the time I spent with Ali was very pleasant. He is, as he loves to call himself, "a modern Egyptian." He left his parents' home at the age of eighteen to move to Cairo, where he worked for a few years in his aunt's pharmacy. Eventually he found a job as a pharmaceutical rep. He earns commission and always exceeds his quota, an achievement he is understandably proud of, just as he is of putting on a suit and tie every morning.

Ali's life outside work is full as well. He organizes meetings and social events for Cairo's couchsurfers, of whom he has become a sort of unofficial leader. During my stay, he took time off work to show me around. We went to see the Old City one day, and on another, to a gathering of local couchsurfers. They were all men, with the exception of one woman whose home I would visit, though not stay in, a few days later (see page 113). We had a cookout under the hot sun, a water-balloon battle, and a mini soccer match, during which Ali showed off his formidable skills on the field. Good, he conceded of his skills, "but not good enough to make me a professional soccer player," he said, "even though that would have been my dream."

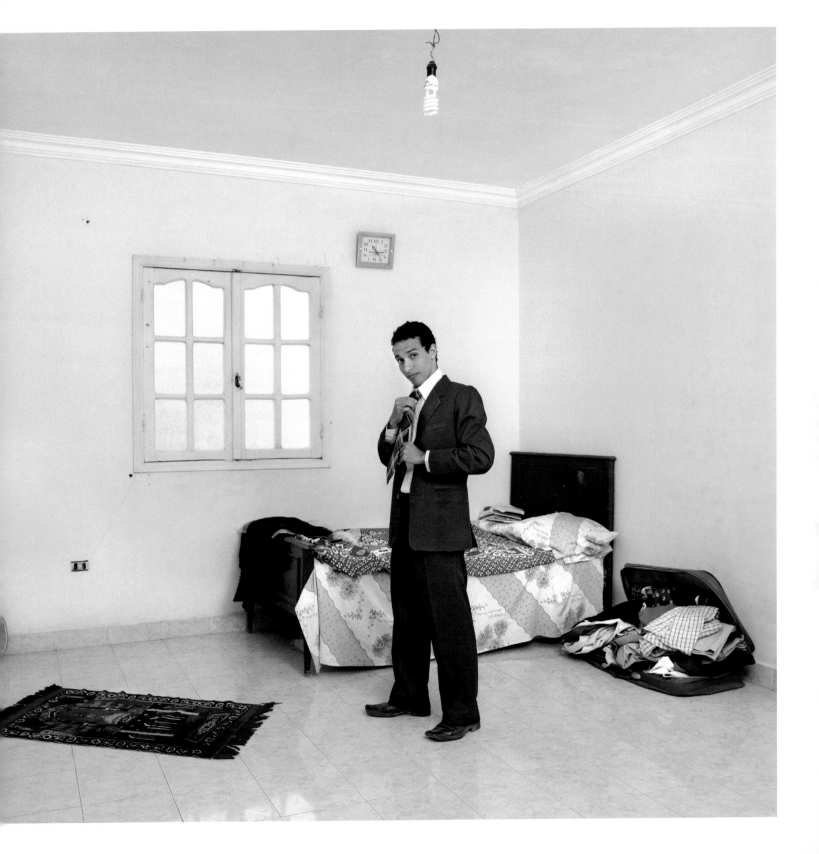

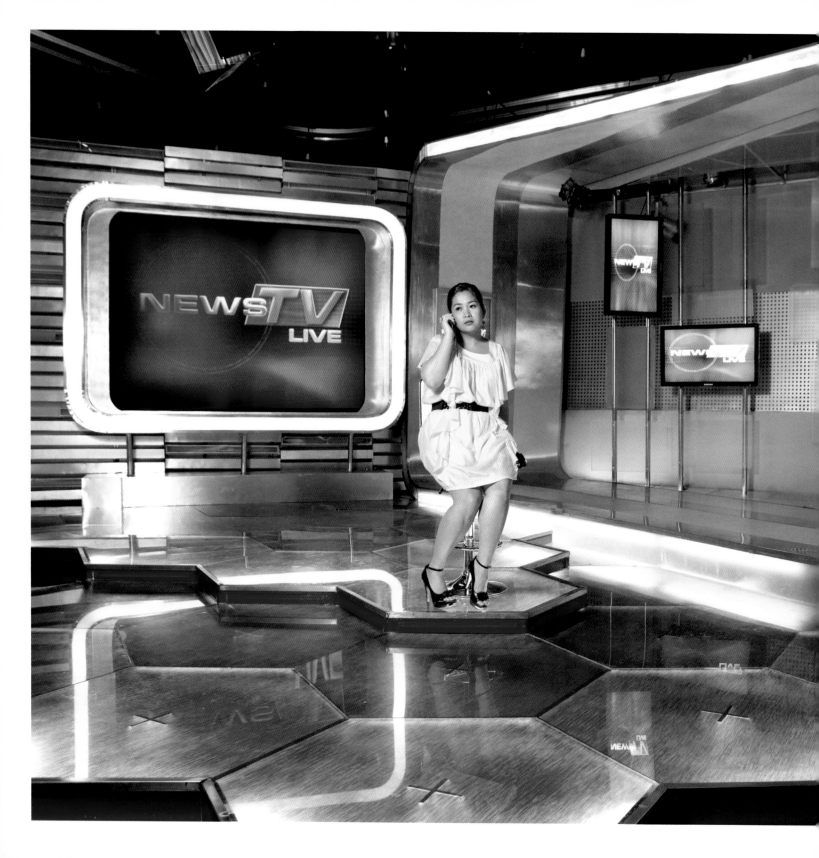

MANILA
—
THE PHILIPPINES

BRENDA FERNANDEZ, 33

Her name is Brenda, but her friends and colleagues call her Little Miss Sunshine because of her positive outlook on life—and her life is far from ordinary for a woman from the Philippines.

With a successful career at one of the leading television networks in her country, she earns a good salary and enjoys her independence. She climbs mountains and volcanoes, swims with whale sharks, bungee jumps, and skydives. Her favorite sport is boxing—you don't mess with this girl in the ring if you know what's good for you.

Brenda is also a free-spirited traveler, which she sometimes does alone—she has been to more than thirty-five countries. Her home, a large apartment on the top floor of a skyscraper in one of Manila's central neighborhoods, holds mementos of her explorations around the world: Charcoal paintings from Myanmar hang alongside an antique mirror from Iran and hand-painted masks from Bali. In the living room, books and hookah pipes speak of her travels throughout the Arab world. A huge sofa beneath the large TV turns into a bed for couchsurfers.

Despite her busy work and social calendars, Brenda devotes a lot of her free time to her visitors; she shares not only her home, but also her stories about her life, adventures, and relationships. While I was there we went out to dinner together to a few nice restaurants. She took me swimming in her building's private pool and even on an excursion outside Manila, to a volcanic crater lake.

Brenda is confident when she talks about herself, and knows very well the type of person she is. The fact that there's no man in her life doesn't worry her. "Romantic love is important, but it's not everything. I am surrounded by family and friends who love me. I'm happy being single because I can do all the things I want to do." Every year she sets new goals for herself and achieves them. What's the greatest lesson the world has taught her so far? "Believe in the power of kindness," she told me, "and never lose faith in humanity.

KALULUSHI
ZAMBIA

TAVARIS NGALANDE, 29

Three hours on a propeller plane, eight hours on a bus with no air-conditioning, and one hour in a minivan driven by a nun, I finally, exhausted and slightly dazed from my journey, was able to entertain the red earth around the village that is home to Saint Joseph's Mission, a facility for the poor and sick in northern Zambia. It doesn't see many foreign visitors. It's not so much a tourist destination as a place for those who want to devote their lives to helping others. Tavaris, my host and the only couchsurfer in this part of Zambia, is one of those. The village has extremely high percentages of malaria and HIV/AIDS victims. A doctor, Tavaris spends all his days taking care of children, pregnant women, and the sick.

His story is moving. He grew up alone with his mother in conditions of extreme poverty. "My most wonderful memory is of when my mother came home with my first pair of shoes. I still don't know how she managed to get them," he told me. When she finally found a way to send her son to school, he promptly won a government scholarship. He studied until he obtained his medical degree, and then practiced around rural Zambia before coming to this mission.

In the clinic he shares with three colleagues, Tavaris spends his days doing what he can with the little he has at his disposal. Equipment and medicine are scarce, but patients abound. I spent hours watching him work, mesmerized by his patience and devotion. So great is his commitment that I chose to photograph him in the modest room where he receives his patients.

It is similar to the mission room where I stayed, surrounded by the sisters. I discovered one Italian nun among their number, and she and I spent a lot of time together, walking around the village while I tried to understand her life. During the day, while I waited for Tavaris to finish with his patients, I spent my time either with her or playing soccer with the children, with whom I communicated using gestures. In the evenings, when even Tavaris could rest, he and I ate together in the mission refectory. One night they had a party. Priests and nuns danced arm in arm to the rhythm of local music with a joy that was contagious. It seemed to me proof that happiness is, above all, a condition of the spirit.

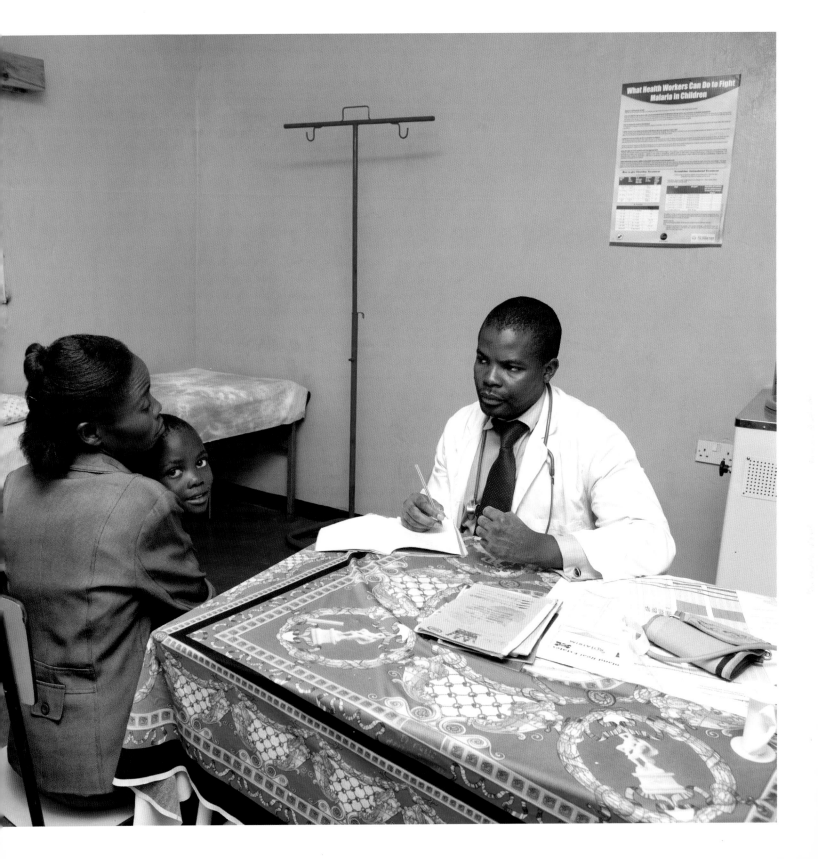

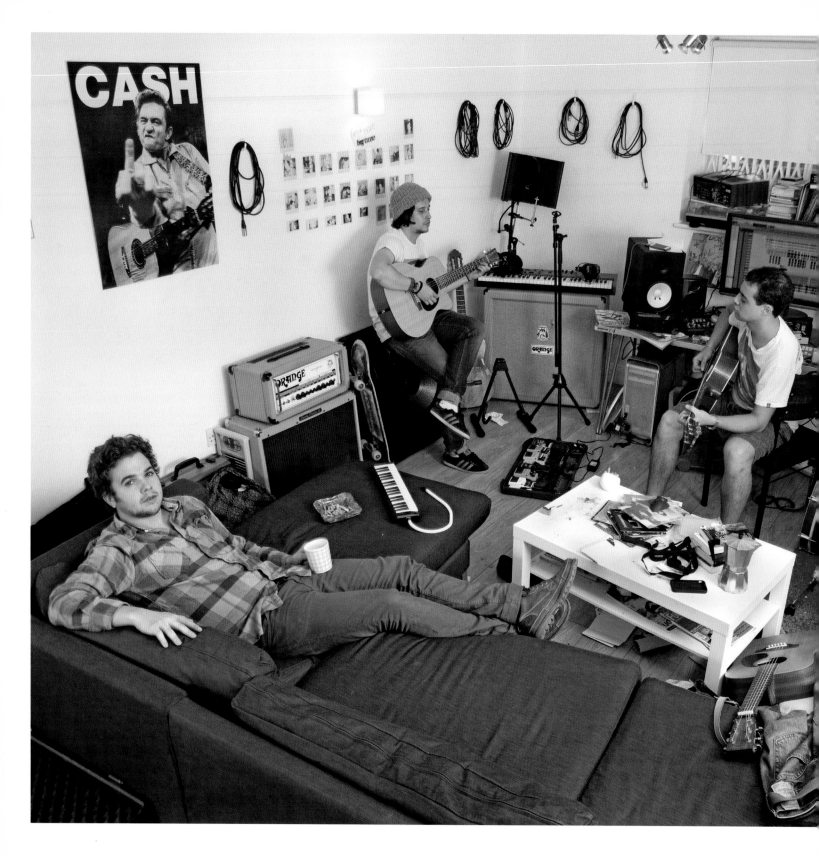

LONDON
— UNITED KINGDOM

STEVEN VOGES, 21, HAMID MASHALI, 24, and JUAN JOHANSSON, 23

The ashtrays overflow with cigarette butts. The coffee cups are half full. Wires hang from walls and shelves, or lie wherever they've fallen. A skateboard, some beer cans, and a mountain of dirty dishes share space with a computer (or maybe more than one) and, of course, musical equipment: guitars, drums, microphones, and an amp. Oh, and the poster—Johnny Cash, their "patron saint," as the three musicians jump to explain, perpetually flipping the room the bird. This place is their hideout, their lair, and somehow I ended up in it. It is the recording studio and home of Alex the Great, an indie band made up of three musicians who, between them, probably combine every ethnicity in the world.

Steven was born in Hong Kong, but he has since lived in Holland, Curaçao, Washington, Madrid, and London. Hamid was born a Colombian, but he studied in Spain before moving to London. Juan is half Brazilian and half Swedish, but he's lived practically everywhere, from Sweden to Australia, by way of Poland, Japan, Spain, and now, finally, London.

The three met in Madrid and then reunited in England, joining forces to make music and improvise jam sessions with whichever couchsurfers came to stay in this home-cum-recording studio that occupies two floors in east London. I spent one musical afternoon with them, trying my hand as a drummer and later sitting on the couch and listening to them play—the same couch on which I'd later fall into a deep sleep.

Alex the Great has recorded its first album. These days the band members travels around London and the length of England playing their music. "The world is divided into leaders and followers," Hamid told me, explaining his philosophy of life. Needless to say, Alex the Great hopes to lead the music scene one day.

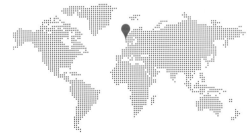

LIMA

PERU

CÉSAR FERNANDEZ MATA, 28

At first glance, there is no sign of a rebellious or adventuresome spirit in César. Yet I quickly learned that one of his dreams is to throw his belongings in a backpack and travel around the world. As a child, his goal was to study at the Catholic University of Lima, of which his dear uncle is an alumnus. César grew up with his nose buried in books, which his house is still full of today. He earned a law degree and now works at an important firm. He dreams of becoming a government minister or having another important role one day. That's probably why, when he showed me around Lima, he began with the buildings where power resides: the courts, central bank, and halls of government. (Most couchsurfers start with a place's natural beauty or the best nightclubs!)

Everything in César's home is precisely in order. He has two guest rooms, a kitchen, and a living room, modest in its simplicity, where a large ceramic dog lends a hint of humor. The most frequently used object is the ultramodern stationary bicycle César rides every evening.

While I was there, conversation with César was waning a bit, despite his cordiality, when another couchsurfer came looking for a place to stay. She livened things up, encouraging César to plan a night out involving at least a drink or two. That evening, I took advantage of the large kitchen to make risotto. After dinner, our host took us to a bar, where we drank a generous amount of the local spirit, *pisco*. César's fun streak began to show—and we all had a very good time, though we were back home before midnight. A few drinks are fine, but everything in moderation.

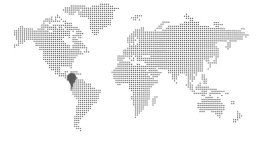

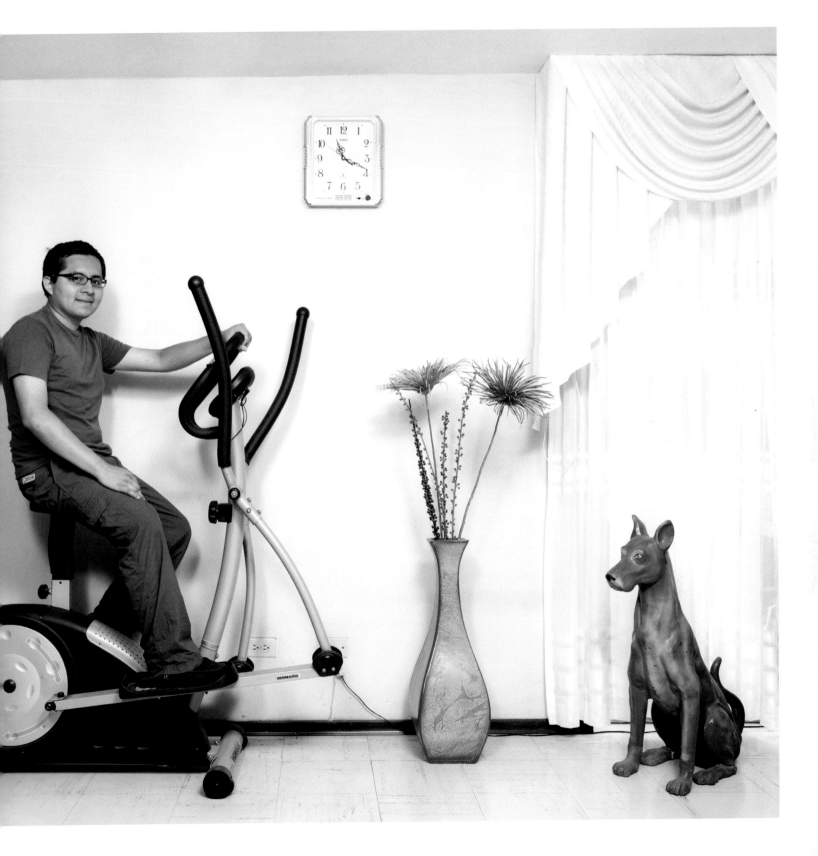

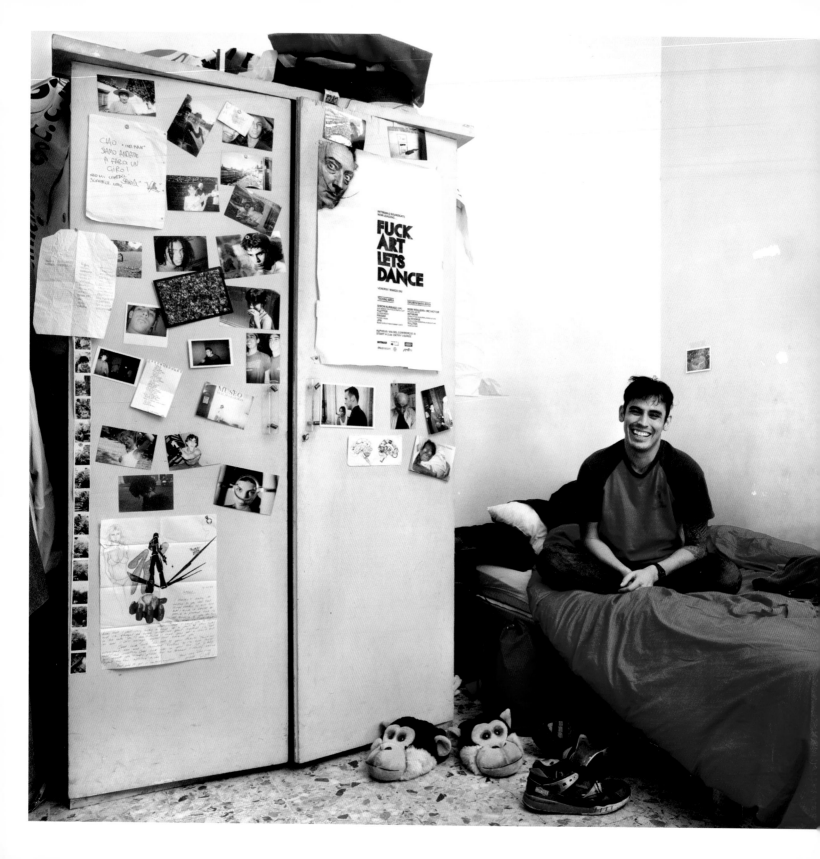

INTI D'AYALA VALVA, 27

Taped to the wardrobe near Inti's bed is a jumble of family photos. They are as disorganized as the thousands of objects crowded into this big house that is just steps away from St. Peter's Basilica in Vatican City, at the very heart of Rome. "This is my brother who lives in London, and this is the other one, who lives in Paris. This is my sister, who lives in Berlin. This lady is my mom. She's Bolivian. This is my dad. He's older than eighty, but he still stands as straight as a twenty-year-old," Inti said, pointing at each picture, his smile and energy unwavering throughout his exposition. He probably inherited his energy from his father, an Italian architect who once worked as an assistant to Frank Lloyd Wright. "A legend," is how Inti described his dad, who was currently napping in the next room, a place so crammed with papers that it was hard to make your way across it. The living room is similarly jam-packed, and is home to the sofa for visiting couchsurfers.

Inti is a deejay and music producer. "My stereo is my most important possession," he told me. Records fill his bedroom. When he was only fourteen, he met a well-known Roman rapper named Piotta, of whom he was a big fan. Years later, after meeting again onstage at comedian/activist Beppe Grillo's "V-Day" (a political movement challenging traditional Italian politics), the two ended up working together. "I had written and produced the anthem for the movement with a friend of mine, and Piotta was called in as a guest star. We were on the same wavelength, so we started to work together."

Inti could chalk it up to luck, but there could be another reason, one connected to the frequent description of him as "happy-go-lucky." He does all he can to be happy. "There's no problem so big you can't face it," he told me. "It just takes ideas." And more ideas are all Inti asks of his future.

ATHENS
GREECE

DANAI GOURD, 20

Persuading couchsurfers to let me photograph them for this book wasn't always easy. Some are shy; others don't think they're photogenic; some get embarrassed. Danai, however, was as eager to be photographed as she was happy to welcome me into her home. As a young girl, she studied classical ballet; in more recent years, she has posed for local fashion photographers, so she's very relaxed in front of the camera.

Actually, Danai is relaxed and confident in pretty much everything she does. The youngest of three sisters from a good Greek family, she studies computer science at university and has a lot of friends. When she's not with them, she loves to walk around the archaeological park in Sounio, south of Athens, her hometown and site of some of the most important ruins in Greece. "Stopping to look at the sea and letting the warm light of the sunset wash over me—that's what makes me happy," she tells me, and she can do it simply by stepping out of the small, private apartment she's built for herself at the far end of the portico leading to her parents' house. It consists of a single room and a private bath, so couchsurfers

stay in the main house—a villa with a garden located in an enviable spot by the seashore. The furniture in Danai's room has a vaguely antique look that contrasts sharply with the dozens of neon-bright swimsuits overflowing her drawers and spilling from behind her closet door. For years, Danai's father worked for a company that made bathing suits, which his daughter preserves and shows off as though they were treasures.

In my quarters, I made spaghetti for Danai and two of her friends one night. I was proud of the results, but disappointed when the dish was too spicy for their liking. They repaid the favor just the same, showing me around the Acropolis and sharing stories of ancient Greece.

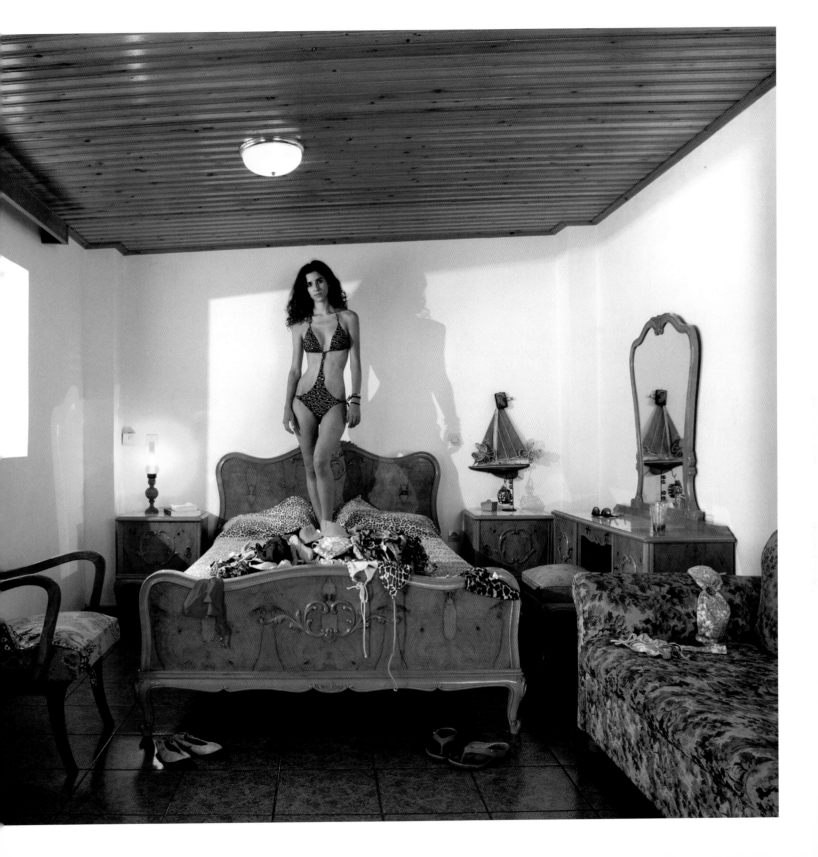

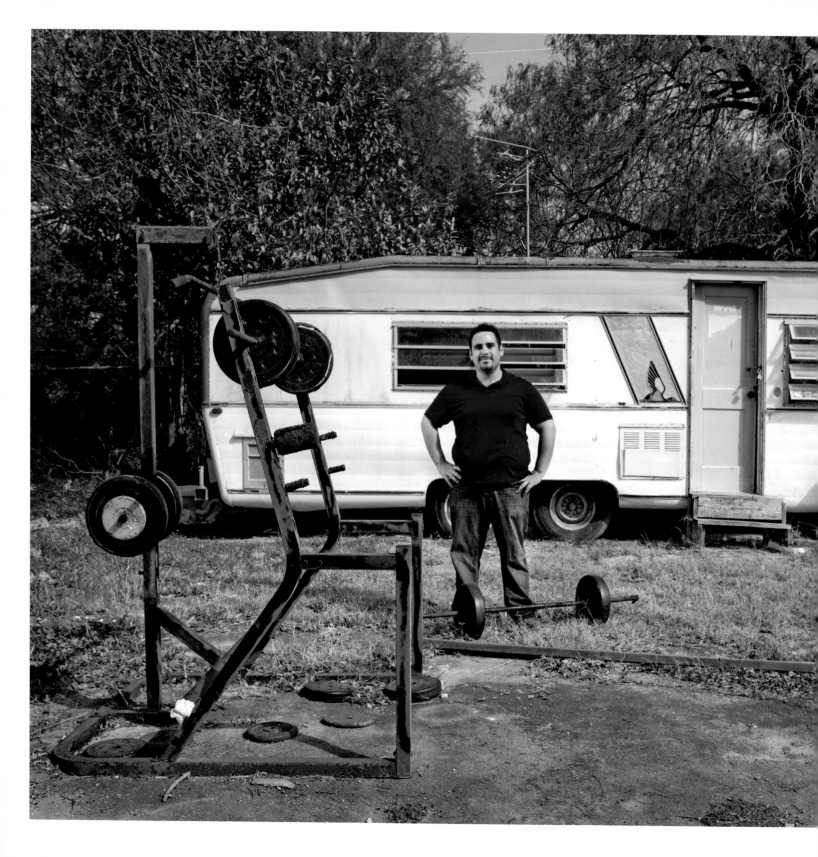

BROWNSVILLE
—
TEXAS

HENRY GARZA, 26

Mexico is just over the border. You can see it if you lean out of either of the two trailers parked side by side on this grassy patch in Brownsville, sandwiched between a tiny open-air weight-lifting setup and a workhorse of a pickup truck. Henry arrived here when he was just a year old, carried by his mother and his grandfather, who made the difficult border crossing on foot. His mother remarried a Texan, and Henry's grandfather raised Henry in the same trailer where, today, Henry is raising his own son. It's a home that bears the marks of the past: yellowed photos of ancestors on the walls, old-fashioned ceramic souvenirs, and the sound of mariachi music. Henry's grandfather, flashing broad smiles behind dark glasses at the rare guests who find their way here, plays the music all day.

Visitors sleep in the trailer next door, which has become a storage unit. I have had the chance to sleep in both trailers, having come here twice to listen to Henry's stories. One of Henry's dreams is to open a restaurant, where he says he would serve the best Parmigiano-Reggiano cheese and fine wines. It would be an Italian restaurant, naturally, like Carino's, where Henry is headwaiter. All the employees there are Mexican—apart from Henry, who is, as he proudly reminds me, American, as is his taste in food. In his opinion, the best meal is a McDonald's hamburger. The best drink, however, is that same tequila his grandfather sips. It's a family tradition.

LA PAZ
—
BOLIVIA

VIVIANA CANDIA, 36

Viviana's life is as surprising as the view from her window in La Paz. The city is extraordinary, crowded into a bowl surrounded by breathtaking mountains that are as extraordinary as the life that Viviana has managed to make for herself and her daughter, Ivi—so different from the lives of other Bolivian women.

The differences begin with the fact that Viviana, who has a degree in anthropology, is a young single mother. Ivi's father is a French painter who spends long periods in La Paz seeking inspiration. He and Viviana haven't been together for a while, but when he is in Bolivia, he spends time with his daughter. The task of raising Ivi nonetheless falls entirely to Viviana, but she doesn't see it as a burden. On the contrary, she'd like to have another child, and so she will consider adoption.

Like everyone in her family, Viviana works in the tourism industry. She spends a lot of her time with foreigners who come to enjoy La Paz's incomparable panorama, so she has plenty of chances to meet people. The doors of her home are always open to couchsurfers. She takes them in, offering her guest room while she and Ivi sleep in the big double bed in the next room, surrounded by clothing, toys, and the joyful chaos that only a three-year-old can create.

Viviana is full of energy and enthusiasm. I was particularly tired from altitude sickness during my stay in her home, which is perched in the high area of the city. First, she tried giving me coca leaves to chew, per the local old wives' tale. When this didn't work, she turned to a stronger remedy: the delicious cuisine of Lake Titicaca. It took us a few hours to get there by bus, but a stroll through the local markets and some delicious trout fillets helped restore my energy. The view of Titicaca was one of the most beautiful I'd ever seen.

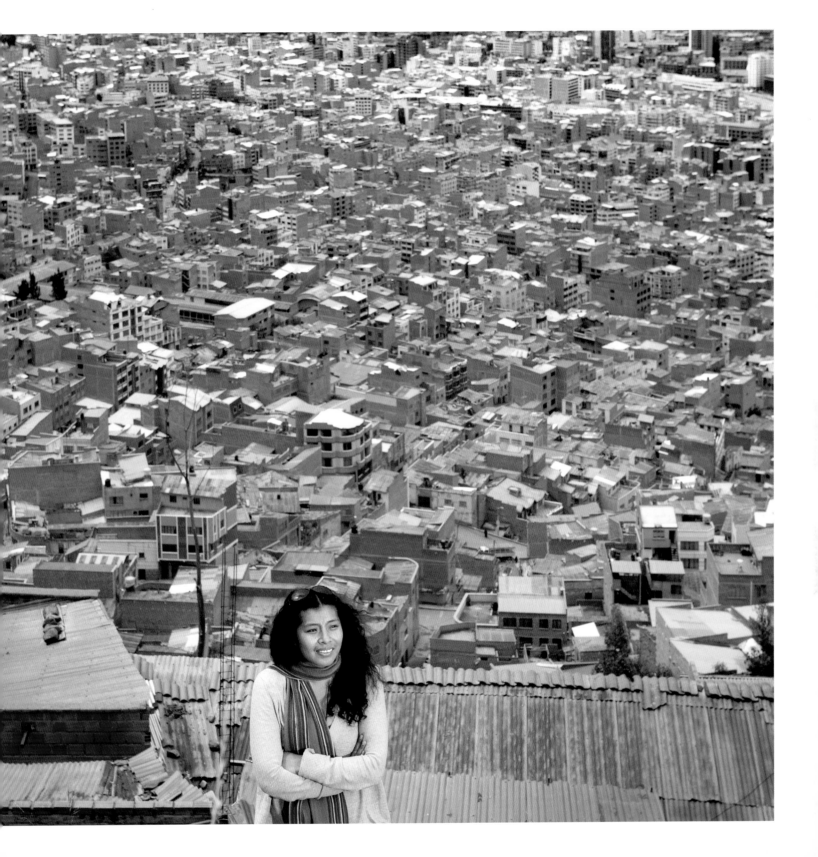

KUALA LUMPUR
—
MALAYSIA

JEEVA PRATABAN, 26

Three pythons, two cobras, two Mexican iguanas, a coral snake, and a black widow shared my room with me in Kuala Lumpur. They hissed and scuttled menacingly, only an arm's length away, maybe less, pressing against the glass for a better look at me. Their owner, Jeeva, calls them his "puppies." In fact, the whole family treats them like cuddly pets. Gathered together, they make an unusual family portrait. Upon waking in the morning, I found his mother and sister on the love seat, playing with the python lying across their laps. Jeeva, meanwhile, relaxed on the sofa, an iguana perched on his arm. I had to take this picture. Who would ever believe me, otherwise?

Jeeva lives in a massive apartment block on the outskirts of the city. He enjoys having international guests, but because the second room is his mother and sister's, visitors must share his bed (which explains how he ended up having a Canadian couch-surfer girlfriend for a while). As courteous as Jeeva was, I barely slept a wink that first night in Kuala Lumpur. As I was sandwiched between my new friend, whom I'd met just an hour before bedtime, and glass tanks full of exotic creatures, can you blame me? You really can get used to anything, though. By the second morning, the iguana perched on Jeeva's shoulder already seemed less odd (or, at least, odd in a funny way).

One day, when he didn't have a shift at any of the three local restaurants where he works as a chef, I hopped on the backseat of the souped-up scooter he's using until he can afford to buy a motorcycle and we went to see a beautiful waterfall outside the city. Jeeva's dream is to leave Malaysia and open a restaurant in some other part of the world. What would he take with him? His television, his family, and of course his pets.

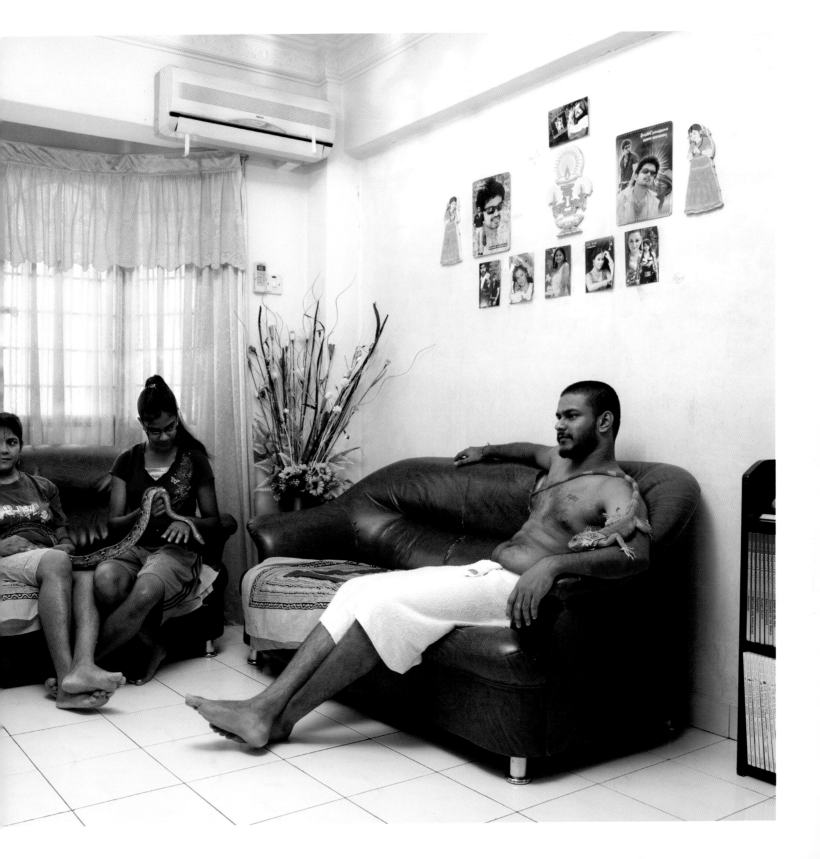

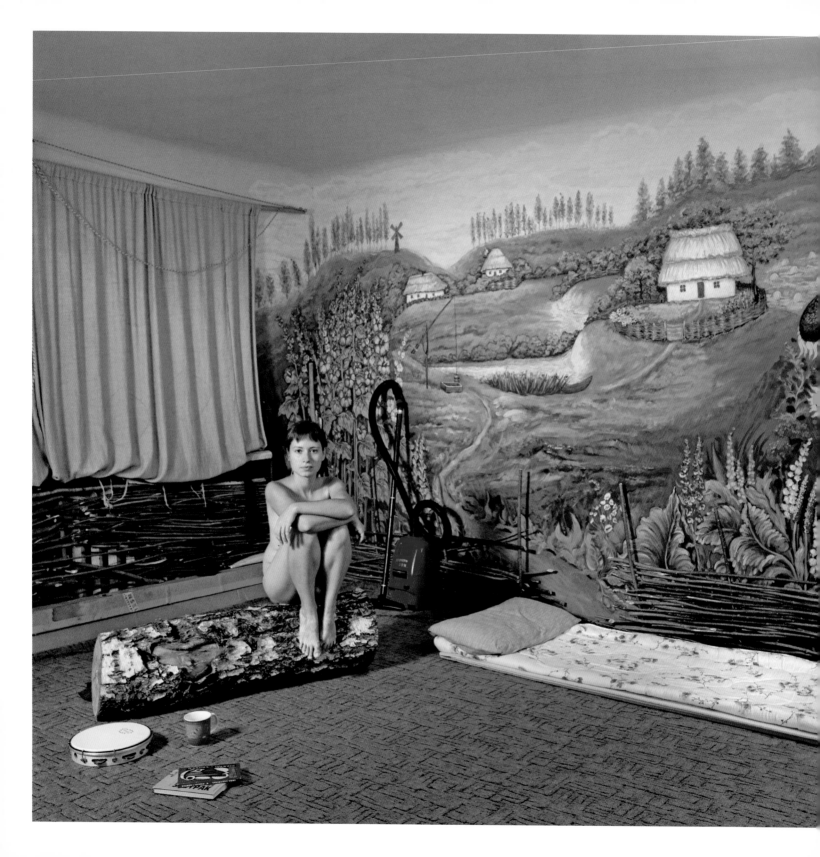

OLENA NAUMOVSKA, 22

All you have to do is set foot—strictly bare feet; no shoes allowed—in Olena's Kiev home to understand the tenets by which she lives: a tree trunk for a bench, rocks for chairs, and boulders for tables. All around the walls, country scenes are painted, a verdant landscape contained within an apartment's walls. Olena is a committed naturist. "I don't like to wear makeup or, when I can avoid it, clothing—especially not in my own home," she tells me.

She and her boyfriend, Igor, often walk around the apartment—which consists of a living room (where I slept on a yoga mat during my stay), kitchen, bedroom, and bathroom—naked. While I was there, they did it so naturally that I quickly got used to it. They don't ask their couchsurfer guests to do as they do, but only to leave the bathroom door open when showering, in case someone needs to go in to get something. I got used to that pretty quickly, too.

Olena studies philosophy—"since math is too complicated," she says—and works as a waitress in a pastry shop. She dreams of becoming a writer. In the meantime, she gives out hugs to strangers. She belongs to one of those groups that can be found all over the world these days, and every once in a while show up on the news. When she has a couple of free hours, she goes down to the square in front of the train station with a sign that reads, "Free Hugs," and waits for people who need some affection. "You have no idea how many stop. It seems like there are a lot of people, too many, who aren't getting the love they need."

Her apartment is always open, both to international guests and local friends. I spent more than one evening there, cooking and listening while she and Igor played the guitar. The menu in Olena's home is strictly nature-friendly, too. She doesn't drink or smoke, and she tries to shop for food only in local markets. "The last song I wrote, the last blouse I made, the last person I smiled at is the thing I'm most proud of," she told me. She may not have her degree yet, but she's already a bit of a philosopher.

BUGGIBBA
——
MALTA

ROB KOSSETZ, 29, and MARIKA STRALE, 33

They fled the city for an island in the Mediterranean. That sums up the story of Rob and Marika—well, it does if you throw in love at first sight and a cross-continental move executed on four wheels. Marika is from Latvia. She met Rob one sweltering summer during a vacation in Malta. Rob, from Germany, had come to the island for a master's program after finishing his undergraduate degree in communication technologies. "It's quiet and sunny and everyone's nice," he said of Malta. "When I realized I could come here, I didn't think twice."

Francesco, the Cupid of couchsurfers, from Malta (see page 75), did the rest. Not only does Francesco host numerous visitors in his own home but he also organizes a weekly dinner for all the couchsurfers on the island. It was there that Rob and Marika met. Something between them sparked, and they spent two weeks together—until Marika's vacation ended. For a year they stayed in touch, talking and writing using every means of technology at their disposal, until Marika made up her mind to move to Malta, too. That's how they ended up packing a car and driving it across Europe. Their destination was the little apartment building in Buggibba on whose roof they posed for this photo, surrounded by anten-nae, which for me were the symbol of what helped them to stay in touch during their year apart.

Their home is a small apartment in a recently constructed building just over a mile from the sea—a sort of love nest. I spent five nights on the couch in their kitchen-cum-living room, their home's center of activity. During that visit, they took me to see a bit of everything: we rented a car and drove around the island in search of the best beaches and hidden spots.

When I left, we promised to keep in touch, and we have. Not only did I meet up with them in Latvia while they were vacationing there, but a few months later, they invited me to their wedding. Sadly, I couldn't make it, but not long ago they sent me a photo of their first baby.

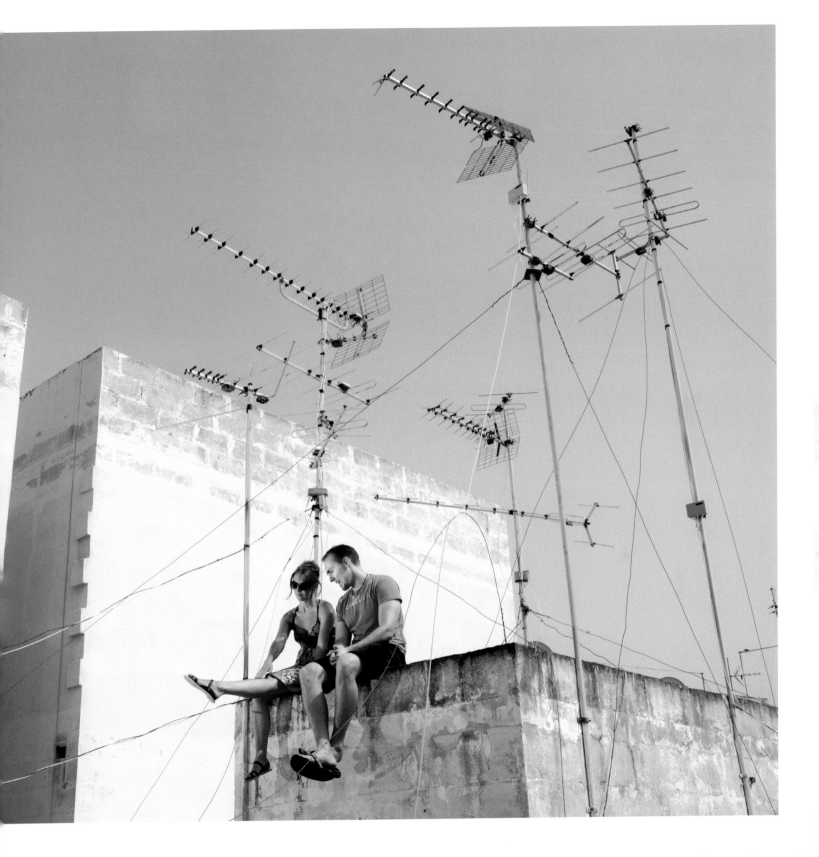

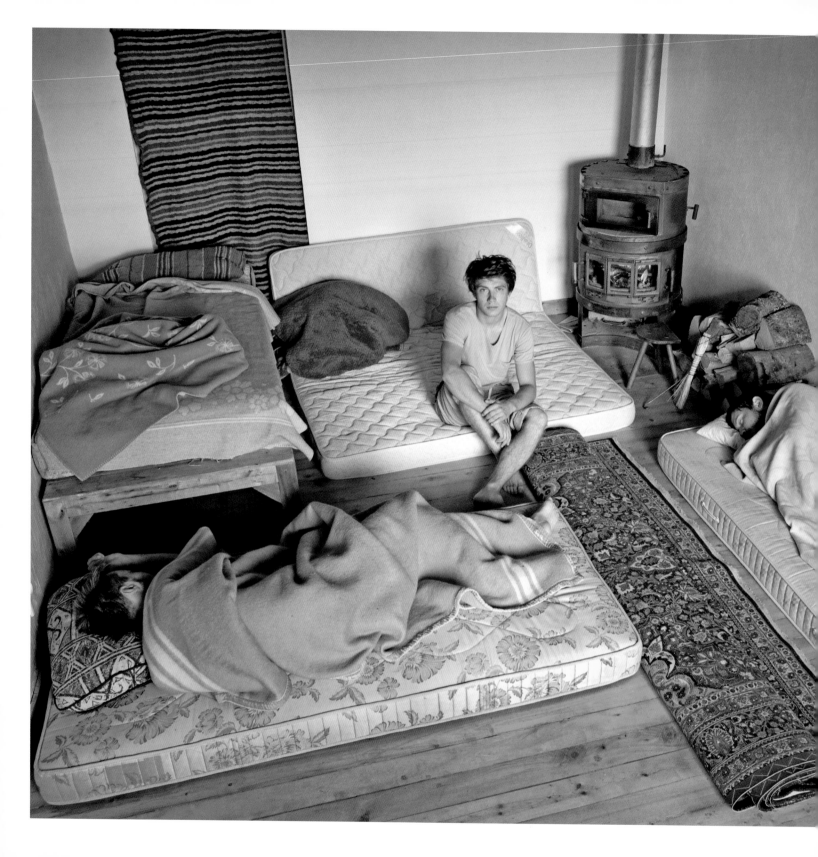

DIMITRI PROCOFIEFF, 22

To reach Dimitri's family's home, travelers must first get through more than six miles of dense forest, a sort of sanctuary for the ecologically aware wayfarer spread high in the mountains above Geneva. The very large house, constructed almost entirely of wood, is set on the shore of a small lake with a clear view of Mont Blanc. There are no neighbors, no connection with the rest of the world. Everything in Dimitri's home has zero environmental impact, and is recycled and sustainable. The energy used in the house is produced by wind turbines and solar panels; rainwater is collected and circulated, and heat is generated using wood from the nearby forest (but only from trees ready to be cut, of course). It's thanks to that wood that I ended up couchsurfing with Dimitri and his family. Every year they organize a get-together: three days during which friends, acquaintances, and couch-surfers recruited from near and far help cut all the wood needed to heat the house through the winter. Think of it as a sort of jamboree, where guests work during the day and party at night with people from just about everywhere.

Dimitri is also a photographer, and our paths had crossed before at a photography festival in Vevey, Switzerland. So I knew about his family's summer wood-cutting tradition and decided to go claim one of the numerous mattresses he puts out for visiting couchsurfers. Their home may be simple, but it's very big, and Dimitri, his mother, and her partner open their doors to whoever passes through.

Dimitri's incredible hospitality may be, at least in part, a consequence of his nomadic history. Born in France to a family of Russian origin, he spent his early years moving from one place to another: Paris, Moscow, Tbilisi, Sri Lanka, and Belgrade, the place where, finally, at the age of fifteen, he started to feel at home. When his family went to live in Senegal, Dimitri headed to Geneva, which is where he lives today and where his mother and her partner later joined him, surrounded by friends and couchsurfers. As he told me, "The thing I'm most proud of is having maintained real relationships with friends whom, unfortunately, I only rarely see."

BOGOTÁ
—
COLOMBIA

CATALINA JURADO, 33

Catalina is a teacher and director of communications in a private school in the north of the city. Bogotá was the last stop on my journey, and her couch was the last one on which I would sleep. At the time, she was sharing a large apartment with a girlfriend while she waited to move into the apartment she had bought, sight unseen, based on a builder's plans. She was given the keys the day after I arrived, and she invited me to accompany her to open the door for the first time.

Her parents were there, standing by the door. They hadn't spoken to each other in a long time, and hadn't seen each other since they'd separated. Catalina was understandably nervous, but also joyful and beaming. I was excited for her. It was time for a toast; her father had brought a bottle of wine, but had forgotten a corkscrew. I improvised one using a pair of pliers and a screw borrowed from some workmen on the building site.

Catalina's new home wasn't ready to be lived in, so after the celebration, we went back to her old apartment. One night, I offered to prepare us a special Italian dinner (my grandmother's ravioli recipe) in honor of the occasion. It was there that the feeling I'd had for Catalina since we'd stayed up late talking the previous evening grew and turned into the beginning of a relationship that would last for two years.

For the next few days she showed me around Bogotá. She took me to the school downtown where she'd taught until a year before—a job and a place she's so proud of that it's where she asked me to take her picture, surrounded by her former students. We spent the following months as a couple, our relationship moving between Tuscany and Bogotá, and sometimes to other countries. My mission to couchsurf across the five continents was over, but my travels around the world were not.

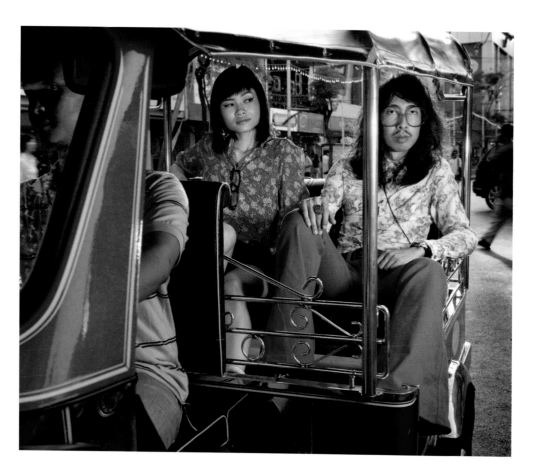

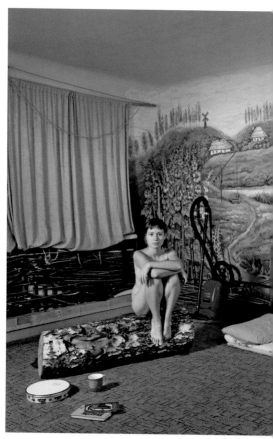

ACKNOWLEDGMENTS

I would like to thank:

All the couchsurfers photographed for this book and all the others who are not in this book but have hosted me around the world over the course of the past five years of my travels.

My family.

Arianna Rinaldo, Cristina Guarinelli, and all the people who work at *D, La Repubblica*.

Paolo Woods, Edoardo Delille, Claude Baechtold, Serge Michel, Pietro Chelli, my agents at INSTITUTE, and the Waxman Leavell Agency.

Catiello and all my friends in Val di Chiana.

All my friends in Firenze, Elisa Paolucci, Catalina Jurado, Alia Bengana, Vanessa Peters, Chiara Amorini, and Annina Truci.

The gang at Via Vigevano, 9.

Dominique, who gave me somewhere to go the first time I ever took a flight alone.

Studio Marangoni in Florence, Cortona on the Move, couchsurfing.com, Massimo Pulcini, Carlo Bach, and all the people at Illy.

A special thank-you to Gea Scancarello, for her invaluable assistance in putting my stories down on paper, and to Jennifer Delare, for holding true to the essence of my storytelling in her translation.

INDEX

ABOUT THE AUTHOR

Gabriele Galimberti, born in 1977, is an Italian photographer who often lives on airplanes and occasionally in Val di Chiana (Tuscany), where he was born and raised.

He has spent the last few years working on long-term documentary photography projects around the world, some of which have become books, such as *Toy Stories* (Abrams Books) and *In Her Kitchen* (Clarkson Potter/Publishers), which won the 2015 James Beard Foundation Award for Photography.

Gabriele's job consists mainly of telling the stories of people he's met in his travels, recounting their peculiarities and differences, the things they are proud of, and the belongings with which they surround themselves. He became committed to documentary photography after starting out as a commercial photographer, and after joining the artistic collective Riverboom, best known for its work entitled "Switzerland Versus the World," which was successfully exhibited internationally in festivals, magazines, and art shows.

Gabriele continues to travel around the globe, working on both solo and shared projects (including one sponsored by Illy coffee), as well as on assignments for international publications, such as *The Sunday Times*, *Stern*, *Geo*, *Le Monde*, *La Repubblica*, and *Marie Claire*.

His pictures have been exhibited in shows worldwide, including at Les Recontres d'Arles in France, the well-known Festival Images in Vevey, Switzerland, and the renowned Victoria & Albert museum in London. They have won the Fotoleggendo Festival Award in Rome and the "Best in Show" prize at the New York Photography Festival.

www.gabrielegalimberti.com